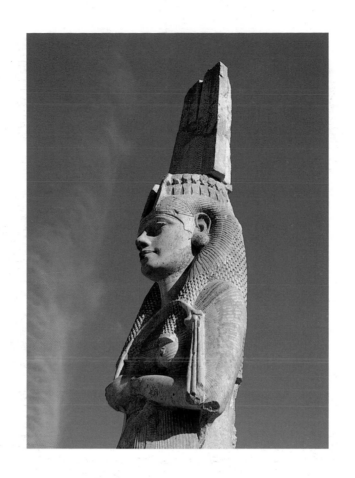

SILENT IMAGES

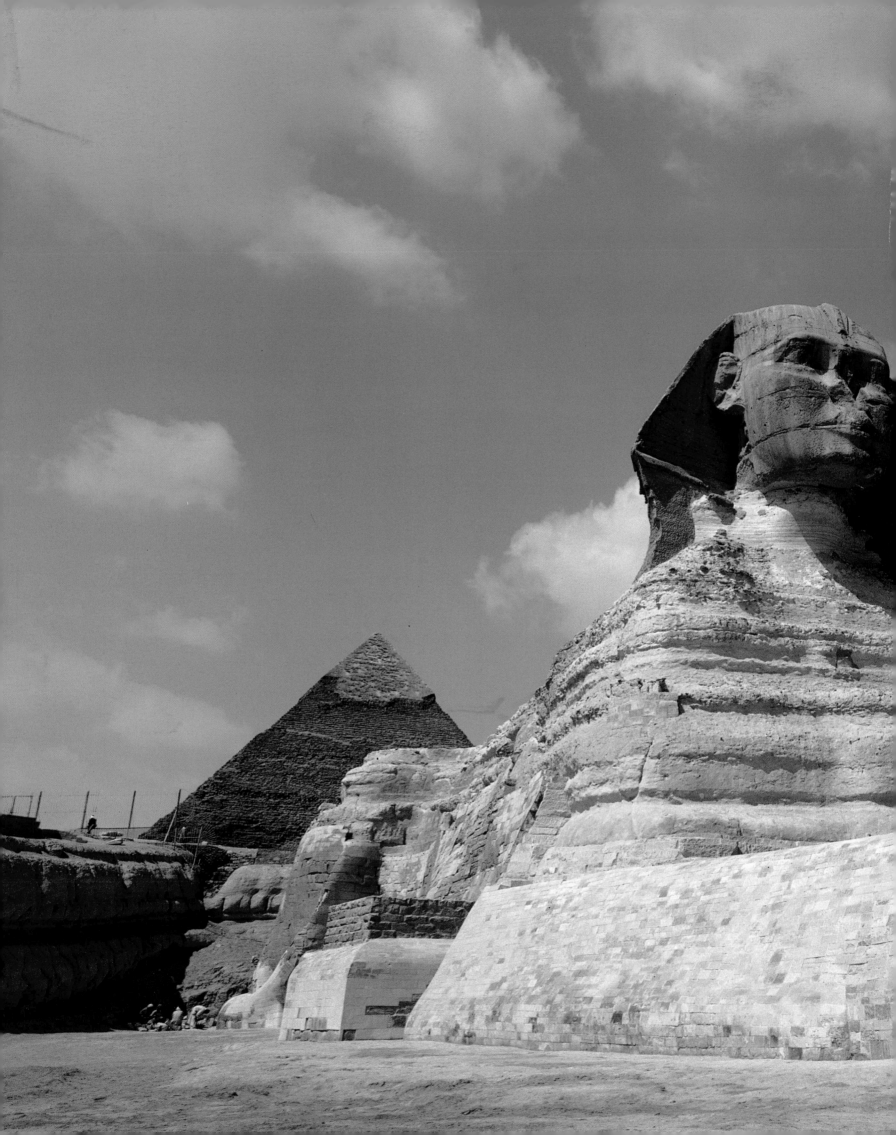

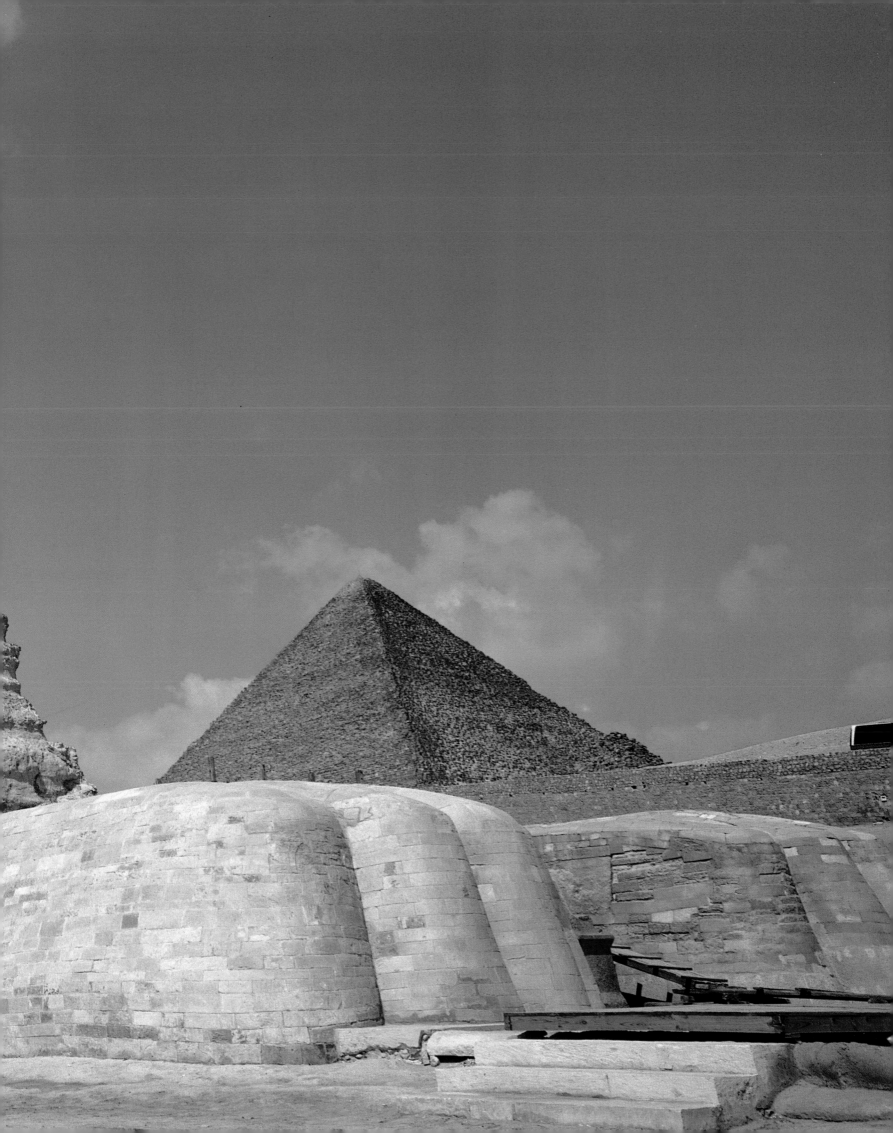

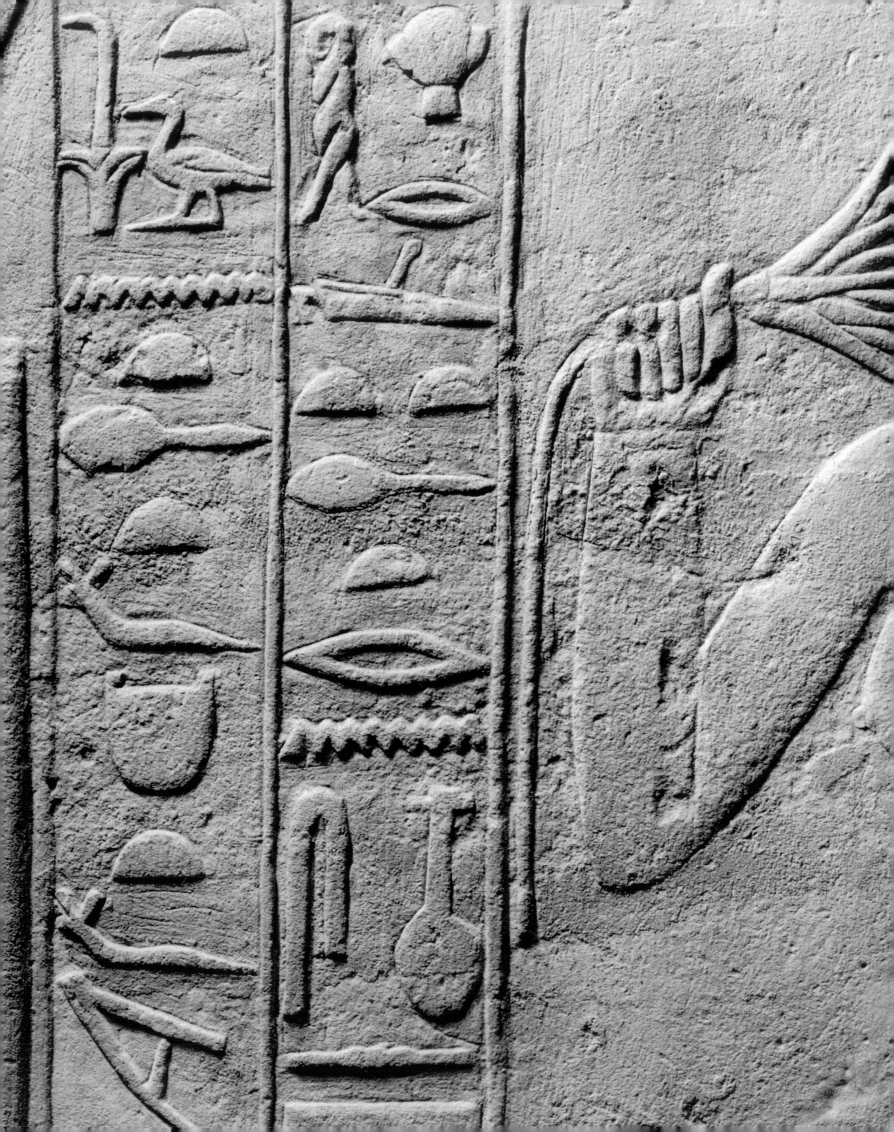

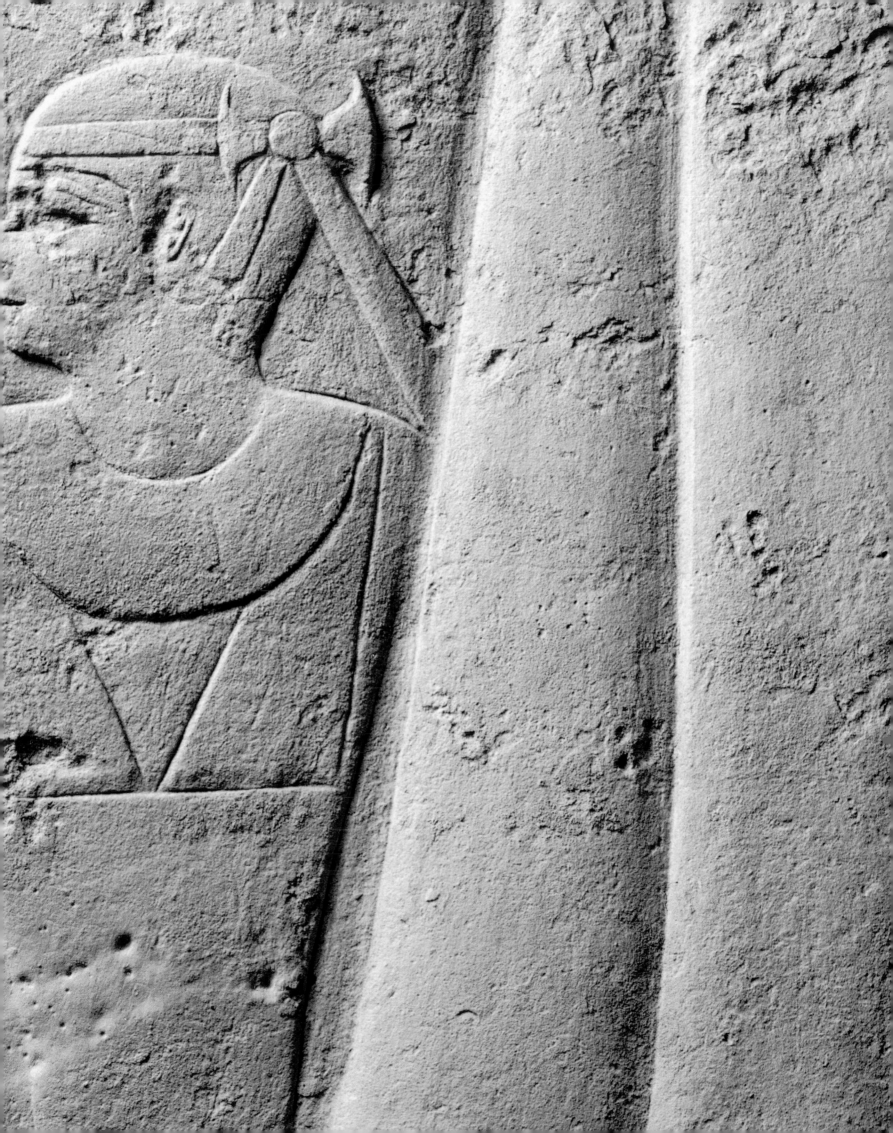

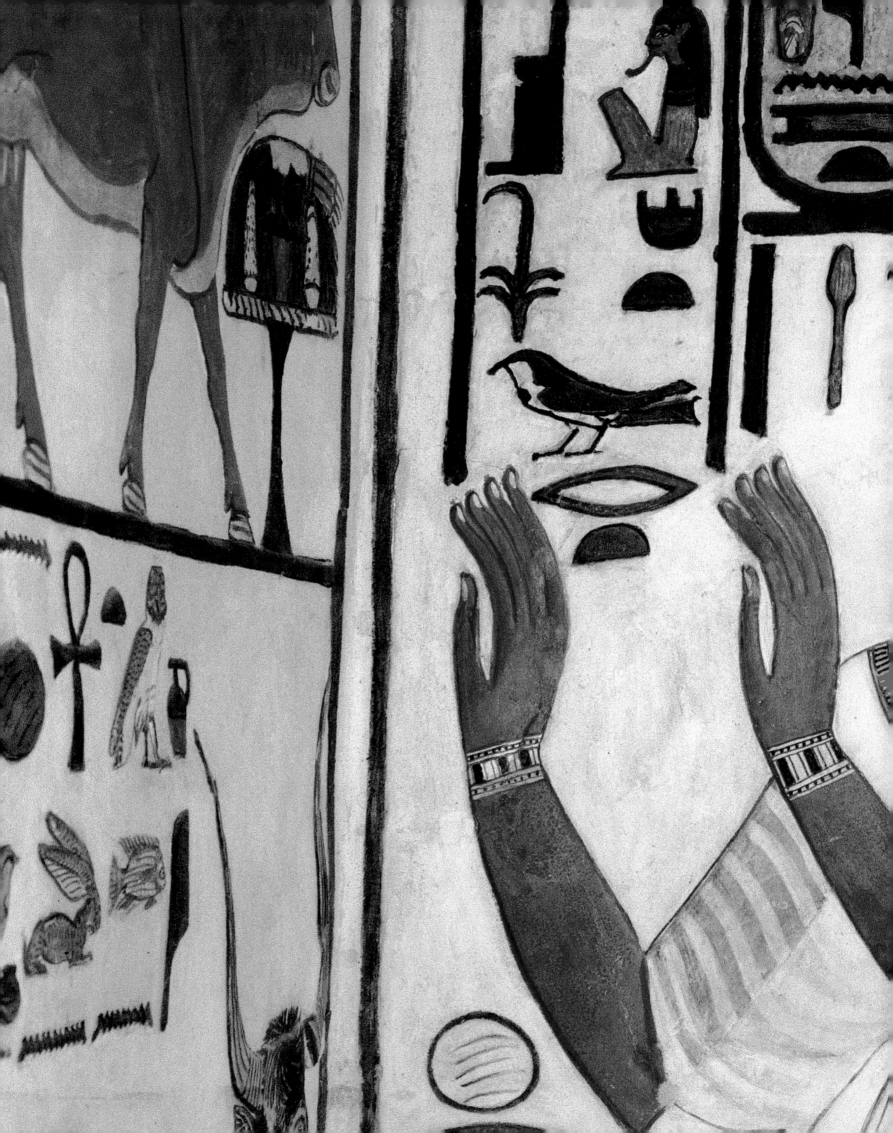

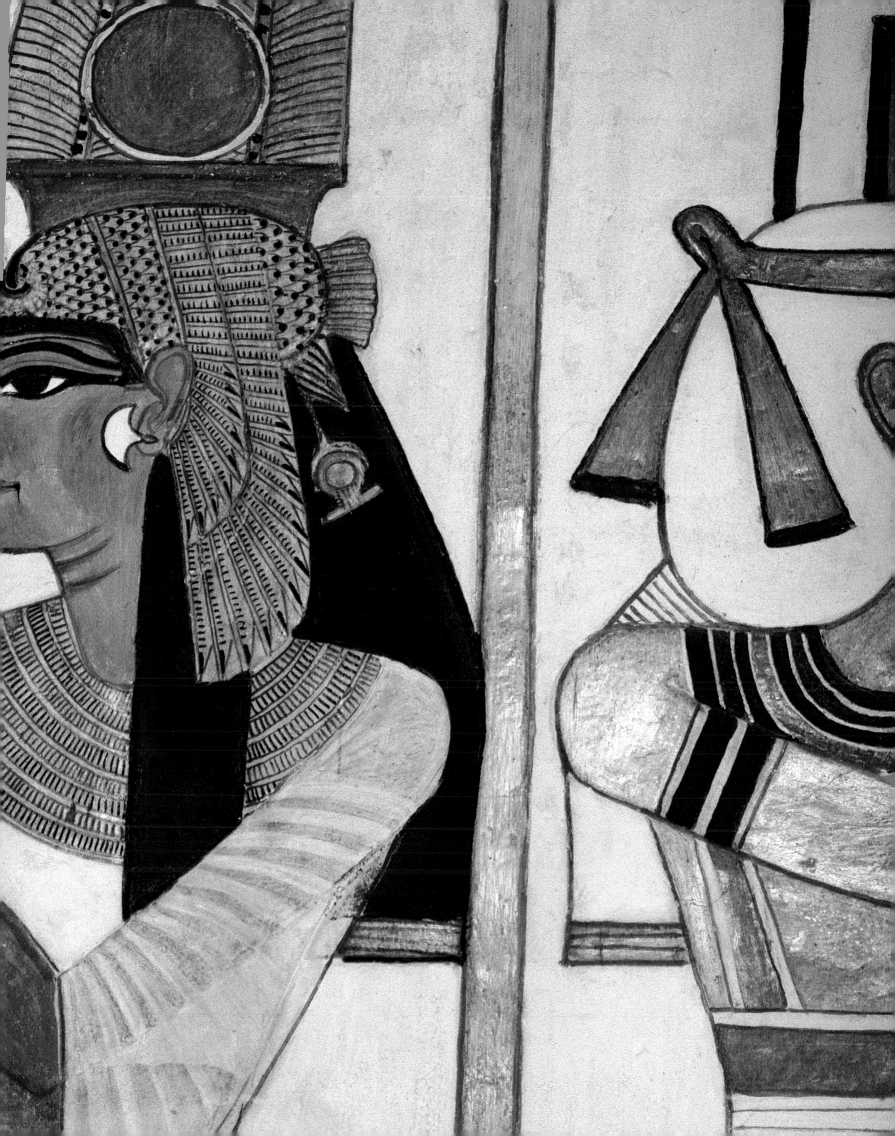

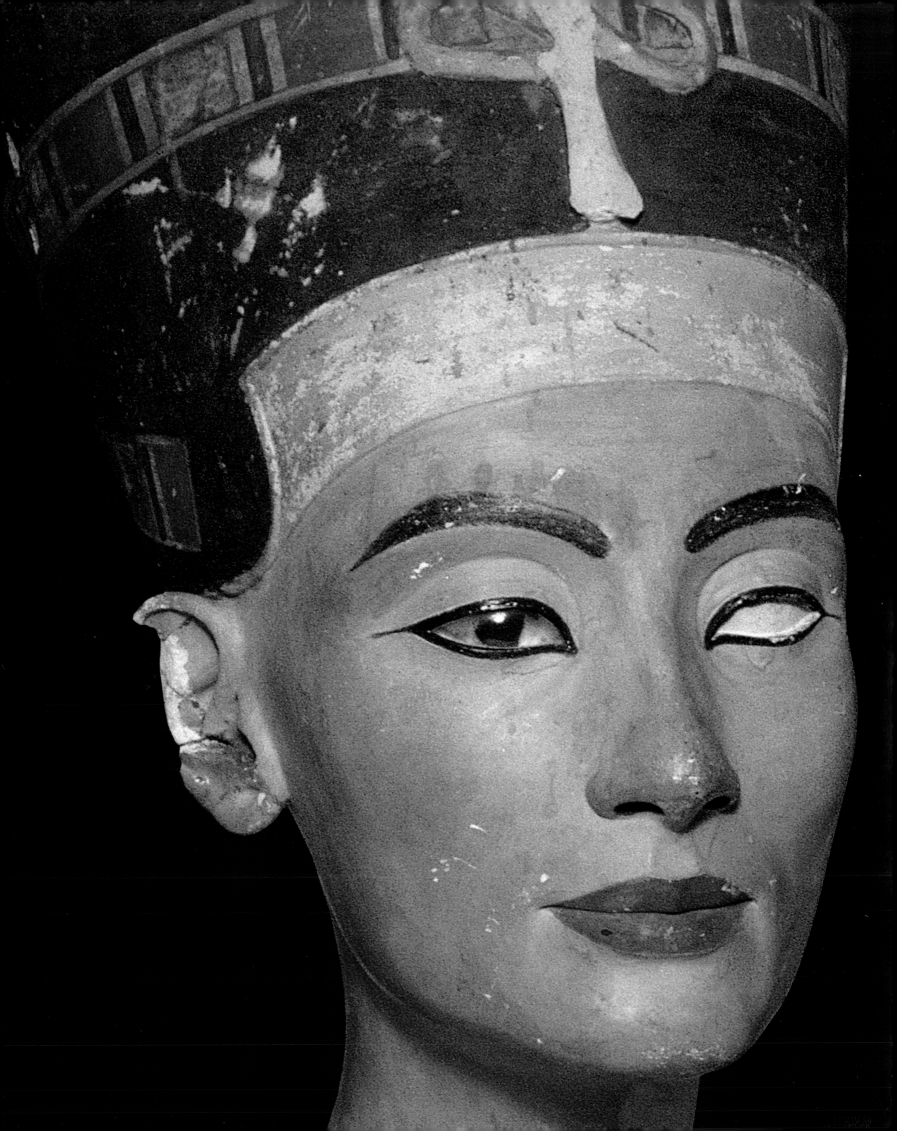

SILENT IMAGES

WOMEN IN PHARAONIC EGYPT

ZAHI HAWASS

FOREWORD BY SUZANNE MUBARAK

HARRY N. ABRAMS, INC., PUBLISHERS

CONTENTS

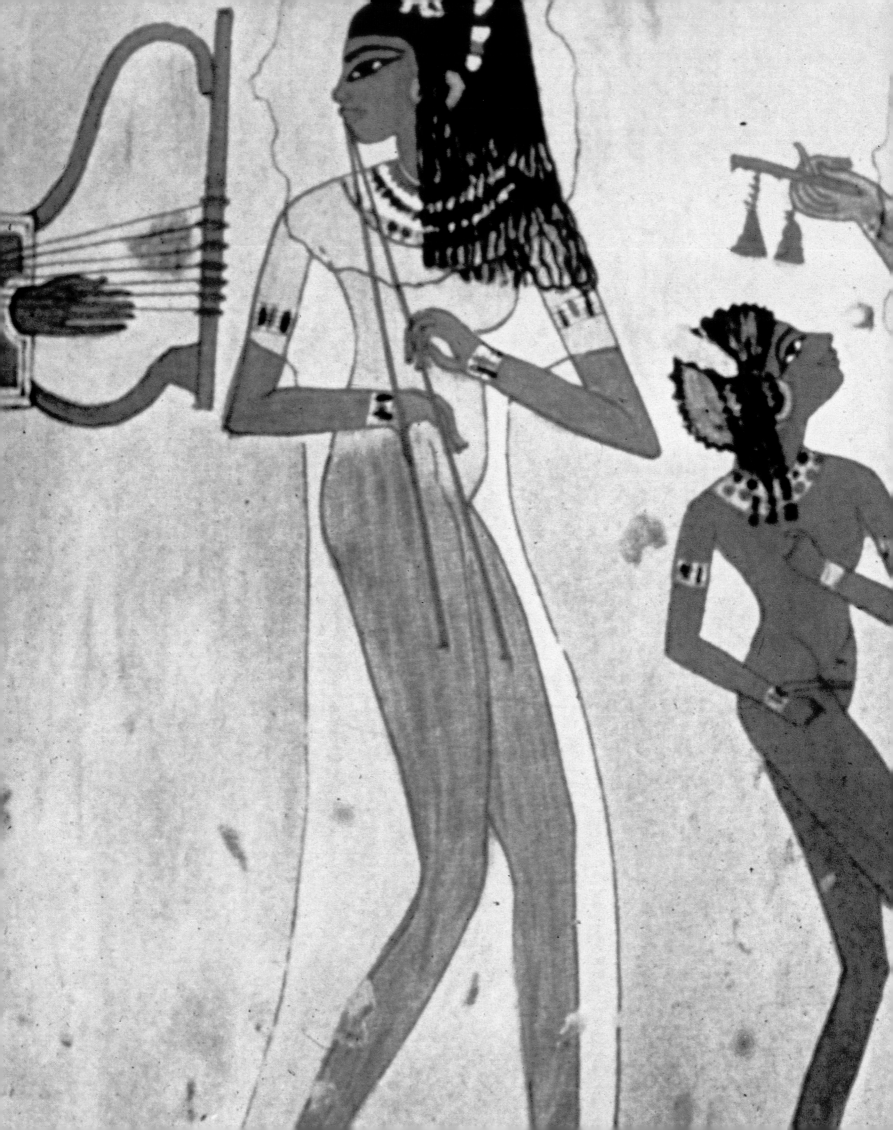

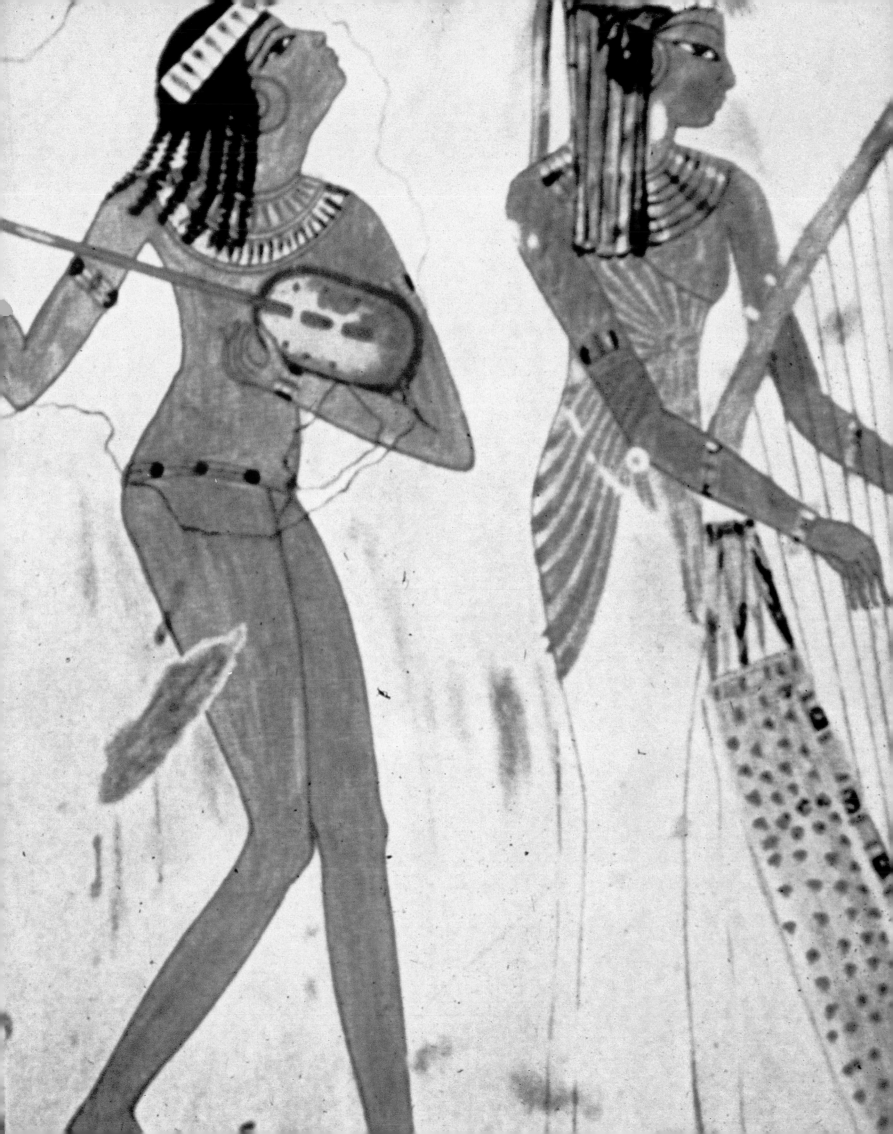

FOREWORD

When I first learned of the United Nations 4th World Conference on Women I was most anxious that Egypt should participate. The history of ancient Egypt is one of the earliest of mankind's journeys on this planet. To identify the role of women in ancient Egypt is therefore fundamental to understanding the importance of the part they played in the development of today's society and the world as we know it.

So I asked Dr. Zahi Hawass to research the issue, and when he presented his findings to me, I was fascinated by the results. Over the last year, that has been the methodology used to prepare this book.

The result is that, as seen through the writings, arts and artefacts of the time, it is clear that the women of ancient Egypt enjoyed a much more prominent position in society and far fewer restrictions than their counterparts in ancient Greece or Rome. The independence and respect accorded to Egyptian women, predicated upon their legal equality with men, could serve as a model for today's feminist awakenings.

We as women have traditionally shouldered the main burdens of raising families, balancing budgets and caring for the primary income producers, be they husbands or partners. We as women have been responsible for maintaining the emotional equilibrium of our family units. And we as women have been at the fore because we have always tried to organize our work and time economically in order to accomplish all that was required. The most efficient methods of completing any task, be it weaving or computer programming, are always sought to allow time to enjoy family and friends, and our community lives.

Times are changing, as are the roles which women are undertaking. But past can serve as prologue, and the conclusion is that women will always prevail in a thoroughly modern society as they did in the traditional society that was ancient Egypt.

My country has been called the 'gift of the Nile' due to the importance of that great waterway in giving life to our people. And from studying ancient history, it is also appropriate to say that Egypt's women have been part of its gift to development.

Please permit me to share with you my adventure in learning about the role of women in our early history as it was defined during the glorious millennia known as ancient Egypt.

SUZANNE MUBARAK

ACKNOWLEDGMENTS

The preparation of this book involved the assistance of many people whose cooperation, advice, and aid it is a pleasure to acknowledge. Above all, I would like to thank H.E. Mrs. Suzanne Mubarak, who first conceived of the idea of a book about women in pharaonic Egypt to present to delegates at the United Nations 4th World Conference on Women. I am greatly honored that she asked me to write it, and am grateful for her encouragement, without which this book would never have been completed.

I was fortunate in having the support of Mr. Farouk Hosni, Minister of Culture, to publish the original edition of this book through the Cultural Development Fund. My thanks go to him and to Mr. Samir Gharieb, former Director of the Cultural Development Fund and now Chairman of the National Library and Archives.

I would like to thank Mr. Giuseppe Lamastra of Leonardo International, who suggested the republication of this book with new additions and the latest information on the recent archaeological discoveries connected with women in ancient Egypt.

My gratitude also goes to my friend Mark Linz, Director of The American University in Cairo Press, who encouraged me to prepare the new material and collaborate with Leonardo Mondadori in publishing the book.

I would also like to thank Mr. Neil Hewison and Mr. Daniel Rolph at the American University in Cairo Press for reading and editing the new manuscript.

My very special thanks go to my colleague Yvonne Harper for reading the previous edition and correcting the type, and to my friend Angela Jones for her gracious help in organizing and editing the first manuscript.

Last but not least, I am greatly indebted to my colleague Tarek el-Awady, who was of tremendous help in the organization of the photographs for the book, and worked with The American University in Cairo Press in the editing and organization of this edition.

Finally, it is to my sons, Sherief and Karim, that I dedicate this book.

ZAHI HAWASS

INTRODUCTION

When I was asked by H.E. Mrs. Suzanne Mubarak to write a book about women in ancient Egypt, I felt highly honored but also rather daunted by the magnitude of the assignment. Nevertheless, I accepted this task with alacrity because I have always felt that the ancient Egyptians should be much more accessible to an Egyptian scholar than to someone brought up and educated in the West. Here, in our country, so many of the traditions and social customs in our villages are the direct legacy of ancient Egypt that it should be possible to put some new insights into a subject which has recently come under scrutiny—the role of women in society.

There is no doubt that any study of women is unbalanced because it focuses on only half of the population. Paradoxically, however, this study is perhaps not actually as biased as it ought to be. Ancient Egyptian women are not as prominent in the records as they appear at first sight. Delving into the sources for our information, it became more and more apparent that hard facts about them are not always easy to find.

Nearly all the information that we possess about ancient Egypt has been extracted from sources about, or written by, the other half of the population—the men. And it was an even smaller percentage of these men, perhaps only ten percent, who were in a position to decide what to record and how. Not only do our chief sources come from this very small and privileged segment of the population, but they present their own view of the other sex, which, I think, is rightly suspected to be idealistic and very incomplete. To compound this difficulty, many of these sources are best known only from the translations and interpretations of male Western scholars.

Estimates of the population of ancient Egypt vary enormously and, in truth, we do not have enough information to attempt an accurate assessment. In the Roman period, census data show that about seven million people lived in Egypt, with another half million in Alexandria. The improved agricultural and irrigation techniques of this late period meant that the land could support a much greater number of people than in earlier periods. Estimates for the Old Kingdom population, however, though not necessarily correct, are as low as one million. Whatever the actual figure, it is clear that most people, perhaps as many as eighty percent of the total population, worked on the land. These farmers, for whom literacy would have been irrelevant, were governed, taxed and generally imposed upon by a small, educated aristocracy. It is this literate, male elite who have left us the records in writings, paintings and sculpture.

Nowhere do we find for certain a text written by a woman for other women. We do not even know if they agreed with the images imposed upon them by their menfolk. Did they like to think of themselves as the slender, wisplike creatures depicted on the monuments? Or, if the truth be known, were they really proud of a good girth, which in Egyptian villages nowadays denotes strength and fertility? Perhaps the slender figure was only an upper class tradition. We simply do not know.

One of our chief sources about how the ancient Egyptians thought of themselves is the genre of 'Wisdom Literature,' popular at all times. These texts were usually written in the form of advice given by an educated official, or even a king, to his son. In other words, they were written by men, for men. They do talk about women, advising how to choose and treat wives, to avoid 'women of easy virtue,' and illicit relations with married women, but always, of course, from a man's point of view. The counsels which women's traditions must have contained do not survive and were undoubtedly oral instructions. If only we had a mother's advice to her daughters on how to deal with a stingy or autocratic husband, how to keep him on 'the straight and narrow,' or how to make sure he provided her with a good funerary monument! One can almost imagine it:

Make sure you place his favorite meal in front of him,

Then you will be successful in all your desires.

A husband who is well-looked after

He is a never-ending source of gifts!

The reason why writings by women and addressed to other women do not exist is presumably the low level of female literacy. Schools were for boys, and although some of the royal and aristocratic ladies could read and write, it was not apparently an essen-

tial skill for them. For any man, however, who sought preferment in the omnipresent government bureaucracy, it was a pre-requisite. A woman's chief role was to provide heirs who would look after aged parents and attend the shrines of the family ancestors. In an age before modern medical techniques and medicines, much of their lives would be spent fulfilling this task which imposed its own physical restrictions. The resulting segregation in the outward lives of men and women is apparent in the scarcity of women in administrative positions, especially after the Old Kingdom.

The modern interpretation of such a segregated society, based on the well-documented sufferings of women in more recent history, is that the suppression and alienation of females automatically follow. But this is impossible to verify with the sources available for ancient Egypt. Must women's silence be taken as evidence of repression? All social restrictions limit individual choices and actions, but their total absence brings anarchy. Ancient Egyptian women may have valued the security of close-knit family ties above personal independence, as their successors in Egyptian villages today will put up with social restrictions because they value the reassurance of belonging in a community.

In fact, ancient Egyptian women's legal rights are well documented and contrast very favorably with the low status of Greek and Roman women. In Egypt, women were legally the equals of men. They could inherit or purchase land, houses or goods, and dispose of them as they wished. They could initiate court cases and were responsible for their own conduct.

We are fortunate that so many legal texts have survived, especially the more mundane civil texts—wills, property contracts, legal jottings, court cases, and so on—which were found in great numbers at Deir al-Madina, the village of the workmen who made the tombs in the Valley of the Kings. These are the source of much of our knowledge of the workings of the legal system and society in general. The villagers of this community had the habit of writing on flakes of limestone or fragments of pottery, known today as 'ostraca,' which have survived much better than papyrus. The high literacy level of the inhabitants is evident in the enormous number of the documents found here, discarded on the ancient rubbish heaps. Lists of commodities, rations, supplies, and fluctuating prices, as well as letters, complaints, hints of intrigues, gossip, and adultery are found in the texts. Daily work rotas and registers of workmen are recorded, as are the first known workers' strikes.

These texts give us a remarkable in-depth view into this unusual and rather privileged community of the Rameside period. In the well-preserved remains of the village, some of the houses can even be assigned to certain workmen. The picture we are given is that of a total community, women and children as well as men. It is a priceless archive to balance the selective and idealized portrayal of society and life given in funerary and official monuments.

The stability of ancient Egyptian society suggests to me that the goal of an acceptable and enduring balance between the very different roles of men and women was achieved. The results would certainly not please today's feminists, but women then were not encumbered with modern ideas of independence and equality. Nor were men! Ancient Egyptian society was in theory governed by the religious ideal of maat, the cosmic order. In practice it was authoritarian and totally hierarchical, with the divine king at the top of the social 'pyramid.' His power devolved through his nobles and courtiers, who held unlimited sway in their own districts. The rest of the population were the 'cattle of Re' and could suffer cruelly under a despotic leader. Their lives were also harder and shorter as was shown in the examination of skeletal material from the cemetery of the workmen's community at Giza. The whole system, like many other ancient societies, was based on privilege and this is why I have not hesitated to use such a term as 'lady' where it conveys the right nuance of rank and social status, although it seems somewhat outmoded these days.

However, there was a strong concept of noblesse oblige to counteract oppressive tendencies. The advice given in the Wisdom Literature for moderation and compassion towards the needy is also echoed in the standard funerary assertions: 'I have given bread to the hungry, clothes to the naked. I have protected the weak and given aid to the widow.' No doubt this was sometimes an empty boast, but it would be cynical to assume that this ideal was never observed nor achieved.

The picture that emerges is of a highly segregated and stratified society in which women did not play nearly such prominent or active public roles as men. Their place was as the anchor of the family, bearing and nurturing the next generation. They were thus entrusted with the well-being not only of their heirs but also, paradoxically, of their ancestors who, through regular offerings and prayers, bestowed prosperity and protection. The importance of motherhood and the care of both children and forebears was emphasized by the popular mythology of the goddess Isis, the supportive and resourceful wife of the dead Osiris and the mother of his avenger, Horus.

What has become clear in compiling this study is the resilience of the Egyptian people. After centuries of invasions and foreign rule, of foreign systems of government and cultural influence, ancient Egyptian ideals are still present among us. In the villages, many of the ancient customs have been kept alive by assimilation into the later practices of Christianity and Islam. Here the women continue to play a central and honorable role in that most enduring and important of all Egyptian institutions, the family. They bear and nurture our children and they are the chief mourners at the burial of the dead. In the face of increasing social fragmentation in the West, the importance of the family as the matrix of a stable and secure society and the key role that women play in this are being rediscovered and revalued at this time. I think the ancient Egyptians knew about this all along.

THE HISTORICAL SETTING

The emergence of Egypt as home to one of the earliest civilizations was due to the bounty of the river Nile. Flowing north through its cliff-lined valley, the river was the country's natural highway and chief source of water. Each year, in July, the waters rose to cover the land and deposit a layer of rich silt, ensuring the fertility of the coming year. When the inundation receded four months later crops such as emmer wheat, barley, beans and pulses, were sown, none of which needed further watering. The harvest was gathered in the spring, and by the following summer, the land, parched and dry, was waiting for the next flood. Unusually low or high inundations could mean disaster, but normally the land produced more than enough to feed the population. Surpluses were stored for the future and for trade.

THE PREDYNASTIC PERIOD (5500–3100 BC)

Early settlements along the high ground at the edge of the valley and beside the Nile may have been seasonal at first. Flint tools, domestic and wild animal bones and pottery speak of a simple farming and hunting economy. By 3500 BC settlements were large and permanent. Simple mud and reed structures housed the living while the dead were buried in shallow pits with a few pots or in deep shafts lined with mud plaster or wood. The larger and better endowed graves denote a more stratified society with an emerging ruling class. Grave goods included flint knives, shell and stone ornaments and grinding palettes, as well as pottery and stone vessels.

In the Eastern Desert copper and gold deposits were worked, and from these metals a variety of artefacts were made both for the home market and for export, thus enriching certain communities. Imports included lapis lazuli from Afghanistan, Sumerian artefacts from Mesopotamia, and later, timber from Lebanon.

THE EARLY DYNASTIC PERIOD (3100–2686 BC)

As the wealthier tribes dominated the weaker ones, the whole valley gradually polarised into two kingdoms, the northern Delta (Lower Egypt) and the southern valley (Upper Egypt). The act of unification came in about 3000 BC when the south, under the legendary king Menes, overwhelmed the north and established the pattern of unified kingship which was to endure for the next three thousand years. He created a new capital city later called Memphis, 24 kilometers south of modern Cairo, where the Nile emerges from its narrow valley and divides into different branches as it flows into the broad, flat Delta plain.

The succession of kings who followed Menes were divided in antiquity into dynasties; these have been further grouped into periods of achievement and of decline. Of the Archaic Period little is known apart from the archaeological record. Hieroglyphic texts, which first appear at that time, are mostly labels or perfunctory descriptions. There are brief references to historical events, such as campaigns against the Nubians or the Libyans, but we have no details of the political history of this time.

The kings of Dynasties 1 and 2, regarded as powerful gods in their lifetimes, were still divine after

death and were buried at their ancestral funerary ground at Abydos in large multi-chambered tombs. In the central chamber their bodies were placed within wooden coffins, and each tomb was covered with a tumulus. Some of these tombs were surrounded by the graves of attendants who accompanied their masters into the Afterlife. The kings' funerary palaces near the cultivation are impressively large mudbrick enclosures. At the Memphite burial ground of Saqqara, huge mastaba (bench) tombs were built for the nobility along the escarpment, suggesting a well-organized controlling administration.

Gunter Dreyer, a German Egyptologist currently excavating the royal tombs of Dynasties 1 and 2 at Umm al-Qaab (Abydos), has discovered that writing was known to the Egyptians 150 years before the unification of the Nile Valley. In addition, the name of Djoser was found inside the tomb of his father Khasekhemwy, proving that Djoser was the founder of Dynasty 3. Dreyer also discovered that the Egyptians made human sacrifices during this period.

THE OLD KINGDOM (2686–2181 BC)

Dynasty 3 marks the beginning of one of the most dynamic periods. King Djoser (2667–2648 BC) set a new style of funerary monument, and, combining the funerary enclosure with the tomb, built a massive six-stepped pyramid of stone, 60 meters high, dominating a complex of ceremonial courts and structures. These were clearly intended for the use of the king in the Afterlife as none of them are functional, being merely ornate facades or narrow corridors added to solid rubble-filled cores.

His successors emulated this example but failed to finish their monuments, although the last king of this dynasty, Huni (2637–2613 BC), is credited with beginning the pyramid at Meidum which his successor completed as the first smooth-sided pyramid. Both the step and the true-sided pyramid seem to be concrete images of the cosmological myth that all life came forth from the primeval mound. As the matrix of life, this mound was also seen as the means of rebirth, and it was therefore fitting that the king, the source of prosperity in this life, should be buried within a symbol of future life.

Pyramid building reached its apogee in Dynasty 4. During his long and active reign, Sneferu (2613–2589 BC) built himself two pyramids at Dahshur. It was his son, Khufu (2589–2566 BC), benefiting no doubt from the experience of his predecessors, who erected the largest and most perfectly constructed pyramid, the Great Pyramid at Giza. Until this century, this was the largest building in the old world, whose dimensions, precise orientation and meticulous masonry still astonish.

The straight rows of courtiers' tombs around the pyramid—east for the king's relatives and west for the nobility—suggest a centralized and tightly controlled government, as well as an efficient and wealthy economy. The titles of the officials tell us of the organization which achieved these stupendous monuments but nothing about the actual logistics of building them.

Next to the Great Pyramid Khufu's son, Khafre, built the second pyramid, only slightly smaller than his father's. His son, Menkaure, added the third, diminutive pyramid. All three pyramid complexes included a mortuary temple, causeway, and valley temple, built from locally quarried limestone with casings of finer Tura limestone or Aswan granite. In one of the nearby quarries at the foot of the desert escarpment a knoll of rock was sculpted into the Sphinx, a figure with a lion's body and a king's head, who guards the necropolis. A god in its own right, and later identified with Harmakhis, 'Horus-on-the-Horizon,' it was worshipped in a small temple built in front of the forepaws.

Important discoveries have been made at Giza, among them the tombs of the pyramid builders located to the south of the Sphinx. A settlement has also been found under the villages near the pyramids, and a pair-statue of Rameses II made of red granite has been recently unearthed near the base of the south side of Menkaure's pyramid.

The pyramids of Dynasties 5 and 6 are poorly-built. At this time, columns of hieroglyphs first appear on the walls of chambers within the king's pyramid. These are religious texts designed to secure the necessary powers for the king to pass into the Underworld as a powerful god.

In this period, sun-temples first appear, their chief feature being a squat, tower-like structure with a pyramid-shaped top. It seems that the nation's religious focus was shifting away from the cult of the

dead and deified king to the sun cult of the god Re. Wonderful reliefs and life-like statues adorned the royal monuments, including details of trading expeditions to Lebanon, Nubia, and Punt. Both the sun-temples and the pyramid complexes were endowed, theoretically in perpetuity, with large estates whose produce maintained the cults and supplied the revenue for the personnel employed. In effect, they became important economic units, with extensive storerooms and workshops, redistributing much of the produce of the country.

The king's family and court officials were usually buried near their monarch. The increasing size and complexity of these private tombs, with their wonderful scenes of everyday life, indicate that wealth and power were gradually less concentrated solely in the family of the king. Reliefs become more detailed and biographical inscriptions record military and trading or mining expeditions in the north-east, in Nubia and in the Eastern Desert. There is even an occasional hint of political conflicts or scandals within the government. Scenes of everyday life sculpted on the walls of tombs ensured a magical supply of commodities needed for the double or ka of the dead owner.

As the body was thought to be essential for the welfare of the spirit or ba, various precautions were taken to ensure its survival. The dead were now mummified, a process of drying out the body and preserving it with unguents and oils before it was wrapped in linen bandages. In addition, statues of the deceased were often included in wealthier tombs, to act as a substitute should anything happen to damage the body. This practice gave rise to amazingly lifelike and beautiful portraits.

Twenty Old Kingdom blocks carved with delicate relief were recently found under thirty meters of sand to the south of the causeway of Sahure. Perhaps the most evocative scene is that of a group of men bending in the direction of the pyramid. Courtiers and high officials, and men with their hands placed on their knees or raising their hands in a begging gesture, are also depicted. The latter are Bedouins, weakened by hunger. The inscription written above them reads, 'pyramidion in three great halls.' This scene is a prototype for one found in the causeway of Unas at Saqqara which is often assumed to represent a famine, even though a famine did not hit Egypt during the reign of Unas.

Two other tombs have also recently been found at Abu Sir. One, dating from Dynasty 26, belonged to Iuf-ka, who held the title 'Director of the Palace,' while the other is that of Qar, the vizier of King Pepi I. At Saqqara, the mummy and tomb of Tetiankhkem, a son of King Teti, have also been found.

The site of the capital of Egypt in the Archaic period, Ineb-hedj, the 'White Wall,' has been located in the northern area of the Saqqara site. Memphis, the capital of the Old Kingdom, was situated at or very close to the pyramid site, the king having built his palace near his mourtury temple. Since the whole pyramid site was a national project, the capital would therefore be intimately associated with the king's building. This theory is supported by a reference in the Abu Sir Papyri that indicates that Djed-Kare-Isesi lived in a palace near his pyramid. The discovery of the settlement at Giza also suggests that the administrative town was located near the palace and the pyramid.

Towards the end of the Old Kingdom, some of the nobles and provincial governors were buried in rock-cut tombs near their home towns, indicating a less strictly centralized government and the emergence of provincial ruling families.

THE FIRST INTERMEDIATE PERIOD (2181–2055 BC)

When the Memphite government collapsed at the end of Dynasty 6, it ushered in a century of famine and trouble. Perhaps it was the long reign of Pepi II (2278–2184 BC)—over ninety years according to ancient sources—that weakened the reins of central government, or a series of low or destructively high Nile floods, bringing famine. Large-scale buildings and works of art cease, and it is probable that the pyramids were entered and robbed at this time. It was not until the country was reunited under a new

line of kings from the southern city of Thebes in Dynasty 11 that its former prosperity was regained under the Middle Kingdom.

THE MIDDLE KINGDOM (2055–1650 BC)

One of the first acts of the Middle Kingdom kings was to consolidate their hold on the country by establishing a new royal residence and seat of government near Memphis, at Lisht. The precise location of the new capital, Ititawi, is not known, but it probably lay very close to the pyramid of Amenemhat I at Lisht. Here Amenemhat I, the first king of Dynasty 12, built his poorly preserved pyramid, using blocks taken from the older pyramid complexes at Saqqara and Giza to enhance and sanctify his edifice. His son, Senwosret I (1965–1920 BC), followed suit and successive kings of this dynasty built their monuments at Dahshur, Lahun and Hawara, designed with elaborately hidden entrances and a maze of false corridors and chambers to confuse tomb robbers. None of these pyramids has survived well. Built with time and labour-saving rubble or mudbrick cores, they collapsed when their white limestone facing was robbed for re-use in later periods.

The warlike tribes in Nubia, which had caused havoc during the previous period, were subdued by the powerful kings of Dynasty 12, and a line of massive mud-brick fortresses was built at the second cataract to control the Nile route. Part of this activity was doubtless to secure the lucrative gold sources in Nubia, and the wealth thus obtained is visible in the prosperity of the period and in the material remains. The delicate sculptured reliefs and superb statues are equal to anything from the Old Kingdom.

Of political events only the outlines are known. It seems that the first ruler of Dynasty 12 was murdered while his son and co-ruler Senwosret I was on campaign, but the succession was not interrupted. The greatest Middle Kingdom ruler was Senwosret III (1874–1855 BC) who consolidated Egyptian authority in Nubia and effected a change in the system of government at home whereby the power of the provincial families was curtailed. His son Amenemhat III (1855–1808 BC) sponsored a great land reclamation project in the Fayoum, where he built several monuments, including his pyramid, and was later worshipped.

THE SECOND INTERMEDIATE PERIOD (1650–1550 BC)

Middle Kingdom prosperity was interrupted by a period of stagnation and fragmentation. The kings of Dynasty 13 came and went with astonishing rapidity but the country seems to have been ruled effectively at first by a line of strong viziers. However, immigrants from the north-east known as the Hyksos settled in the Delta, bringing with them a new art of warfare using chariots and horses. They gradually set up a separate kingdom in the eastern Delta region, fragmenting the country again and threatening Egypt's security. At the same time Nubia broke away from its Egyptian overlords and formed a powerful independent kingdom in the south.

THE NEW KINGDOM (1550–1069 BC)

Once again, it was a family from Thebes who finally drove out the Asiatics from the Delta and reunited Egypt. This marks the beginning of the New Kingdom, the period of the greatest expansion and prosperity of ancient Egypt.

The early years were spent in consolidating Egypt's frontiers. A succession of strong warrior kings, Ahmose (1550-1525 BC), Thutmose I (1504–1492 BC) and his grandson, Thutmose III (1479–1425 BC), campaigned in Syria-Palestine and subdued the fractious city-states there. A system of vassal-states was organized, paying handsome tribute to Egypt but essentially self-governing. At the border with Nubia the old Middle Kingdom frontier at Semna was regained, and the boundary pushed even further south.

Nubia was annexed and administered directly from Egypt; her gold resources were ruthlessly exploited and Egypt grew prosperous on trade and tribute from north and south. Even the anomalous rule of Queen Hatshepsut (1473–1458 BC), who declared herself king against all traditions, saw extensive building and sea-borne trade with Punt.

The only major upheaval during this period was the radical religious change wrought by Amenhotep IV (1352–1336 BC), or Akhenaten as he called himself. This king chose to elevate the sun's disc, Aten, to a preeminent position as his personal god, and tried to eliminate the existing pantheon at least from the official religion. He did not succeed. Akhenaten's successors abandoned the new royal residence he had built at Amarna (Barry Kemp, excavating at Amarna, has been able to reconstruct the plan of the capital of Akhenaten), and restored the traditional cults of the Egyptian pantheon, and with them the time-honored basis of the economy and culture of the land.

The new wealth is seen in the tremendous building activities of this period, especially in the expansion of the great national shrines, preeminent among which was the Temple of Amun-Re at Karnak. Much of the booty of war and the tribute which followed was endowed to this temple, and the power and influence of its priesthood grew. In fact, by the end of the period they challenged the authority of the king.

The kings chose to be buried, not in pyramids, but under a pyramid-shaped mountain in a remote valley in Western Thebes—the Valley of the Kings. Their progressively grandiose mortuary temples lined the desert fringe overlooking the Nile valley. The one tomb that survived almost intact, that of Tutankhamun, displays the incredible wealth with which they were interred. Some of this wealth filtered down to the nobility, as is clear from the range of beautifully decorated tombs which stud the hills behind Thebes. These belong to the elite of an efficient civil service which lasted virtually unchanged for five hundred years.

The tombs in the Valley of the Kings were excavated and decorated by a specialised workforce amongst whom were some of the finest sculptors and draughtsmen in Egypt. They lived with their families in the village known by its modern name of Deir al-Madina, located in a secluded desert valley at the southern end of the Theban necropolis. The relative affluence of the inhabitants and the unusually high literacy of its menfolk, if not also its women, has resulted in the survival here of an extraordinary amount of written material. The records from this village are one of the most important literary sources about day-to-day life in ancient Egypt.

In Dynasties 19 and 20, kingship and the capital passed to families from the Delta, who moved the chief residence to the north, but continued to be buried in the south, at Thebes. Seti I (1294–1279 BC) followed in the tradition of Dynasty 18 rulers by undertaking an extensive building program, and military campaigns into Syria where the Hittites were threatening Egyptian interests.

His son, Rameses II (1279–1213 BC) so fulfilled the ideal of Egyptian kingship as a great warrior and statesman and a prolific family man (he had approximately one hundred children) that his name was synonymous with Kingship for generations. The most notable events of his long reign were the conflicts against the Hittites, eventually resolved by a peace treaty which was ratified by a diplomatic marriage to the Hittite king's daughter.

Rameses II's heirs tried in vain to imitate his successes, but external events were against them. Movements of landless peoples in the Eastern Mediterranean, the 'Sea Peoples,' were disrupting trade and stability, and although their attacks against Egypt in the 13th and 12th centuries bc were unsuccessful, economically the country was in decline. By the end of the period there are references to civil unrest, incursions by desert raiders, fraud, and repeated tomb robbing. Outside Egypt, control over Syria-Palestine was lost as the city-states were overrun and destroyed by newcomers. To the south, Nubia broke away under the leadership of the former Egyptian viceroy.

The Third Intermediate Period (1069–747 BC)

The decline at the end of the New Kingdom foreshadowed the period of fragmentation, when the Delta was ruled by men of Libyan origin and the south became virtually independent under the High Priests of Karnak. With the exception of Sheshonq I, who campaigned against the new kingdom of Israel, the Egyptian rulers confined their activities to home affairs. Most of this three hundred-year period is marked by continual friction with the south and with rival dynasties in the Delta. Few new buildings of this date have survived. As an indication of the legendary status of Rameses II, most of the buildings at Tanis, the new capital of Dynasty 21, were constructed from monuments of that king dismantled at his now abandoned residence and rebuilt on the new site.

The Late Period (747–332 BC)

The fragmentation and subsequent weakening of the country encouraged intervention from an unexpected direction. In the eighth century, a new line of kings from Kush in Nubia, Dynasty 25, was accepted first at Thebes as legitimate rulers, and then throughout the country. They inaugurated a renaissance, initiating many new building works and repairing existing structures, as well as copying older works of art and texts.

During the seventh century bc, however, Egypt became increasingly drawn into foreign conflicts. Assyria followed up repeated threats by invading and eventually sacking the country. The Kushite kings retreated south and the Assyrians appointed a local ruler from Sais to be king, who became the founder of Dynasty 26 when the invaders withdrew. Contacts with Europe were increased when Greek trading posts were opened in the Delta and Greek mercenaries were employed in the army. Over a century of relative peace brought prosperity as Egypt was able to resist foreign ambitions.

In 525 BC the Persian king Cambyses (525–522 BC) ended this period of independence, and Egypt became part of the massive Persian Empire. Local rebellions were followed by severe repression and not until 404 BC was the country free again under the native rulers of Dynasties 28, 29 and 30. This brief interlude is marked by increased building activities, interrupted when the Persians succeeded in re-capturing the country briefly for a ten-year period. They were finally ousted by Alexander the Great in 332 BC.

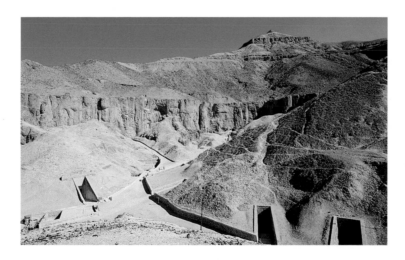

The pyramid-shaped mountain above the Valley of the Kings.
Thebes, West Bank.

I
RULING QUEENS

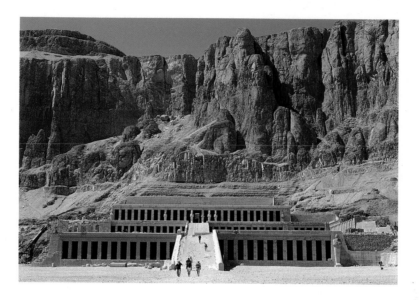

According to Egyptian legends, when their country emerged from the primeval waters of chaos at the moment of creation, the gods ruled on earth. It was they who established the form of government, the religious rituals and the art of writing, bringing order and civilization. This tradition of the divine origin of Egyptian culture is one reason why it survived with apparently little alteration for nearly three thousand years. Changes could only be made within the existing framework and the older an institution, the more it was respected.

Central to this culture was the concept of divine kingship. The mortal heirs to these divine primordial rulers claimed a share in their divinity, and were recognized as the human embodiments of an ancient sky-god, the falcon Horus. As a god, the king was responsible not only for good government and general security, but also for the natural forces that affected the overall prosperity of the country, for the annual flood and the harvest. He was the intermediary between the human world and the divine world and the focus of the spiritual and material well-being of his people.

The Egyptians saw divine energy manifested in the forces of nature and gave their gods the forms of birds and animals as well as of humans. The king, too, was identified with this natural world. Part of his royal regalia was the protective cobra on his forehead and the bull's tail attached to his kilt, both of which linked him with the powers of the animal kingdom. His person and regalia were so highly charged with divinity that for an unauthorized person to touch them, even by accident, was punishable. His chief task was to maintain divine order, or *maat*, by making sure that religious rituals were carried out correctly, thus ensuring that the gods would grant prosperity and security to the land. His duties included not only making offerings to the gods (he was in theory the only person qualified to do this), but also making sure that building works, crafts and arts as well as agricultural tasks were carried out cor-

Hatshepsut's funerary temple at Deir al-Bahari.
New Kingdom.

Hatshepsut's obelisk at Karnak Temple,
Luxor. New Kingdom.

rectly. His ability to communicate with the spirit world would ensure that the Nile rose at the right time to inundate the land, that the harvest was plentiful, and that men, 'the cattle of the gods,' fulfilled their tasks. He was responsible for the ultimate fertility and prosperity of Egypt and from the beginning of historical records, he ruled absolutely through a highly centralized and efficient bureaucracy.

THE STORY OF ISIS AND OSIRIS

The concept of divine kingship in Egypt had its roots in religious myth which defined the role of both king and queen. According to the ancient religious center of Heliopolis, the god Osiris was one of the mythical divine rulers of Egypt who brought the arts of civilization to the country. His consort was his sister and wife, Isis. His hot-tempered and jealous brother Seth ruled the deserts and had as consort another sister, Nephthys. Seth plotted to murder his brother and seize the throne. To this end he constructed a beautifully made chest and offered it to anyone who fitted within it. When Osiris tried it, the lid was slammed down and the box cast into the Nile where the king drowned. His devoted sisters rescued his body, and with the help of the jackal-god, Anubis, revived it sufficiently for Isis to conceive a child, an heir and avenger for Osiris, the falcon-god, Horus.

Isis hid from the jealous Seth who was now ruler of Egypt. She bore her son in secret in the marshes of the Delta where he grew up protected by the goddess Hathor. When he was old enough, he fought his uncle Seth, at first without much success. But the council of gods grew tired of the noise of these two contenders and decided that Horus was the rightful heir of his father. Horus took his place on the

Queen Hatshepsut depicted as a king. The protecting cobra fixed over her forehead, and the bull's tail attached to her kilt, both symbols of kingship, are shown. The Red Chapel of Hatshepsut. Open Museum at Karnak, Luxor. New Kingdom.

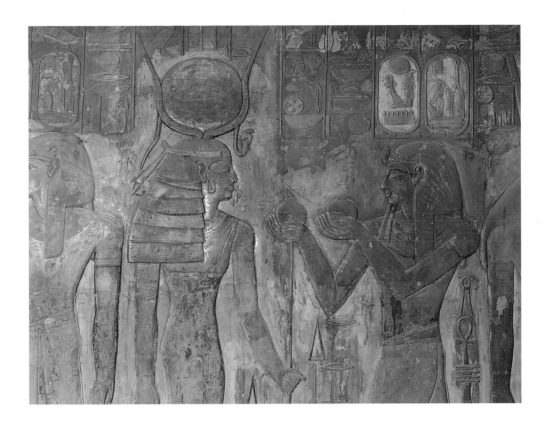

throne of Egypt and gave as an offering to his dead father the magic eye which Thoth, god of wisdom, had restored for him. With this offering Osiris was revived, and took his place as ruler of the Underworld.

This story is clearly linked to the natural cycle of the seasons when the land was drowned under the flood waters each summer and emerged newly fertile for the coming agricultural season. It also defined the relationship between the living king and his predecessor. Whoever carried out the funerary rites for the dead king, usually his eldest son, was the new manifestation of the god Horus and therefore automatically his heir. The dead king was identified with Osiris as ruler of the Underworld and so became linked with the fertility of the waters of the Nile.

THE ROLE OF QUEENS

Throughout pharaonic history, only four women are recorded as having ruled in their own right. The identification of the king with the god Horus, and the masculine principle of fertility symbolized by a bull, meant that his role could not adequately be fulfilled by a woman. That there were so few female rulers is less surprising in view of the essential masculine nature of the job, than the fact that there were any at all. It is noticeable that, with one possible exception, these female rulers only came to power in troubled times. The king's queens—his chief wife, his mother or sometimes his daughter—fulfilled roles which symbolized the female principle and were complementary to kingship. That some of these queens exerted considerable authority and power of their own will be shown in the next chapter.

The principal queen and the queen mother shared in the divinity of the king and also had a ritual

King Seti I making an offering to the goddess Hathor.
Tomb of Seti I, Valley of the Kings, Thebes. New Kingdom.

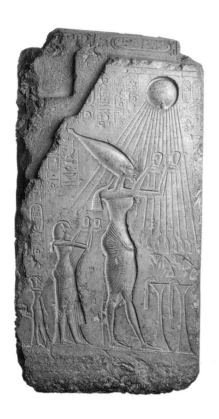

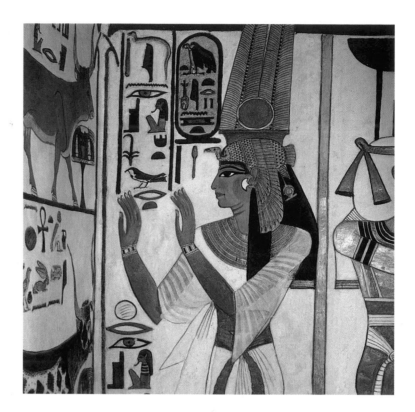

role to play in religious life. While the king was associated with male images, such as the falcon and the bull, his queen was identified with the vulture-goddess Nekhbet, the tutelary deity of Upper Egypt. The queen often wore a close-fitting crown formed like a winged vulture.

The king was called 'the son of the sun-god Re.' His queen wore the horns and sun disc of the cow-goddess Hathor, the daughter of Re and protector of the child Horus. Queenship was thus a counterpart and balance to kingship, and had its own well-defined mythical and ritual roles. The two offices were fundamentally different and not interchangeable.

One marked difference was that, although they frequently accompany the king in temple rituals, queens are only rarely shown presenting offerings to the gods themselves. Communicating with the divine world was part of the king's job which could be delegated to a high priest, but seldom to a woman.

Principal queens had their own households of servants and officials which were supported by estates of their own, given to them by fathers or husbands. For example, a granddaughter of Khufu, Queen Meresankh, records in her tomb that she possessed thirteen estates. These estates may have been economically independent and the wealth accruing from their lands and the services of a group of loyal officials could provide a potential powerbase for an ambitious woman.

Details of early queens are elusive. The rulers of the first two dynasties are shadowy creatures of whom little is known beyond their large funerary monuments. But among the large mastaba tombs of this period, two belong to queens. A large tomb at Naqada was made for Neith-hotep, who is associated with two of the earliest rulers of Egypt, Narmer and Hor-Aha.

She may have been the wife or daughter of one of these kings, or, it has been suggested, a royal heiress whose marriage cemented the unification of the North and the South. Another large tomb

Queen Nefertiti and her husband King Akhenaten making offerings to the god Aten. Egyptian Museum, Cairo. New Kingdom

Queen Nefertari wearing the vulture crown with two feathers enclosing the sun disc. Tomb of Nefertari, Valley of the Queens, Thebes. New Kingdom.

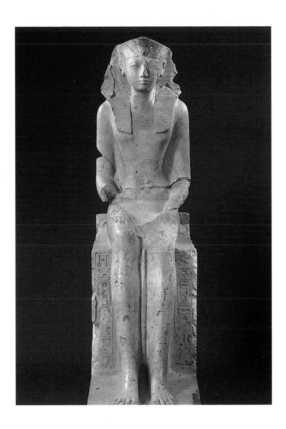

in the royal cemetery at Abydos belonged to Queen Merneith; its location among the tombs of the kings of Dynasty 1 suggests that she may have been a ruling queen. Unfortunately, the information from this early period is too scanty to provide clear evidence.

QUEEN NITOKERTY

In the Old Kingdom, and especially from Dynasty 4 on, our sources of information increase. Through their tombs, queens and royal women can be named and their relationships to the king and to each other can sometimes be defined. However, at the end of the Old Kingdom, during the troubled period when the central government was collapsing, records again become scanty and sometimes confusing.

During this period of upheaval, later records speak of a Queen Nitokerty who, according to one source, was the last ruler of Dynasty 6, and 'the noblest and loveliest woman of her time, of fair complexion'. This source goes on to assert incorrectly that she erected the third pyramid at Giza, which is known to belong to Menkaure, grandson of King Khufu of Dynasty 4. She came to the throne at a time when a weakened central government was beginning to break up and when there were presumably no suitable male heirs to take control.

In fact, no monuments of this queen have been identified with certainty, but her appearance in the lists of kings that the ancient Egyptians compiled means that her historical existence cannot be doubted. Further excavation, especially at Saqqara, may yet reveal monuments belonging to her time and shed further light on this enigmatic queen of whom we know so little except her name.

Hatshepsut as a pharaoh sitting on a throne wearing male clothing.
Painted limestone. Metropolitan Museum of Art, New York. New Kingdom.

The Greek historian, Herodotus, writing in the 5th century BC, recounts one of his highly improbable stories about her. After the assassination of her husband, which put Nitokerty on the throne, she planned revenge by ordering the construction of a banqueting hall that was connected by underground passages to the Nile. She then invited her husband's killers to a lavish feast, and when they were sated with food and beer, she ordered the secret passages to be opened. The waters of the Nile rushed in, and all the assassins were drowned. Then, according to Herodotus, she committed suicide by throwing herself on a fire.

QUEEN SOBEKNEFERU

The troubled period following the collapse of the Old Kingdom lasted about a hundred and fifty years before the country was reunited under the strong central government of Dynasties 11 and 12. Powerful warriors restored law and order, extended Egyptian interests in Nubia, built themselves funerary monuments, and in all ways tried to restore the prestige and might of kingship. In this they were successful, and it was only at the end of this period that a gap in the dynastic succession once again allowed a woman to become ruler.

Fortunately, more evidence has survived of Queen Sobekneferu than of Nitokerty. Ancient sources credit her with almost four years of rule at the very end of Dynasty 12. She was the daughter of Amenemhat III and probably the sister or half-sister of his son and co-regent, Amenemhat IV. Two fragments from her father's enormous funerary temple at Hawara bear her name beside that of the king. This has given rise to the interpretation that she ruled as co-regent with her father for a short time. However, a more likely explanation is that she added a chapel for her own cult to her father's prestigious establishment. Our meagre records do not suggest that she was ever associated with her brother, Amenemhat IV, either as wife or co-regent. She may have come to the throne when the ruling family line had produced no male heir, or she may have been the victor in a family feud. Two pyramids at Mazghuna might belong to Amenemhat IV and Sobekneferu, but the evidence is not conclusive.

Fragments of statues, including part of a sphinx, give her full titles as 'the Female Horus, Meryetre, the King of Upper and Lower Egypt, Sobekneferu, the Daughter of Re, Sobekneferu,' leaving no doubt that she proclaimed herself king. Her titulary as king illustrates the difficulty that faced a female ruler trying to fill the place of a king. The five special names given to a king at his coronation expressed his relationship to the male gods and there was really no specifically female counterpart. For example, as an embodiment of the god Horus, Sobekneferu had to invent 'the female Horus,' an entity which had no mythological basis.

Sobekneferu was the last ruler of the family of Dynasty 12. The following period was one of gradual decline and incursions of Asiatics (Hyksos) into the Delta which split the country into different petty kingdoms. Once again, it was a family of strong rulers from the South who reunited Egypt and eventually drove the foreigners back to their northern homelands. Their ascendancy to power meant that their local god, Amun, was also elevated to the kingship of the gods. Thebes (Luxor) became the religious capital, and, for a time, the seat of government.

These powerful rulers of Dynasty 17 were aided by their very able queens, who seem to have taken over the reins of government at times when the king was away on military campaigns or was a minor and unable to rule alone.

They did this as queen consorts, however, and did not seek kingly titles. Where there was a strong line of male heirs, queens were able to exercise power as consorts or mothers within the existing tradition. They may have had little or no opportunity and perhaps no desire to assume kingship.

Queen Hatshepsut

This famous queen is perhaps the one exception to the idea that ruling queens only took power in times of dynastic crisis. As the daughter of Thutmose I, one of the early rulers of Dynasty 18, she followed a royal tradition much in evidence at this time by marrying her half-brother Thutmose, who succeeded his father as king in about 1492 BC. Their only child, a daughter, was called Neferure.

During his thirteen years of reign, Hatshepsut was described as the king's daughter, king's sister and great royal wife. But it was another title, that of 'god's wife of Amun,' which she preferred to use, perhaps because it was a priestly office that carried considerable power.

When Thutmose II died in about 1479 BC, he left as his only male heir a young son whose mother was a minor harem girl called Iset. This boy, Thutmose III, was too young to rule alone, and his step-mother and aunt, Hatshepsut, became regent, and as a contemporary chronicle says, 'controlled the affairs of the land.' For the first few years of Thutmose III's reign she continued to use her queenly titles and that of 'god's wife,' but to these she added that of 'mistress of the two lands,' a female version of the king's title 'lord of the two lands.' Elsewhere she is recorded doing things normally reserved for kings. A block from Karnak shows her making offerings to the gods and her building works included the quarrying and erection of two obelisks at the temple of Karnak, both tasks usually only performed by kings. There is no doubt that she was an able and ambitious lady controlling a powerful and efficient bureaucracy.

This regency, which conformed with accepted practice, did not last. For unknown reasons, some time before year 7 of Thutmose III's reign, Hatshepsut abandoned the pretence of being a mere regent and declared herself ruler and senior co-regent with her stepson. From now on she described herself as the 'King of Upper and Lower Egypt, Maatkara and the Daughter of Re, Khnemetamun Hatshepsut.' She counted the years of her reign from Thutmose III's accession and although he is occasionally depicted as co-regent, as on the blocks from the 'Red Chapel' at Karnak, Hatshepsut was always the dominant partner.

Hatshepsut's reasons for taking this drastic step will probably never be known. Whether there was a crisis threatening, or whether her ambitions could not be restrained, the records do not say. She must have realized that as the young king grew older, she would have to hand back her powers as regent and let him rule alone. She may have enjoyed power too much to do this, or she may have been afraid of hostile factions trying to control the king. Throughout the years of their joint reign, Thutmose III was not much in evidence, although some officials dated their records by both kings' names. His later successes in military campaigns suggest that, like many young princes, he spent his youth training in the army.

Soon after declaring herself king, Hatshepsut started an ambitious building program which included an enormous mortuary temple for herself at Deir al-Bahari. On one of the walls of this temple she inscribed the story of her divine birth, justifying her claim to be king. Here she recounts how the god Amun, the king of the gods, called together all the gods and goddesses of Egypt to announce his desire to beget a child to rule over Egypt. Thoth, god of wisdom, recommended Queen Ahmose, wife of Thutmose I, as the appropriate mother, and led Amun to the royal palace where they found the queen asleep in her bedroom. They announced to her that she would give birth to a daughter of the god.

Accompanying this text, the fine relief carvings show Amun and the queen discreetly seated on a couch while two goddesses, Neith and Selkit, support their feet. Amun places the sign of life in the queen's hand, and with the other hand he holds another sign of life to her nose, that she may breathe divine life. The next scene shows the potter-god, Khnum, fashioning the royal infant on his potter's wheel as well as an identical counterpart, the *ka*, or vital spirit that everyone possessed. Both the infant and its *ka* are shown naked and both are shown as male, illustrating some of the iconographic difficul-

ties Hatshepsut had in assuming male kingship. Here and elsewhere, her scribes sometimes use the feminine pronoun when talking about her, sometimes the masculine. Depictions of her as king show male regalia, including the false beard and the kilt.

The pregnant queen-mother is now led to the birthplace, accompanied by various deities, and presents her daughter to Amun. Then, to further justify her claim, a long and fictitious inscription tells how her human father, Thutmose I, assembled his court in order to introduce his daughter as his heir.

The temple which Hatshepsut had constructed at Deir al-Bahari is one of the jewels of ancient Egyptian architecture. Rising in three terraces against the golden cliffs of Western Thebes, and culminating in a rock-cut shrine of Amun, it was approached by an avenue of sphinxes and trees.

Each terrace was colonnaded on both sides of the central ramp, and the walls were decorated with fine relief scenes. These include the divine birth episodes, and the transport of the great obelisks she erected at Karnak. Perhaps the most interesting and unusual scenes are those depicting the trading mission sent by Hatshepsut to Punt, a country on the Red Sea, probably Somalia, to bring back incense and incense trees to be planted at Deir al-Bahari. Here the representatives of the queen are shown presenting gifts of beer, wine and other Egyptian goods to the king of Punt. Behind the king are his enormously fat wife, their children, and the donkey 'who carries his wife.' The Egyptians were clearly impressed by her size! The inhabitants of this land lived in round domed huts built on stilts. They are shown bringing to the Egyptians ebony, ivory, gold, heaps of incense, and incense trees, their roots contained within baskets.

The official responsible for the temple of Deir al-Bahari was the queen's loyal steward, Senenmut, a man of apparently humble birth who rose to be the most powerful administrator during her reign. During his life, he secured at least twenty different offices, including that of tutor to Hatshepsut's only child, the princess Neferure.

Thereare several statues of him holding the child on his knees or in his arms. Whether authorized or not, he had images of himself carved on the temple walls at Deir al-Bahari, placed discreetly where they would be concealed by open doors, a privilege rarely if ever accorded to non-royalty. He constructed two tombs for himself, but whether he ever occupied either of them is not known. After year 16 he is not heard of again, and his images at Deir al-Bahari and in his tomb were destroyed, as well as his quartzite sarcophagus.

Hatshepsut constructed her tomb in the Valley of the Kings, in the cliff on the other side of Deir al-Bahari, and seems to have planned to bring the body of her father Thutmose I to be buried with her. Whether this plan was ever carried out is not known as the end of her reign is obscure. By year 22 Thutmose III was ruling on his own and the queen was presumably dead. It is not known whether she died naturally, or was forcibly removed. Neither do we know what befell her daughter, Neferure, who also disappears at this time.

When he came to rule alone, Thutmose III must have been in his mid or late twenties. It is hard to understand why he tolerated his step-mother's rule for so long, unless he was content to wait until she died naturally. It is tempting to think that, in the end, he took action and removed her forcibly. After her death, her name and image were obliterated from many of her monuments and her statues smashed. If this had been done in revenge, one would expect it to have been carried out early in the sole reign of Thutmose III, but apparently it was not until late in his reign that the defacement was ordered. The purpose of expunging her memory may have been not so much vengeance as a desire to correct an episode—a woman assuming the role of a male king—which was not in accordance with the cosmic order and the ideal world that the king was supposed to uphold. Her images as queen in female dress and regalia were not touched.

Excavations at Deir al-Bahari early this century brought to light the extent of the destruction of Hatshepsut's monuments. Hundreds of fragments of statues, many of them life-size, were found in a

quarry pit near the temple where they had been dumped by ancient workmen. When they were rescued and restored they emerged as fine sculptures of Hatshepsut in the classical kingly style as a pharaoh, as a sphinx or kneeling to present offerings. All of them show the queen in male garb, wearing the kilt and often the false beard of kingship.

Only the softer, more feminine facial features and musculature, and the slender waist and limbs, distinguish these images from the usual masculine depictions of the ruler.

QUEEN TAUSRET

The anomaly of Hatshepsut's declaration of kingship in an apparently peaceful and prosperous period was never repeated. Important and powerful queens of the later New Kingdom existed, but exercised their power beside the king, not instead of him. It was not until there was another dynastic crisis at the end of Dynasty 19 that a woman took the titles of kingship again.

Like her predecessors, Nitokerty and Sobekneferu, little is recorded of the short reign of Queen Tausret. She was the chief wife of King Seti II who ruled for about ten years. When he died, his successor was a boy called Rameses-Siptah, perhaps his son by a minor wife, and it was Tausret who acted as regent and governed the country during his brief reign of six years. It has been suggested that struggles with a rival claimant to the throne led her to seek the help of a powerful official named Bey. He seems to have been a Syrian by birth, and described himself as 'kingmaker.' He also claimed to be 'the great chancellor of the entire land' and was influential enough to construct for himself a small tomb in the Valley of the Kings, a location reserved normally for rulers. Clearly he wielded great power at this time.

The young king, who changed his name to Merenptah-Siptah in his third year of reign, died while he was still young. Tausret assumed the titles of a pharaoh and ruled alone for about two years. Not surprisingly, there are few records of her brief reign apart from expeditions to Sinai for copper and turquoise and a building project at Heliopolis. At Thebes, she constructed a small mortuary temple for herself that was found, very ruined, at the end of the nineteenth century. In the Valley of the Kings her unfinished and partially decorated tomb was usurped by her successor, a man called Setnakht, the founder of Dynasty 20. He plastered over the representations and cartouches of the queen and replaced them with his own name and figure. Presumably he also removed the queen's mummy to make room for his own burial.

The end of Twosret's reign is obscure and may have been marked by a crisis in succession because Dynasty 19 concludes with her reign. The succeeding Dynasty 20 portrayed itself as restoring order in a time of chaos when 'the land of Egypt was cast adrift' and under the leadership of an Asiatic. This grim picture may be no more than propaganda to enhance the successful claims of a rival branch of the royal family.

The fact that, throughout the long period of Egyptian history, only four women became rulers in their own right, whether through personal ambition or because there was no suitable male candidate, illustrates how alien this was to Egyptian culture. Kingship represented the male principle of the universe and was not normally open to women, who were expected to play their own role as the female complement. When a woman did claim kingship, however competent she might be, it was seen as something out of balance with the divine cosmic order. In order that it should not be perpetuated, the records were altered and the reign ignored in later documents.

FOLLOWING PAGES:

Temple of Queen Nefertari at Abu Simbel. New Kingdom.

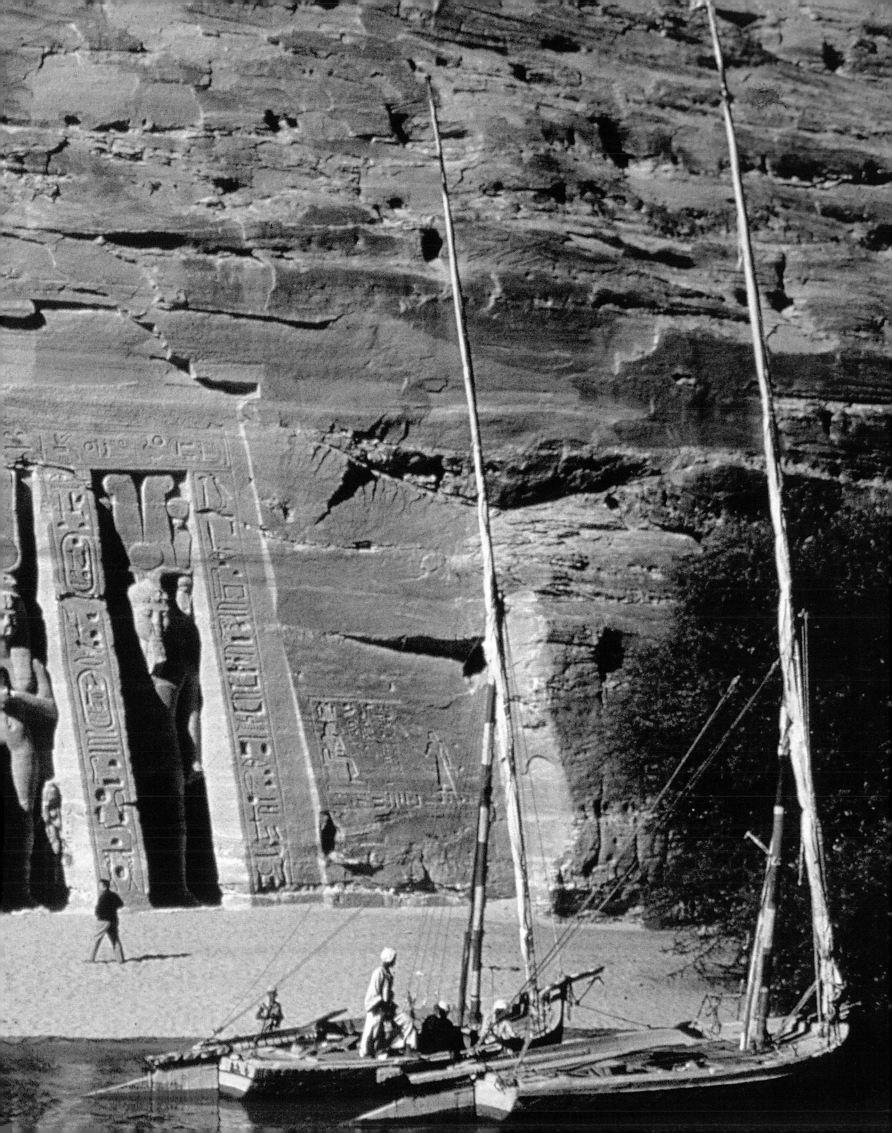

II
ROYAL LADIES

Although it was rare for a woman to take on the office of kingship, there is ample evidence throughout Egyptian history of powerful and influential ladies at court. Unfortunately, our records before the New Kingdom are patchy and usually devoid of everyday details, suppressing anything that was not a reflection of the ideal world. Nevertheless, a certain amount of information can be gleaned from these earlier periods.

Of the first three dynasties, very little is known. Even the names and order of some of the early kings are in doubt, and we know even less about the queens. It is not until Dynasty 4 that it becomes possible to give names and define relationships of members of the royal family. Our information comes principally from the large cemeteries of mastaba tombs around the kings' pyramids of this period. Many of these belonged to members of the royal family who were often also administrators in the government.

Their tomb chapels were decorated with inscriptions giving names and titles of the owner and sometimes details of his or her family. Much space was taken up with the important prayer for offerings and there is little or no information about actual events in the earlier tombs. By the end of Dynasty 5, names and titles of the owner were being supplemented by autobiographical details which supply a wealth of carefully edited information. The purpose was not a factual record of life events but a summary of positive contributions and worth as a justification for eternal life and a name that would be remembered. It did not, therefore, record a person's shortcomings or failures, or details that did not reflect the ideal spiritual world.

Colossal statue of Amenhotep III and his wife Queen Tiye. Egyptian Museum, Cairo. New Kingdom.

Tomb of Khentkaus. Giza. Old Kingdom.

KHUFU'S QUEENS

From these bits and pieces of inscriptions, quite a lot is known about the family of Khufu, builder of the Great Pyramid at Giza. East and west of the Great Pyramid are carefully ordered cemeteries of mastaba tombs where the king's family members and officials were buried. Next to the Great Pyramid, three smaller pyramids were built for his major wives. Beside them were the mastaba tombs of their children.

Each of these small pyramids originally had a little funerary chapel on the east side that would have been inscribed with the names and titles of the owner, all now lost. The northernmost one, which is the most ruined, was probably for his chief wife, Meritites, mother of Prince Kawab who was buried in a mastaba tomb nearby. A boat-pit, recently cleared, lies next to her pyramid. The second pyramid may have belonged to the mother of King Djedefre. The southernmost and best preserved was associated in later times with Queen Henutsen, mother of Prince Khufukhaf and possibly also King Khafre. Some two thousand years later, a temple of the goddess Isis-Mistress-of-the-Pyramid was built on the eastern side of this pyramid, incorporating the original cult chapel.

In connection with the second pyramid, Herodotus recounts one of his racy and wholly fictitious stories about the tyrannical Khufu who, in order to procure the income he needed for his grandiose building projects, sent his daughter to work in the brothels. Wishing to leave a monument to perpetuate her own name, she demanded from her clients the stones from which she built herself the central small pyramid. Fortunately, there is no reason to believe any of this!

Throughout Egyptian history, the king could have more than one wife. Usually, but by no means always, the chief wife, 'the great royal wife,' was of royal blood and the succession went automatically to her eldest son. When, for whatever reason, the successor was the son of a minor wife or came from a secondary branch of the royal family, his claim was usually consolidated by marriage to a royal daughter, especially a daughter of the chief wife. Often this would mean marrying a half-sister or a niece, a common practice for the king.

Sometimes the king also married his full sister. The reasons for this are not clear. Perhaps it was in order to consolidate family power, or more likely, because there was a divine precedent for it in the marriages of divine siblings such as Geb and Nut, Isis and Osiris, Seth and Nephthys.

The importance of the lineage of these royal daughters can be guessed at from the inscriptions in the tombs of Khufu's descendants. He was succeeded not by the Crown Prince Kawab, the son of his chief wife, who died before his father, but by another son, Djedefre, whose mother is not known. Djedefre married Kawab's widow, an act which has been interpreted as an attempt to consolidate his claim to the succession. His funerary monument at Abu Rawash, unfinished at the end of his short reign, was apparently deliberately smashed and all statues broken up, suggesting an attempt to obliterate his memory, perhaps by a rival claimant to the throne. He was succeeded by another of Khufu's sons, Khafre, who married Kawab's daughter, Meresankh. The inscriptions in her tomb hint that dissension split the royal family at Khufu's death and it has been suggested that Kawab was assassinated in order to place Djedefre on the throne.

THE HETEPHERES MYSTERY

A remarkable discovery in the early years of this century was the burial place of King Khufu's mother, Queen Hetepheres, the only royal tomb of the Old Kingdom substantially intact. A small, sealed shaft, 30 meters (100 feet) deep, was found near the northern small pyramid, south of the causeway of the Great Pyramid. In the chamber at the bottom was a remarkable collection of burial items, including

a carrying chair, a bed and a canopy made of wood with gold overlay, several wooden boxes and a jewel case containing twenty silver anklets inlaid with malachite, lapis lazuli and carnelian.

However, to the excavator's astonishment, the alabaster sarcophagus of this apparently undisturbed burial was empty, although the canopic chest containing the visceral remains of the queen was there. The theory proposed to explain the absence of the body was that the queen was originally buried at Dahshur near the pyramid of her husband, King Sneferu. When it was discovered that the tomb had been entered, it was decided to move the burial to Giza where it would be easier to protect. King Khufu may not have been informed that his mother's body was missing. The shaft into which the burial items were transferred was unmarked by any superstructure, perhaps for additional security.

Another theory proposed recently was that the queen was interred in the Giza shaft as an interim measure during the early years of construction of the pyramid complex, when it was planned to build a small pyramid above the burial. When the siting of the three small pyramids was changed, her body, perhaps with a new set of burial equipment, was eventually transferred to the northern small pyramid. However, it has been pointed out that, if the body were transferred, it would be strange not to take the viscera as well, and most unlikely that the elegant and costly burial furniture should be left behind.

A third suggestion is that the queen was originally buried in the northern small pyramid but her burial was plundered in the disturbed period at the end of the Old Kingdom. The priests of Khufu's funerary cult removed the burial furniture and the empty sarcophagus and transferred it to the more secure unmarked shaft where it was eventually found.

QUEEN KHENTKAUS

The last king of Dynasty 4, King Shepseskaf, left no male heirs. In the vacuum created by this break in the direct royal line descended from Khufu, a lady called Queen Khentkaus seems to have been an important link between Dynasties 4 and 5. The information from this period is scarce and confusing. She may have been a daughter of Menkaure, or, as has been recently suggested, of Prince Hordjedef, a son of Khufu. Her husband is also disputed; she may have been the wife of Shepseskaf, the last king of Dynasty 4, or of Userkaf, the first king of Dynasty 5. But her most significant title is usually translated as 'Mother of the Two Kings of Upper and Lower Egypt,' and although these kings are not named, they are thought to be Sahure and Neferirkare of Dynasty 5. If this title reads as 'Mother of the King of Upper and Lower Egypt, acting as King of Upper and Lower Egypt,' it suggests that Khentkaus may have acted as regent for her son while he was too young to rule on his own.

Khentkaus is known chiefly from the impressive funerary monument that she built at Giza between the causeways of Khafre and Menkaure. Its superstructure was a sarcophagus-shaped mastaba mounted on a high rock platform. A small mortuary temple was cut into the rock podium on the south-east side and originally decorated with fine relief carvings, only fragments of which have survived. The funerary monument, which is the largest funerary edifice ever built for a queen in the Old Kingdom, had a valley temple near the temple of Menkaure which was connected to the mortuary temple by a causeway. The city of the priests, where the priests who maintained the cult of the queen lived, was connected with the monument.

However, the inscriptions do not prove that Khentkaus ruled Egypt, because her name is not written in a cartouche, she does not hold the usual titles of a king, and she is also shown wearing the usual tiara of a queen, not a crown.

At Abu Sir, where the cult of the queen lasted for about three centuries, evidence of another Queen Khentkaus was found. Her name and title appear on an alabaster offering table, and another inscription, found inside the tomb of Mersetjefptah, mentions her funerary temple. Excavations to the south

of the pyramid of Neferirkare revealed the remains of a small pyramid complex, and inscriptions found there mention Khentkaus as the king's wife. Titles of the queen and other scenes of the queen and the royal family were found in the area, in addition to the inscriptions 'Mother of the King of Upper and Lower Egypt,' possibly referring to King Niuserre, son of Neferirkare, and 'King of Upper and Lower Egypt.'

A scene was also found showing the queen sitting on a throne holding the *wadj* scepter and with a cobra on her forehead: both were symbols of the ruling king. Is the Khentkaus at Giza the same as the Khentkaus at Abu Sir? Did the queens at both Giza and Abu Sir take the throne? If there were two different queens, then it seems that they became regent for a boy king, and ruled without the title of 'King of Upper and Lower Egypt,' which would explain the absence of their names in cartouches. The Czech archaeologist Miroslav Verner believes that the Khentkaus of Giza was the mother of King Neferirkare, who was the husband of Khentkaus of Abu Sir, the queen mother of the two kings Reneferef and Niuserre.

THE QUEENS OF TETI

Teti was the first king of Dynasty 6, holding the title 'He who makes peace in the two lands [upper and lower Egypt]' at the beginning of his reign.

Teti married Iput I, daughter of Unas, the last king of Dynasty 5, and bore him the future King Pepi I. In an attempt to build a strong relationship with the nobles, Teti married his daughter Seshseshet to

Ebony head of Queen Tiye. Ägyptisches Museum, Berlin.
New Kingdom.

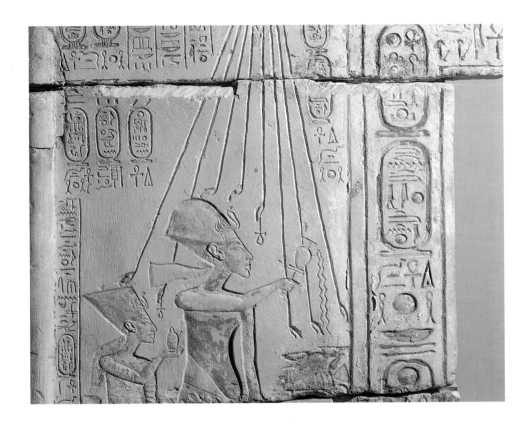

his vizier Mereruka, who became the overseer of the priests of his pyramid. Later he married the Princess Khuit, who is believed to have been the daughter of Isesi.

The Egyptian priest Manetho reports that Teti was killed by his guards, and calls him Othoes. However, there is no evidence to support this claim.

QUEEN IPUT I

The pyramid of Iput I is located about 100 meters away from that of her husband. Initially built as a mastaba by Teti, the structure was subsequently transformed into a pyramid by Pepi I, whose architect built an exterior casing and blocked the pyramid entrance.

The wall reliefs on the entrance contain the titles of the queen, scenes of offering bearers are depicted on those in the pillared hall, while the queen's titles appear again on the reliefs in the sanctuary. The name *mn-nfr* was found three times inside the temple, once on the sanctuary and twice on two other blocks. This was the name of the pyramid of her son Pepi I and also the ancient name of Memphis.

The pyramid of Queen Khuit was also recently discovered next to the pyramid of Iput I. The walls between the pyramids show that of Khuit was completed first, its outer wall being used later to build the pyramid of Iput I. This strongly suggests that Khuit was Teti's main wife. The reliefs inside the pyramid of Khuit consist of scenes of offering bearers, soldiers, and titles of the queen.

The tomb of Prince Tetiankhkem, 'Tetiankh the black,' a son of Teti, was also recently discovered

Amenhotep IV (Akhenaten) with his wife Queen Nefertiti, presenting offerings to the god Aten. Egyptian Museum, Cairo. New Kingdom.

near the pyramids of Teti and Iput I. One relief inside the tomb shows in small scale the wife of Tetiankhkem holding the leg of her husband.

THE QUEENS OF PEPI I

In the reign of Pepi I, Egypt reached new heights in art and culture. It is a testament to the king's status that Memphis was named after the pyramid of Pepi I at Saqqara, known as Mennefer, 'the beautiful port.' Four pyramids belonging to queens have been found next to Pepi I's pyramid. At present, the names of three queens are known, one of which is Nubwenet, who bore the title of royal mother and wife. On one of the gray limestone doorposts of her tomb, the queen, standing clad in a long, tight-fitting, strapped dress, smells a flower. Her titles and name are inscribed above and in front of her.

The name of Queen Meryt-it-is, the wife of King Khufu, builder of the Great Pyramid at Giza, was also found. She enjoyed the titles 'wife of the king' and 'daughter of the king.' She is believed to have lived during Dynasty 4, and to have been related to Pepi I. The third name found was that of Queen Inenk-inti. Inscribed offering tables and an obelisk inscribed with the titles of royal mother and royal wife were found at the entrance to her funerary temple. The name of another queen, Maha, was found, but no pyramid or tomb was discovered.

Pepi I also married two sisters, the daughters of the mayor of Abydos, which could be the first recorded case of an Egyptian king marrying women of non-royal blood.

It is thought that Pepi I left the throne for a period of seven years, as the pyramid texts in his burial chamber follow both the Dynasty 5 style of Unas and that of the Dynasty 6.

Crown and girdle of Princess Sat Hathor. Egyptian Museum, Cairo. Middle Kingdom.

Statue of the beautiful Princess Meryt-Amun. Painted limestone. Egyptian Museum, Cairo. New Kingdom.

PRINCESSES OF THE MIDDLE KINGDOM

A noticeable change in the administration of the later Old Kingdom and the Middle Kingdom is the absence of princes in positions of authority. Where royal sons are mentioned in texts, they are given only their royal affiliation or a priestly title. A fragmentary papyrus dating to the end of the Middle Kingdom contains the accounts of the court over a twelve-day period during a visit to Thebes. Among the fascinating details in this text, it appears that the king was accompanied by one prince, one queen, three daughters, and nine sisters. Also mentioned was a 'house of nurses' which included 19 persons and groups of children. The king was therefore surrounded by female relatives, but only one son, presumably the heir apparent.

This emphasis on royal women is apparent also in the funerary arrangements of this time. During the Old Kingdom, the queens were given substantial tombs or small pyramids adjacent to the king's pyramid. In the Middle Kingdom, tombs of the royal ladies were placed within the king's pyramid enclosure. At the end of the last century, spectacular finds of jewelry from the tombs of princesses were made at Dahshur and al-Lahun. The pyramid complex of Senwosret III at Dahshur included the burials of two princesses, Sat-Hathor and Merit, whose jewelry had been concealed in a separate place within the tomb and had thus escaped the attention of tomb robbers. The king's mother was uniquely honored by having a burial chamber within the pyramid, below that of her son. Some of her inlaid jewelry was found during recent excavations, concealed in a niche.

The next king, Amenemhat III, also built a pyramid at Dahshur, but was not buried in it, perhaps because of structural weaknesses caused by subsidence. But the southern part of the maze of chambers under the pyramid was planned and used for the burial of royal women and had its own entrance on the south-west side. The king built himself another pyramid at Hawara where two sarcophagi were built into the burial chamber, the smaller one intended apparently for his daughter, Princess Neferuptah. Another funerary monument about two kilometers away also belongs to her, and it is likely that she died after her father had been buried and his burial chamber was sealed. Not wanting to reopen the pyramid to admit her body, another monument was then constructed for her burial.

Princess Neferuptah was obviously a favorite daughter. Another daughter of Amenemhat III, Sobekneferu, was the last ruler of Dynasty 12.

THE DISCOVERY OF THE TOMB OF QUEEN WERET

In 1994, the expedition of the Metropolitan Museum discovered the underground burial apartments of a 'king's wife' Weret. The tomb was attached to the pyramid of Senwosret III but was found completely plundered in antiquity. However, an unforeseen wall niche still contained a small but beautiful hidden treasure. From its disparate gold, carnelian, and lapis elements, pairs of bracelets and anklets and a belt of gold shells were reassembled. These pieces apparently formed the official attire of Queen Weret when she performed her stately assignments. Pendants, small lion figures, and a pair of beautiful amethyst scarabs with the cartouches of Amenemhat III can be admired now in the newly opened and popular jewelry gallery on the upper floor of the Egyptian Museum, Cairo.

At the time of the discovery of the tomb, sources seemed to suggest that Queen Weret was the mother of Senwosret III. However, in a later excavation season the funerary complex of another Queen Weret was excavated, a queen who actually carried the title 'king's mother.' Since one cannot assume that one Queen Weret owned two pyramids side by side, an older Queen Weret, 'king's mother' has to be separated from the younger Weret, the 'king's wife,' the owner of the jewelry mentioned above.

This surprising experience teaches us a lesson about the risk of precipitate conclusions in archaeology.

The huge unexplored areas of the royal cemeteries of Dahshur may still hold much new information that could upset our so certain perception of ancient Egypt.

The slow decline of economic and political power which followed in Dynasty 13 weakened the central government's control of the country, and first Nubia, then the Delta broke away. In the North, unchecked by the weak government, Asiatic tribes were infiltrating into the rich pasture land of the Delta and eventually established their own state there. Their rulers imitated features of Egyptian kingship, wrote their Semitic names in cartouches and were included in later kinglists as Dynasties 15 and 16. Nevertheless, their culture was alien and the Egyptians resented the presence of these intruders.

Three Royal Ladies

Once again, it was the chiefs of Thebes who initiated the drive to reunite the country. Strong warrior kings of Dynasty 17 campaigned for three generations to drive out the Asiatics. This achievement was accomplished by a remarkably close-knit family whose women played an exceptional role during these difficult times that preceded the golden era of Egyptian history.

The ancestress of this family was considered in later times to be Queen Tetisheri, the wife of King Seqenenre Taio I, who initiated the push to unite the country. Widowed while still young, Tetisheri acted as regent for her son, Seqenenre Taio II, while he was a child. She bore the titles of great royal wife and king's mother, but seems to have been of non-royal blood herself. She lived to a great age, receiving many honors during her lifetime and directing and advising through three generations and four reigns. After her death, her second grandson, King Ahmose, erected a stela in her memory at the sacred town of Abydos, recalling 'the mother of my mother and the mother of my father, ... Tetisheri, deceased... My Majesty has wished to make for her a pyramid and chapel in the sacred land close to the monument of My Majesty.'

Her son, Seqenenre Taio II, married his full sister, Ahhotep, and continued his father's fight but was killed in battle. His mummy shows a gaping head wound caused by the distinctive axe used by the Hyksos and he doubtless fell while campaigning against the northerners. He left a young son, Kamose, to carry on the struggle, but he too had not succeeded in driving out the Asiatics before he died. His younger brother, Ahmose, then became king. His reign marks the turning point in the reunification process and is counted as the beginning of Dynasty 18, although there was no change in the family of the ruler. By the final years of Ahmose's reign, Nubia had been regained and the detested Hyksos had been driven out of Egypt.

In the early years of Ahmose's reign, the king set up a stela in the temple of Karnak, honoring his mother, Ahhotep, in which she is praised in unusual terms. At some moment of crisis, perhaps the death of her husband, or of her son Kamose, or possibly when Ahmose himself was a minor, she must have seized the initiative and restored order. She is described as 'one who cares for Egypt. She has looked after her soldiers; she has guarded her; she has brought back her fugitives, and collected together her deserters; she has pacified Upper Egypt, and expelled her rebels.' This passage is so much more specific than usual that it must be based on actual events.

When she died, she was given a lavish burial provided with many objects bearing her son's name, including some wonderful jewelry. Her place at court was taken by Queen Ahmose-Nefertari, the wife of Ahmose. This lady was the full or half sister of Ahmose and her titles include the usual 'great royal wife' and 'king's mother.' Her husband also bestowed on her the title of 'god's wife of Amun,' an important priestly office in the cult of Amun of Thebes which brought with it endowments of land and property. It was her preferred title and probably brought with it a measure of economic power. Ahmose also unusually consulted her on his building plans for the memorial to Tetisheri, and her name appears with

his in a quarrying inscription. It is clear from the number of her monuments, which included a statue in the temple of Karnak, that she was a woman of great importance.

We do not know if Ahmose-Nefertari's influence was greater than that of Ahhotep or Tetisheri, but her importance to later generations certainly exceeded theirs. She was revered by later generations as Queen Mother, and she and her son, Amenhotep I, were worshipped as the deified patrons of the community of workmen at Deir al-Madina. Their cult lasted throughout the New Kingdom, prayers were addressed to them and their oracles consulted when the need arose.

The importance of these three great queens seems to lie more in their personalities than in the office they occupied. By contrast, the next two generations of great royal wives of Amenhotep I and Thutmose I did not leave much of a mark. But Thutmose I's strong-minded daughter, Hatshepsut, was not content with the role of regent played so ably by her ancestress, and took the titles of king instead. After her reign, royal women are not much in evidence for the next three generations and may have been kept deliberately in the background.

QUEEN TIYE

Not until Thutmose III's great grandson Amenhotep III ascended the throne in the 14th century BC are there records of another influential queen. Early in his reign, Amenhotep III married a remarkable woman of non-royal birth called Tiye. She was the daughter of a priest of Min at Akhmim, Yuya, who was given the title of 'God's Father' when he became the father-in-law of the king. Tiye was the king's principal wife for the rest of his reign, and features so prominently on his monuments that it may well be that their marriage was a love match.

The king was fond of issuing commemorative scarabs, the first of which announced his marriage to Tiye, giving the names of her parents and describing her as: 'the wife of a mighty king whose southern boundary is at Karoy [Nubia] and whose northern boundary is at Naharin [Syria].' Another set of scarabs was issued when the king made a diplomatic marriage with the daughter of the Mitannian king; even here, Tiye and her parents are mentioned prominently.

Tiye frequently appears on the monuments beside the king, often wearing the crown of the goddess Hathor with the sun's disc between horns. Her name is written in a cartouche, like that of the king. In one of the private tombs, she is depicted seated on a throne which is decorated along the sides with the queen in the form of a sphinx trampling on her enemies, the female counterpart of a motif previously only applied to kings. A colossal statue from the king's mortuary temple at Thebes shows Amenhotep III and Tiye seated side by side on an equal scale. However, on other colossal statues of her husband, Tiye is shown in the more usual diminutive size beside the legs of her husband.

During the reign of Amenhotep III, there was a growing emphasis on the solar and divine aspect of kingship. The cult of the deified pharaoh was maintained at a number of temples beside the cults of the great gods of the land. At Soleb in Nubia, the king built a temple dedicated to the worship of himself and the god Amun. Nearby at Sedinga, another temple was dedicated to Queen Tiye, who, despite her non-royal birth, was deified and worshipped with her husband as patron of the region.

Towards the end of Amenhotep III's long reign, Queen Tiye assisted in the jubilee festivals of her husband, during which the king appears to have become identified with the Aten, a form of the sun god immanent in the sun's disc. Soon after his third jubilee, the king died and his son Amenhotep IV came to the throne. On his accession, the Mitannian king wrote to Queen Tiye, anxious that the good relations enjoyed during her husband's lifetime should continue during her son's reign.

These two letters written expressly to her are evidence of her continued influence at court and her knowledge of foreign affairs.

Queen Tiye lived on into her son's reign and was given an estate at his new capital of Akhetaten (near modern Minya) in Middle Egypt. She is depicted in some of the private tombs there, accompanying her son on state occasions or going with him into the temple of the Aten. She must have died in about the fourteenth year of his reign. A plaited lock of her hair was found in the tomb of Tutankhamun, placed in a miniature coffin inscribed with her name. A mummy found reburied in an earlier king's tomb has been tentatively identified as hers on the basis of its likeness to the boy-king. She undoubtedly originally had her own tomb in the Valley of the Kings, where her parents were also buried, a privilege rarely accorded to non-royalty.

QUEEN NEFERTITI

An aura of mystery surrounds Queen Nefertiti. Her parents are not known and, like her mother-in-law, Queen Tiye, she was probably of non-royal birth. Her name means 'the beautiful one is come' and it is sometimes suggested that she was a foreign princess. However, this is most unlikely; the name is a good Egyptian one and it is known that she had an Egyptian wet-nurse. A possible candidate for her father is a man called Ay, who bore the same titles as Yuya, the father of Tiye, and who may have belonged to the same family. Ay later became king himself after the death of Tutankhamun.

As the chief wife of Amenhotep IV, Nefertiti appears beside her husband on all his major monuments. She very often assists in the offerings, wearing crowns which differ only very slightly from the kingly ones. In fact, no other queen appears so frequently. From the beginning of his reign, Amenhotep IV declared his allegiance to the new form of the sun god, the Aten. He erected a huge temple at Karnak dedicated to this god in the form of the falcon-headed Re-Horakhty. Blocks coming from this temple show the standard scenes of the king making offerings to the Aten, but in one building, it is the queen who is raising the offerings accompanied only by her eldest daughter. nowhere is the king is depicted here. Other motifs usually reserved for the king, such as the smiting of captives, are translated into female idiom, and Nefertiti is shown wielding a club; her throne dais was decorated with female captives.

In his first few years of reign, Amenhotep IV may have been a coregent with his aged and ailing father. A series of dramatic changes that took place between years five and seven probably marks the beginning of his single rule. The cult of the Aten became ever more important and was now depicted only in the form of the sun's disc extending arms instead of rays to an offering table or towards the royal family. Before long, all mention of other gods and their cults were proscribed, in particular that of the god Amun whose name was chiseled out of monuments throughout Egypt. Even the name of his father was not spared.

The king himself changed his name so that it did not contain the offending word 'Amun.' He became Akhenaten, 'The Transfigured Spirit of the Aten.' Nefertiti added to her name 'Nefer-Neferu-Aten,' 'Beautiful is the beauty of the Aten.' The king's supreme god was thus converted into the sole creator god from whom everything issues, expressed in a beautiful hymn inscribed in several of the tombs of this period:

Splendid you rise, O living Aten, eternal lord!

You are radiant, beauteous, mighty,

Your love is great, immense.

Your rays light up all faces,

Your bright hue gives life to hearts,

FOLLOWING PAGE:

Temple of Queen Nefertari at Abu Simbel. New Kingdom.

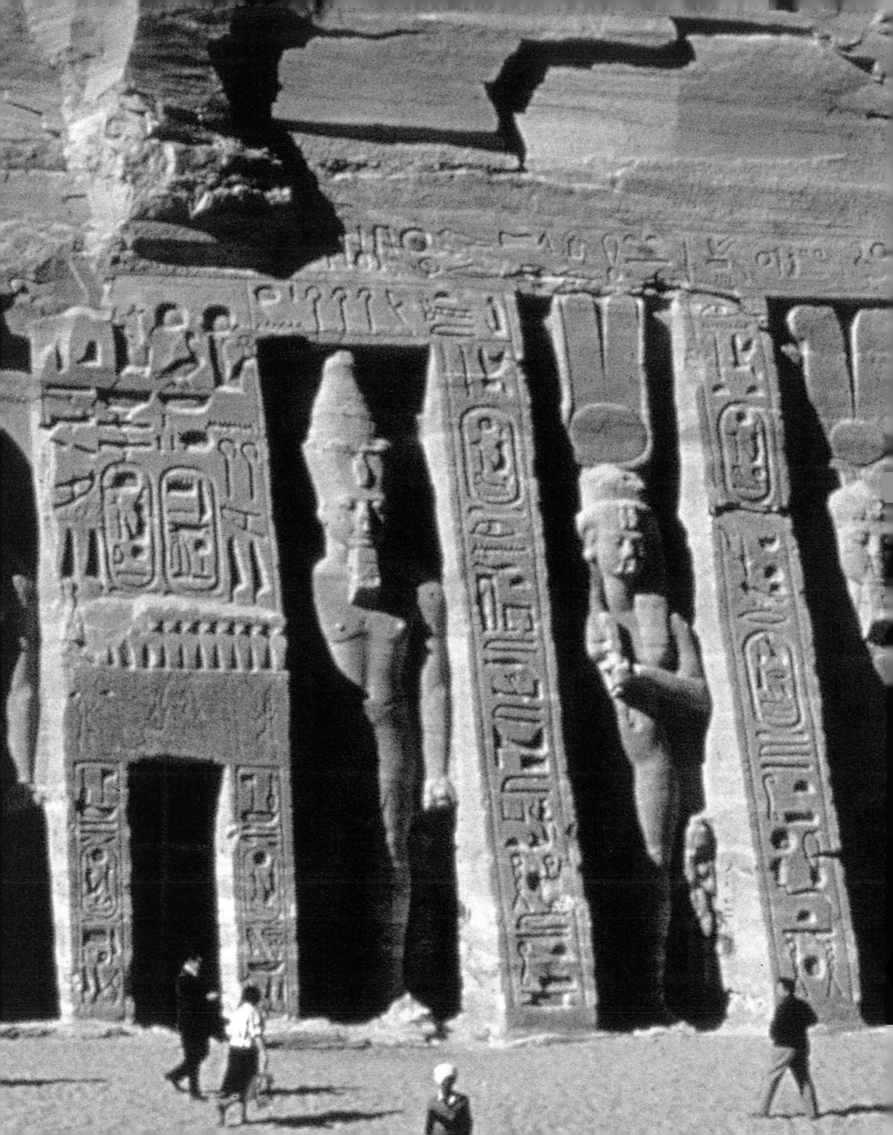

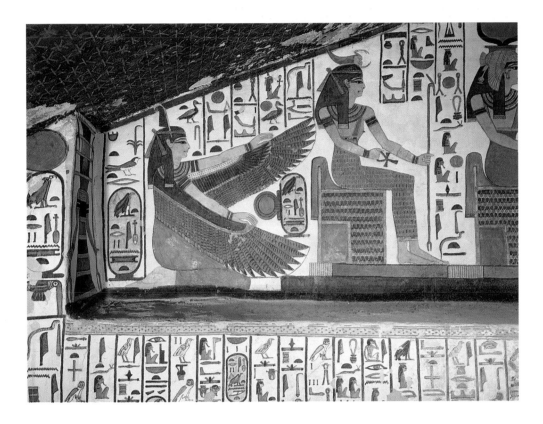

When you fill the Two Lands with your love.
August God who fashioned himself,
Who made every land, created what is in it,
All peoples, herds and flocks,
All trees that grow from soil;
They live when you dawn for them,
You are the mother and father of all that you made.

Soon after, a new capital was prepared for the royal family at a site in Middle Egypt which was to be sacred to the Aten and was called Akhetaten, 'the horizon of the Aten.' The royal family, the court, and all the accompanying bureaucracy, artisans, and workers moved here. The center of the city was occupied by the great temple of the Aten and the royal palace while the suburbs contained the houses of the officials and workers' quarters. Tombs, including those of the royal family, were constructed in the cliffs. Here the decoration no longer showed the usual scenes of everyday life, or the deities of the Underworld. In their place the king and queen are depicted, usually accompanied by their growing family of daughters, offering to the Aten, proceeding from the palace to the temple, receiving dignitaries or bestowing honors on faithful officials. Prayers could no longer be addressed to the old gods, but were now made to the king or the queen, from whom all benefits came.

It was not only the tombs that focused on the royal family. Domestic shrines in the private houses had statues or stelae of the king or royal family. In these, Akhenaten and Nefertiti seem to have formed a triad with the Aten, and are frequently shown with their daughters who eventually numbered six.

The goddess Maat protects Nefertari's cartouche with her outstretched wings while the serpent-crowned goddess Serket, and Hathor, wearing the sun disc between two horns, sit enthroned to the right. Tomb of Nefertari, Valley of the Queens, Western Thebes. New Kingdom.

These scenes, and those in the tombs, display a degree of family affection never seen before on royal monuments. Undoubtedly, this was all part of the new mythology of the Aten as revealed through the royal couple, which was to replace the traditional forms of worship.

Nefertiti features so prominently on Akhenaten's monuments that it is difficult to believe that the king had other wives, including foreign princesses. A shadowy lady called Kiya is depicted on some monuments with the king, but her name and figure were later erased and replaced by one of Nefertiti's daughters, Meritaten. Although only daughters are ever shown with the king, it is extremely likely that his successor, Tutankhamun, was his son, perhaps by a lesser wife. It is thought that Nefertiti ruled the country after Akhenaten's death because she was shown smiting her enemies, an act that was the duty of the king not the queen. However, no solid evidence exists to prove this theory.

No mention of Nefertiti has been found later than the twelfth year of Akhenaten's reign, and she may have died then. Another theory is that she took kingly titles and became Akhenaten's co-regent at the end of his reign. The events surrounding this period are poorly documented and will be disputed for years to come. Akhenaten's attempt to raise the Aten as sole creator god was not successful. It threw out the vast pantheon of deities, the richness of the mythology and the vision of an Afterlife so fundamental to the Egyptians' way of thinking. In their place the new doctrine stressed the intimate and exclusive association of the Aten with the king and his immediate family. Visually, it expressed itself in scenes of the royal family making endlessly repetitive offerings to the Aten. After Akhenaten's death, the Aten cult was seen as an aberration. The gods of the old religion were restored and Akhenaten's monuments were systematically destroyed.

The Valley of the Kings contains two tombs from the Amarna period, one belonging to King Tutankhamun. However, the identity of the occupant of the other tomb, known as KV55, is shrouded in mystery. It has been suggested that the mummy found inside is that of Queen Hatshepsut, but there is a lack of evidence to support this. Other experts favor the theory that this is the tomb of Akhenaten or his mysterious son and successor, Smenkhkare. But other questions, such as why the body was buried in a coffin originally prepared for either Akhenaten's secondary wife Kiya (the mother of Tutankhamun) or Smenkhkare, and why the tomb of King Tutankhamun contained so much burial equipment originally prepared for Akhenaten and Smenkhkare, continue to cause controversy.

One theory is that the KV55 body is that of Akhenaten himself, and that the tomb originally contained the body of Queen Tiye, Akhenaten's mother. It has been suggested that the interment of Akhenaten and Tiye within KV55 followed an official dismantling of the al-Amarna royal burials immediately after the death of King Tutankhamun.

It has also been suggested that apart from objects taken over from Akhenaten himself, the coffin, sarcophagus, and canopic equipment found in the tomb of Tutankhamun may originally have been prepared for the burial of Smenkhkare, an ephemeral ruler who may in fact have been Akhenaten's great royal wife, Nefertiti. The presence of these objects implies that the burial of Smenkhkare had been dismantled at the same time as that of Akhenaten, with the aim of equiping the tomb of Tutankhamun.

QUEEN NEFERTARI

Some sixty years later, another great queen features prominently in the records. But unlike Nefertiti, the great royal wife of Rameses II, Queen Nefertari, is never seen to do anything out of keeping with Egyptian traditions. Nothing is known of her background, but for the first part of Rameses II's long reign, it is Nefertari who accompanies the king on state occasions, giving audiences and bestowing offices and honors. She must have retained his affections against some formidable competition as this

king is known to have had several major wives and literally dozens of lesser ones, and he had over one hundred children. Of these, Nefertari produced several sons, but none of them lived long enough to succeed their father on the throne. Her eldest daughter, Princess Meryt-Amun, later replaced her mother as the king's consort. The surviving monuments of these two, mother and daughter, suggest that both must have been uncommonly beautiful.

One of the best-known monuments of Nefertari is the rock-cut temple built for her at Abu Simbel. As a counterpart to the great temple of Rameses II which was dedicated to Ptah, Re, Amun and the king himself, a smaller temple was hewn nearby and dedicated to the goddess Hathor. On either side of the facade, two enormous statues of the king flank that of Nefertari who, as the living manifestation of the goddess, wears the crown of Hathor. On either side of these figures are diminutive images of their children. Inside, the queen accompanies her husband, and as chief priestess offers incense to Hathor.

Soon after the dedication of this temple in year 24, Nefertari's name ceases to appear on monuments, which suggests that she had died.

Nefertari's importance is best seen in the magnificent tomb prepared for her in the Valley of the Queens. Here, the best craftsmen decorated the walls with scenes carved in low relief of the deities of the Underworld, all depicted in a rich, elaborate style and in brilliant colors which have survived mostly intact.

There is no doubt that Nefertari played a major part in state affairs beside her great husband. Like her illustrious predecessor, Tiye, wife of Amenhotep III, Nefertari was honored in a remarkable way on the royal monuments with large images of herself at Luxor, Karnak, and most notably Abu Simbel. Foreign relations also seem to have required her support. After the peace treaty was signed between Egypt and the Hittites, Nefertari sent greetings to her 'sister' the Hittite queen. The letter was found in the ruins of the palace at the Hittite capital in present-day Turkey, and adds a modest and personal touch to the formal facade of the monument.

Jewelry of Queen Ahhotep from her tomb at Western Thebes. Egyptian Museum, Cairo. New Kingdom.

FOLLOWING PAGES:

Two young princesses sitting on cushions. Wall painting from Amarna. Ashmolean Museum, Oxford. New Kingdom.

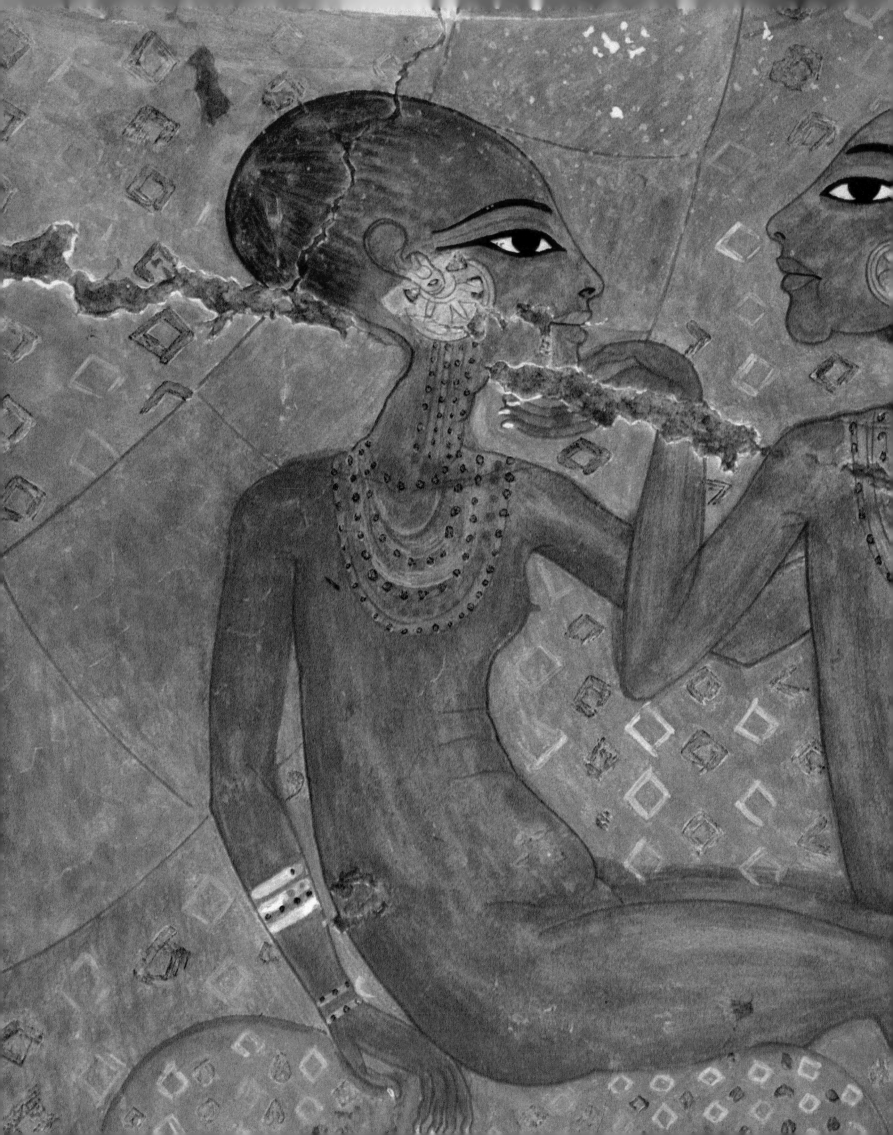

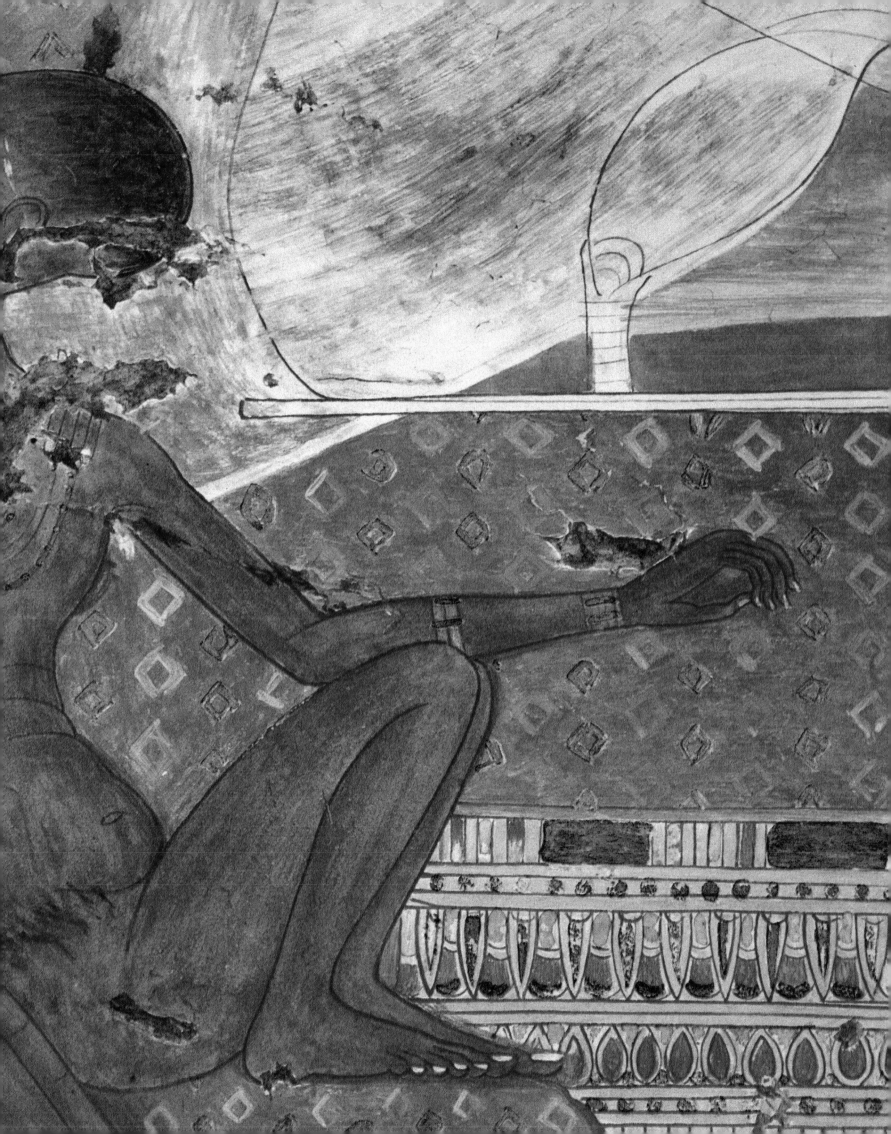

III
PALACES AND HAREMS

Very few royal palaces have come to light in the archaeological record. Royal residences, like most dwelling places, were located in the Nile valley, usually close to the river as this was the main highway of the country. Although the palaces were substantial buildings, they were built of mud-brick lined with stone slabs and were rarely used for more than a few generations. Their ruins have long vanished beneath the tumble of subsequent buildings or the alluvial deposits from the annual flood.

THE KING'S PALACE

The government of the early periods was extremely centralised and focused exclusively on the person of the king, the official intercessor with the divine world. His palace contained the courts and reception halls required for the administration of the country, as the seat of the government would have been wherever the king was. The palace itself was known as the *Per Ea*, the 'Great House' and was so identified with the king's power that in later times it became the usual term for the king himself, and thus the origin of the title 'Pharaoh.'

As none of the early palaces have survived, we have to turn to the New Kingdom for examples where the ruins of excavated palaces at Memphis and Per-Rameses allow us to reconstruct the principal features. The state apartments were a succession of large columned halls, at one end of which a throne room contained a raised dais. These halls were dazzlingly colorful. The walls were decorated with painted plaster or carved limestone slabs depicting the king in the presence of divinities or smiting his

Large ornamental jar found in the ruins of the palace of
Amenhotep III at Malqata, Western Thebes. New Kingdom.

Model of the throne room of the palace of King Merenptah.
University Museum, Philadelphia. New Kingdom.

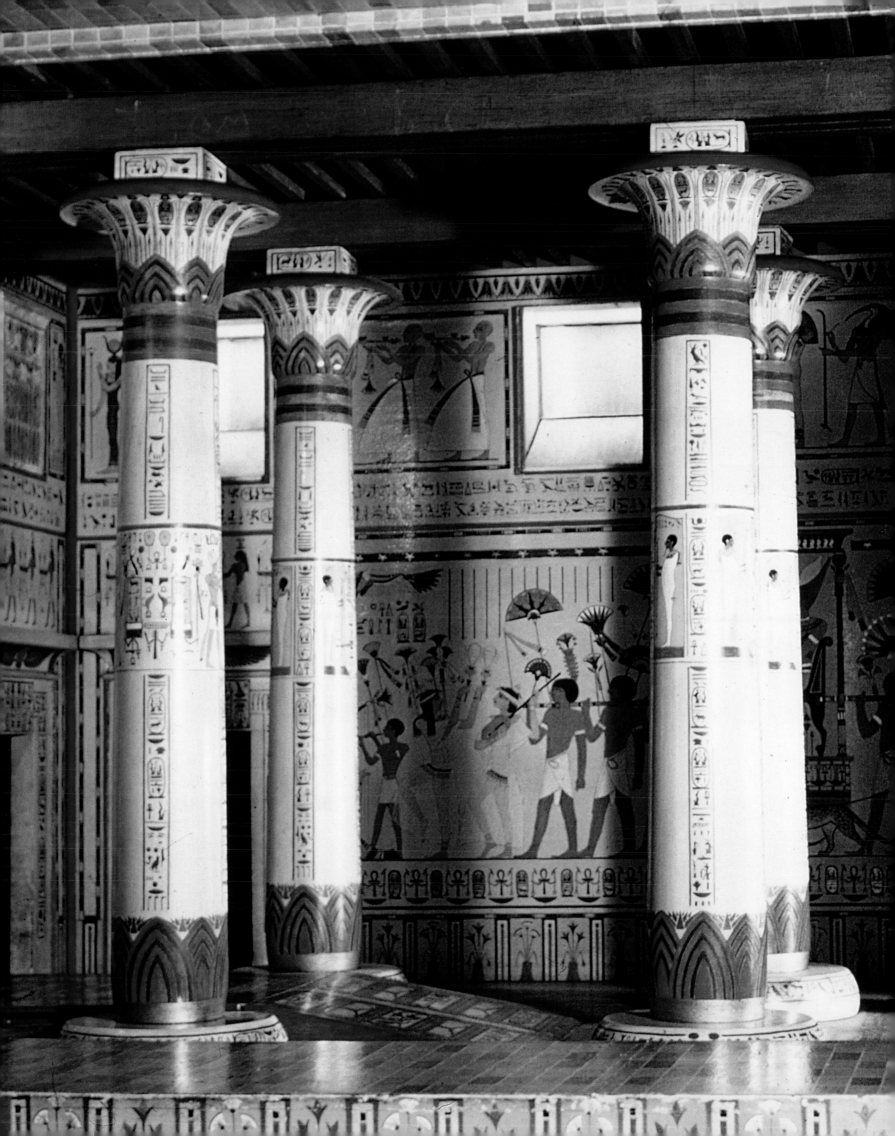

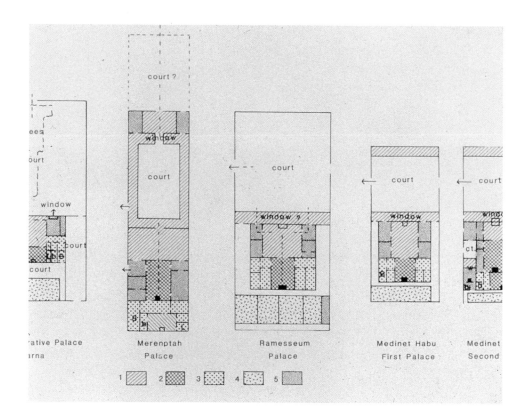

enemies. The columns which supported the roof and the clerestory windows were inlaid with geometric or floral motifs in brightly colored glass and faience tiles. The dais at the far end of the throne room was set with multicolored figures of the traditional foes of Egypt so that whenever the king sat upon his golden throne, he was trampling his enemies underfoot. A richly decorated canopy was erected over the throne. Under this the king, often accompanied by his chief queen or sometimes his mother, appeared as the image of the god Horus.

Towards the middle of the New Kingdom, a new form of royal pageantry was introduced. This was the 'Window of Appearance,' a large, elaborately decorated window, opening out from the main halls of the palace onto a courtyard where officials and courtiers could gather. The king and queen appeared at the window during formal ceremonies, leaning out to dispense honors and rewards.

The official state apartments were distinct from the residential quarters, which were often housed in a completely separate building. The domestic rooms consisted of the private chambers where the king could enjoy the company of his family or friends, and his bedroom and bathroom. The latter was a white-plastered room with a drain sunk into the floor. Like the state apartments, these private rooms were lavishly decorated with painted walls and floors, and colorful inlays of glass and faience. The themes used here were less formal, however, and included wildlife motifs of birds, animals, and water gardens, or intimate family or harem scenes. Within the palace compound were also storerooms for the enormous quantities of supplies needed, guard rooms for the royal bodyguard, and kitchens and workshops. Gardens also formed an important element in the landscaping of palace grounds, comprising lakes planted with lotus and papyrus, avenues of trees, and pergolas supporting vines.

In the Old Kingdom, texts in the tombs indicate that important royal women had their own

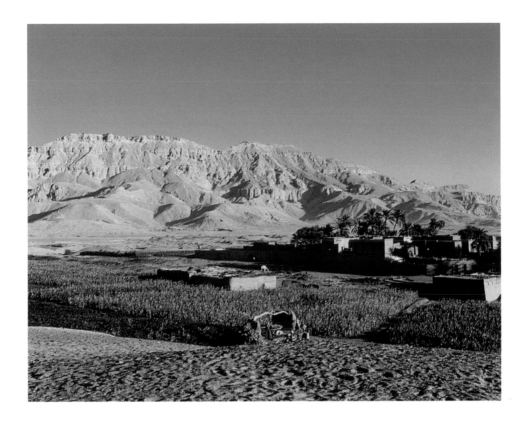

households that were maintained by the income from their personal estates. Their staffs of attendants, stewards, and officials were often largely female. This suggests that, as in the New Kingdom, queens and princesses had their own palaces or at least their own compound within the palace. Like a private house, these would have consisted of columned halls surrounded by suites of smaller rooms. The upper floor would have provided more secluded chambers.

EARLY PALACES

No palaces of the early dynasties have survived, nor of the Old Kingdom. It is even uncertain where they were located. By tradition, King Menes, the legendary founder of Dynasty 1, established his capital at a place later known as Memphis. Situated at the point where the Nile river left its narrow cliff-lined valley and began to branch out into the broad flat pastures of the Delta, this site was of supreme strategic importance. Although individual kings built their residences elsewhere in Egypt, Memphis always remained the key point where the north and south met, from which the whole country could be controlled and defended. It was called 'The Balance of the Two Lands' and here Menes built a fortress, the 'White Wall,' which may have been an administrative as well as a defensive complex.

The earliest existing ruins of Memphis, which lie about 24 km south of modern Cairo, date no earlier than the First Intermediate Period. Geotechnical surveys have shown that in the Old Kingdom, the Nile, or at least a major branch of it, flowed close to the western desert. It is here that the earliest capital of the country is being sought, near the tombs of the earliest dynasties at north Saqqara.

View of the site of Malqata, located west of Luxor. Under the fields lie the ruins of the palace of Amenhotep III. Western Thebes. New Kingdom.

Although it is unlikely that much architecture can be recovered from beneath five millennia of silt deposits, we can speculate that the 'White Wall' may have looked much like a very large version of the recessed mudbrick walls of the early tombs, whitewashed with gypsum plaster. What buildings existed within those walls is not known.

The ancient fortress of Memphis must have housed a ceremonial palace used for official occasions such as the coronation. It seems likely that each king built his residence anew rather than refurbishing an existing one, and in the Old and Middle Kingdoms these may have been sited at different locations outside the capital. This would explain why the pyramids are spread along 90 kilometers of the desert edge from Abu Rawash to al-Lahun. Each king chose a site near his palace or royal domain to build his funerary monument. Unfortunately, such palaces have not been discovered in the desert. They must have been built in the valley where they would now lie meters beneath the present ground level, buried in silt and well below the water table.

At the end of the Old Kingdom there are indications of environmental changes; unusually high and low Nile flooding, desiccation of the western desert, and habitation sites covered by river clay and sand dunes. The western Nile branch which ran near Giza seems to have silted up or to have been diverted, and for a time, the Giza and Saqqara cemeteries were abandoned except by the poor. The kings of the Middle Kingdom chose a new location for their capital, not at Memphis, but at Itj-Tawy near modern al-Lisht. None of this settlement has been recovered. Presumably the palaces of the early Middle Kingdom kings lie here under the modern fields. The later kings of this period built their pyramids at Dahshur and Saqqara, near Memphis, and this may indicate that their residence was once more in the traditional capital.

NEW KINGDOM PALACES

In the New Kingdom, Memphis became important again as a port and as a military center. For the early part of this period the kings lived and ruled in the south, at Thebes (modern Luxor). Here we have textual references to palaces situated near Karnak temple, but none has been found by excavations. They probably lie under existing structures.

However, across the river from Thebes, Amenhotep III built a large rambling palace for the celebration of his jubilees, the first of which he celebrated in his thirtieth year of reign. For this occasion, a large mudbrick palace was built on the edge of the cultivation. Before it an artificial rectangular lake provided the setting for some of the celebrations.

Another jubilee was celebrated in even more style three years later. The existing palace was torn down and rebuilt on a larger scale, and the lake was expanded to cover an area of two square kilometers. The ruins of the second palace were excavated at the beginning of this century. Built of mud-brick it consisted of a number of units containing columned halls surrounded by smaller suites of rooms. The largest of these was for the king and contained a series of large halls leading to a throne room. Behind these formal apartments was a bedroom suite with a bathroom attached. Important female members of the royal family, such as Queen Tiye and Princess Sitamun, each had their own separate unit complete with attendants, servants, and supplies from their own estates. Fragments of painted plaster show that some of the rooms were decorated with lively scenes of birds and natural motifs.

THE AMARNA PALACES

The Malqata palace was not a residential palace but was built just for one specific festival. It may not therefore be typical. The only site which affords a glimpse of a residence of the king and his family is

Amarna in Middle Egypt. Here, Amenhotep III's son, Akhenaten, established a new residential city for himself and his personal deity, the Aten. As the site was never substantially reoccupied later, it contains a remarkable area of well-preserved ruins.

The ancient city, called Akhetaten, was laid out parallel to the river, with a road running north-south along the edge of the desert. In the city center the king built a formal reception palace, known today as 'the King's House,' where he could meet officials and foreign dignitaries, bestow appointments, and reward diligent courtiers. The scenes in the tombs at Amarna depict Akhenaten leaning out of an elaborate 'Window of Appearance,' usually accompanied by Queen Nefertiti, handing out the 'gold of honor' to rejoicing officials.

Across the road lay an enormous complex of rooms and courts, connected with the King's House by a massive mudbrick bridge. This 'Great Palace,' as it is called, probably went all the way down to the river, but much of it remains buried beneath the modern fields. Here, courtyards with colossal statues of the king were part of a formal reception area. Behind were the inner rooms decorated with painted walls and ceilings where the royal family could relax. One painted floor was found intact and depicts a garden scene including a rectangular pool with fish and water plants. Around this, calves gambol and ducks fly out of clumps of reeds and papyrus. Two adjoining rooms have similar pavements. Fragmentary wall paintings depict two young princesses, bejewelled and naked, seated on cushions near their parents. The columns and walls were also decorated with brightly colored glazed mouldings of lotus flowers and bunches of grapes.

Despite the size of this palace, it was not the only royal residence at Akhetaten. Another large complex lies at the north end of the site, enclosed by a massive mudbrick wall. Again, a large part of the ruins including most of the palace proper lies beneath the cultivation. Storerooms and other buildings immediately next to the enclosure wall may have been guard rooms and stabling. Jar sealings of Nefertiti suggest that she lived here.

Midway between the central city and the palace at the northern end of Amarna lies another royal complex known as the 'North Palace.' Here a central ornamental pool is surrounded by rectangular units: an open sun-court with an altar, a stable for cattle with mangers, and a formal garden with exquisite wall paintings of birds in papyrus marshes. The names on the smashed door-jambs and lintels are those of the king's eldest daughter, Meritaten. This layout does not suggest a residential palace but more a special building for certain ceremonies which involved her in particular.

The king and queen feature prominently in the new repertoire of tomb reliefs at Amarna that replaced the old scenes of everyday life. The progress of the royal family from palace to temple or to 'Window of Appearance' is frequently depicted. The family members are shown in chariots, the king and queen proceeded by runners and sometimes followed by their many daughters, travelling along a road lined with bowing subjects. In one famous scene the king and queen are kissing. We are not told if this progress between palace and temple was a daily event, or the preliminaries for a special ceremony, perhaps a *hieros gamos,* a sacred marriage. Akhenaten, of course, was a rebel, and may have devised his own court ritual, but observers like Diodorus Siculus of the first century BC remarked that every aspect of the king's life was dictated by ritual: 'For there was a set time not only for his holding audience or rendering judgments, but even for his taking a walk, bathing and sleeping with his wife; in short, for every act of his life.'

HAREMS

The scenes in the Amarna tombs show that next to the formal state courts and columned halls were the private apartments. Here the royal bedroom was located, containing an elaborate bed covered with

a large, comfortable mattress. One depiction also shows three identical little beds nearby, perhaps for the princesses. These scenes of the public and private life of the royal family are presumably copied from temple prototypes, of which the occasional fragment has survived. From Karnak, a block shows the king and queen hand in hand, entering a similar bedroom.

Around the palace are storerooms and a domestic area, such as the kitchens and bakeries. Also sometimes depicted is a separate building, enclosed and guarded, where women are shown playing musical instruments, dancing or arranging each other's hair. More instruments fill the storage chambers behind their living quarters. These were the women who accompanied the king's court and had their own secluded quarters called the *khener*, usually translated as 'harem.' In the strict sense of the word, this meant an isolated quarter for women. The usual Western image of a harem, with its overtones of the steamy atmosphere of 'A Thousand and One Nights,' redolent of sexual excesses, is not applicable here.

The word *khener* has recently been re-interpreted as 'musical troupe,' but this meaning seems to be rather narrow and does not express the nuance of constraint that the original word conveys. Whatever the interpretation, entertainers—musicians, singers and dancers—were clearly an important part of the king's female entourage. They may well have been restricted in their freedom and some of them may also have served as concubines to the king.

The identity of these women is unknown but some of them may have been drawn from the nobility. Anyone, even a concubine, who had personal access to the king was in a potentially influential position. From historical parallels it can be surmised that families would vie with each other to get a female relative into the king's entourage, a position which would vastly improve their own standing and influence.

Striking *khener* reliefs were recently discovered at Abu Sir. One block contains five rows of scenes,

Stone lining of the royal bathroom in Merenptah's
palace at Memphis.

the first depicting the legs of a row of offering-bearers. A row of men, members of the royal suite, are bending and holding batons in their hands, while to their right a group of young female dancers (members of the *khener*) are performing.

Another scene shows a row of bending men, some carrying batons, others with long objects (perhaps rolled-up mats or linen), while on the right a group of male dancers is performing. The inscriptions identify the men as members of two different groups. On the left side, another row of men, also carrying batons and rolled objects, bends toward the pyramid. On the right, marching in the opposite direction, is a group of men bringing offerings. It seems that the *khener* here consists of female dancers and a musical troupe who are celebrating the completion of the pyramid of Sahure.

Other members of the royal family also included musicians and singers in their personnel. From the Rameside period we have a letter from two singers of the Princess Isetnofret II, daughter of Rameses II, addressed to the princess and inquiring when she would be returning to them. They were writing from the palace of Miwer in the Fayoum. The marshes of the Fayoum were a favorite area for hunting, because the papyrus thickets supported an abundance of wildlife and attracted migratory birds in the spring and autumn. Here, a royal establishment of Thutmose III at Madinat Ghurab, at the entrance of the Fayoum, grew into an important palace housing many of the royal women and owning much of the land around. Its badly eroded ruins form a large mudbrick enclosure surrounding smaller house-like units.

Some of the senior queens are known to have lived here, and one suspects that minor wives, superannuated singers and concubines, no-longer-favorite queens, and perhaps even tiresome children were 'parked' in its rambling compounds.

A tomb found here of a Rameside prince, Rameses-neb-weben, revealed the body of a hunchback

Plan of the palace of King Merenptah showing a series of columned courts. The small central chamber with six columns is the throne room with a dais on the left side for the throne.

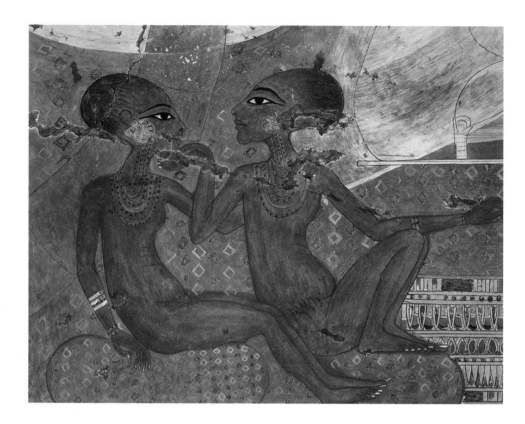

man of about thirty. His deformity may have confined him to the seclusion of Miwer. Other tombs in the vicinity may also have belonged to royal children. The sons and daughters of the king, other than those by his chief wife, are rarely mentioned in documents, but must have been numerous. Rameses II is credited with over one hundred children, many of whom are unnamed and unknown to us. The recently discovered multiple tomb in the Valley of the Kings belonging to many of his sons may fill in much detail about them, but we still lack information about the sons and daughters of earlier kings.

At Miwer, some of the numerous women housed in the palace were occupied in weaving fine linen. In fact, records suggest that this palace was a major supplier of cloth for royal establishments elsewhere. Fine embroideries, like those fragments found in Tutankhamun's tomb, were probably produced here too. No doubt these fine fabrics were exchanged for commodities which the palace could not produce itself, such as spices or luxury items like lapis lazuli and green malachite. The palace owned extensive estates that produced its basic food requirements, managed by a team of male administrators.

HUNTING LODGES AND REST HOUSES

The king would have spent much of his time on official visits to different parts of his realm and undoubtedly possessed several palaces in different regions; a summer residence in the Delta, a palace at Thebes for use during important religious festivals, and various rest houses and hunting lodges up and down the country. He would travel, for the most part, by boat, accompanied by his bodyguard, a host of attendants and officials, and selected royal ladies. Some of the rest houses, known to the Egyptians

Two young princesses sitting on cushions. Wall painting from Amarna.
Ashmolean Museum, Oxford. New Kingdom.

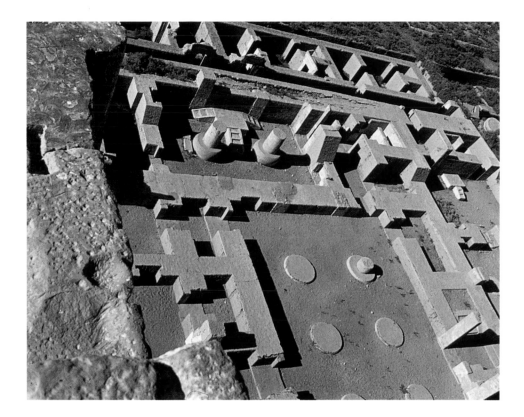

as 'mooring posts' were sited by the river where the king and his entourage could stop for a night on their journeys. Others were situated next to religious centers and were used on special occasions.

One such rest house was discovered in the 1920s near the Sphinx but was removed without proper records by excavators eager to reach the earlier levels below. It seems to have been a villa dating from the time of Tutankhamun and in use until the Rameside Period at least. It would have been used during religious observances at the Sphinx, by this time identified with the god Harmarkhis, and also, no doubt, during chariot practice and hunting in the desert.

Another reason for royal visits was to participate in important religious festivals. At Thebes, two important feasts required the royal presence; the Feast of Opet at Karnak and Luxor, and the Harvest Festival of Min. At major temples, a small ceremonial palace was attached to the first court, providing a reception area and throne room, and private chambers and bathrooms behind for the use of the king and queen.

At Madinat Habu, one of these official palaces has survived. Built on the south side of Rameses III's mortuary temple, it communicated with the first court of the temple by a 'Window of Appearance.' On the other side of this window was a columned hall and beyond this the king's audience hall with a throne dais at the far end. Behind, a corridor separated a row of chambers and bathrooms from the reception areas. These were for the use of the royal family during religious celebrations, but this palace is far too small to be anything other than a rest house.

Other private quarters were located above the gatehouse of the enclosure wall. Here limestone reliefs show scenes of the king being tended by scantily clad young girls, bestowing the occasional caress or affectionately putting his arm over their shoulders, thereby giving us a rare insight into his private

Ruins of the palace of Rameses III at Madinat Habu
New Kingdom.

life. Some of these ladies are named as his children, but others may have belonged to the harem.

Unfortunately, only the actual gatehouse has survived, as this was built of stone. The mudbrick wings that formed the rest of this unusual palace had collapsed and were cleared away by early excavations.

FOREIGN QUEENS AND COURT LADIES

The campaigns of Thutmose III in Syria-Palestine brought under the sway of Egypt the many small city-states of that area. The son or daughter of one of the vassal chiefs of the region occasionally appears among the list of items of tribute sent to Egypt. Presumably these hostage children would have joined the royal household, but very little is known about them. The sons were brought up in a thoroughly Egyptian way and indoctrinated with a positive attitude towards their overlords, while at the same time acting as guarantees for their fathers' good behaviour. The daughters, of whom we know equally little, probably joined the lesser wives or concubines of the king. Records show that they came with their own retainers. One chieftain's daughter who arrived in year 24 of Thutmose III's reign came with thirty attendants, enough to set up her own household.

The diplomatic correspondence of late Dynasty 18 includes letters sent from these princes of Syria-Palestine to the kings of Egypt. Their tone is subservient, they address the king as: 'My Lord, my God, my Sun-god,' and have to comply with peremptory requests from the Pharaoh such as: 'Send your daughter to the King, your lord, and as presents send twenty healthy slaves, silver chariots and healthy horses.' Another letter to the prince of Gezer is a request to supply 40 beautiful women at a cost of 40 pieces of silver for each; 'so send very beautiful women in whom there is no blemish.' The king continues, reassuringly: 'And may you know that the king is in good health, like the sun god, and that his troops, his chariots and his horses are very well indeed; for Amun has put the Upper Land and the Lower Land, the rising and the setting of the Sun under the feet of the King.'

Once these foreign women reached their destination in Egypt, it is rare to hear any more of them. They must have joined the anonymity of one of the king's burgeoning harems. The lady recorded in year 24 may have been one of the three foreign wives of Thutmose III whose tomb was discovered by illicit diggers some decades ago. Their names, Menhet, Mertit, and Menwy, betray their foreign origin but their country and their parents' names were not recorded. They were, however, given a respectable burial with similar sets of funerary equipment, including some of the earliest glass vessels known in Egypt, objects which would have been greatly treasured.

As well as receiving the daughters of Syrian princelings into their entourage, the kings of the late 18th Dynasty also ratified diplomatic ties by marrying princesses from the more powerful northern kingdoms of Mitanni and Babylon. These marriages were important outward symbols of alliance between equal powers that were renewed whenever a new reign began. When Amenhotep III came to the throne on his father's death, he married his father's Mitannian queen. Likewise, on his death, his son, Amenhotep IV (later Akhenaten), inherited Tadukhepa, another Mitannian princess who had arrived in Egypt only two years before.

The alliances thus cemented were based on personal connections, and when a foreign ruler died, his successor's daughter was immediately requested to reconfirm the agreement. For example, when Kadeshman-Enlil succeeded his father on the throne of Babylon, Amenhotep III immediately asked for his daughter in marriage. In this case, the negotiations were protracted. The Egyptian king was dealing, not with a princeling, but with an equal power, as can be seen in the kinship term of 'brother' or 'brother-in-law' used in the correspondence. His Babylonian 'brother' needed 'gold, very much gold' for a palace he was building and was reluctant to send his daughter until he had received it. He was also anxious (or so he said) about his sister, who had come to Egypt to marry the Pharaoh many years previous-

ly and whose whereabouts were not known: 'Indeed, you want my daughter in marriage, but my sister whom my father gave you is with you there, but no-one has seen her [recently], or knows whether she is alive or dead...' She had probably joined the other foreign women at one of the provincial harem-palaces, perhaps at Miwer, and had been forgotten. Amenhotep III was unrepentant, however, and told Kadeshman-Enlil that none of the Babylonian envoys knew her anyway and so were unable to recognise her!

The long reign of Amenhotep III brought many foreign ladies to his court. He is known to have married two Syrian princesses, two from Mitanni, two from Babylon, and one from Arzawa in southeast Asia Minor. These ladies arrived in style; a Mitannian princess, Gilukhepa was accompanied by 317 attendants.

During the confusion of the Amarna period and its aftermath, we hear little about diplomatic marriages. It was apparently not until the reign of Rameses II that this means of ratifying a treaty was revived. A Babylonian princess was received into the Egyptian court, and then, in the later years of Rameses II's reign, negotiations began with Egypt's former enemy, the state of Hatti, for a Hittite princess. The Hittite king promised a splendid dowry 'greater... than that of the daughter of the king of Babylon' and, no doubt, a reciprocal gift of similar value was expected from Rameses II. This may not have been immediately forthcoming, as one reproachful letter from the Hittite Queen intimates: 'My Brother possesses nothing? If the son of the Sun-goddess or the son of the Storm-god has nothing... [only then] have you nothing! That you, my Brother, should wish to enrich yourself from me... is neither friendly nor honorable!...'

Despite this hitch, the arrangements went ahead and the Hittite princess set off with a huge escort for the long journey to Egypt. Her dowry of slaves, cattle, sheep and horses, gold, silver, and bronze, as well as her personal jewelry and possessions went with her. At the frontier, she was met by an Egyptian escort, and conveyed along the Mediterranean coastal road and across Sinai to Egypt, a journey of many months. Finally, she arrived at the palace at Per-Rameses:

'Then the daughter of the Great Ruler of Hatti was ushered in... before His Majesty, with great and rich tribute in her train, limitless, all manner of things. Then His Majesty beheld her, as one fair of features, first among women... Behold it was a great and mysterious event, a precious wonder, never known or heard of in popular tradition, never recalled in writing, since the time of the [fore] fathers—the daughter of the Great Ruler of Hatti coming, proceeding to Egypt, to Rameses II.

Now, she was beautiful in the opinion of His Majesty and he loved her more than anything, as a momentous event for him, a triumph which his father Ptah-Tatonen decreed for him.'

The new queen was given an Egyptian name, Maat-Hor-Neferure, 'She who beholds Horus, the splendour of Re' and, unlike other foreign princesses, became for a time the king's principal wife living in the royal palace. However, as the years rolled by, she in her turn was replaced by younger women, including the king's own daughters, and sent to join the other senior royal ladies at Miwer.

Although these diplomatic marriages set the seal on foreign alliances, the Egyptians thought of them as another form of tribute. For this reason these marriages only worked one way; the Egyptian kings refused to send their daughters abroad. A request from the Babylonian king was refused outright: 'from old, the daughter of an Egyptian king has not been given in marriage to anyone.' The Pharaoh probably considered himself mightier than other kings, or he may have feared that the union of an Egyptian princess with a foreign ruler would give the latter a claim to the throne of Egypt.

This indeed is what is suggested in an extraordinary letter recorded in the Hittite annals, written by 'the queen of Egypt' to the great Hittite king, Suppiluliumas: 'My husband has died and I have no son. They say about you that you have many sons. You might give me one of your sons, and he might become my husband. I would not want to take one of my servants. I am loath to make him my husband.'

The Hittite king was astounded, 'such a thing has never happened before in my whole life!' He sent, not a son, but an envoy to check this extraordinary request. The envoy returned with a second letter: 'I have not written to any other country, I have written only to you… He will be my husband and king in the country of Egypt.' Reassured, a Hittite prince was dispatched on the long journey south, but he never reached Egypt. He was assassinated en route. The Egyptian queen is not named but was probably Tutankhamun's widow, Ankhesenamun. Instead of a Hittite prince, her new spouse was the aged Ay, the legitimate heir of Tutankhamun as it was he who had enacted the funerary rites for the dead king. A commoner by birth, Ay reinforced his claim to the throne by marrying Ankhesenamun, the daughter of Akhenaten and therefore of royal blood.

Unfortunately, the Egyptian records are quite silent about this episode, as they are equally uninformative on the union recorded in the Bible between Solomon, king of the new state of Israel, and 'the daughter of Pharaoh.' After the economic and political upheavals at the end of the New Kingdom, the king of Egypt may not have been so snobbish about allowing his womenfolk to marry foreigners. But there is no Egyptian record of this event.

HAREM CONSPIRACIES

The tendency of the official records to omit anything that was not considered *maat*, especially when relating to the royal family, can be most frustrating. It is impossible to believe that the harem palaces did not reverberate from time to time with the machinations of jealous wives and ambitious mothers. Yet all this is usually omitted from formal annals. Occasionally, however, the veil of silence swings back for a moment, to allow a glimpse of what was happening behind the official facade.

Hints of trouble in the palace are referred to obliquely in the autobiography of a 6th Dynasty official called Weni. Among the usual claims of royal favors, he boasts that he was a trusted official:

'When there was a secret charge in the royal harem against Queen Weret-yamtes, his majesty made me go in to hear (it) alone. No chief judge and vizier, no official was there, only I alone;… Never before had one like me heard a secret of the king's harem.'

We are not told what the charges against the queen were. Perhaps she was accused of adultery, or perhaps she was caught conspiring against the king or the crown prince. The secrecy that surrounded her crime was typical of the policy to ignore or suppress anything which threatened the normal concept of divine order.

A more serious affair was the conspiracy of harem women and officials in the reign of Rameses III. The documentation for this is much more substantial because the records of the trials of the accused have survived. It involved several women of the 'harem of accompanying' and some male officials of the palace and the harem. The aim of the conspirators is never clearly stated. Apparently one of the minor queens, Tiy, with the help of the other women of the harem, plotted to assassinate the king in order to place her son, Pentwere, on the throne. One of the harem women wrote to her brother, a captain of archers in Nubia, saying: 'Stir up the people, make enmity and come to make a rebellion against your lord.' The conspiracy was found out, however, before it had got too far and the culprits were brought to court. The trials did not proceed without a hitch: at one stage, five of the judges were themselves accused of carousing with the women under arrest! In the end, the conspirators were condemned to death or to suicide.

PAGES 70-71

A blind musician playing the harp before the tomb owner and his wife. Tomb of Inherkhau, Deir al-Madina

Plan of the palace of Amenhotep III at Malqata, Western Thebes. New Kingdom.

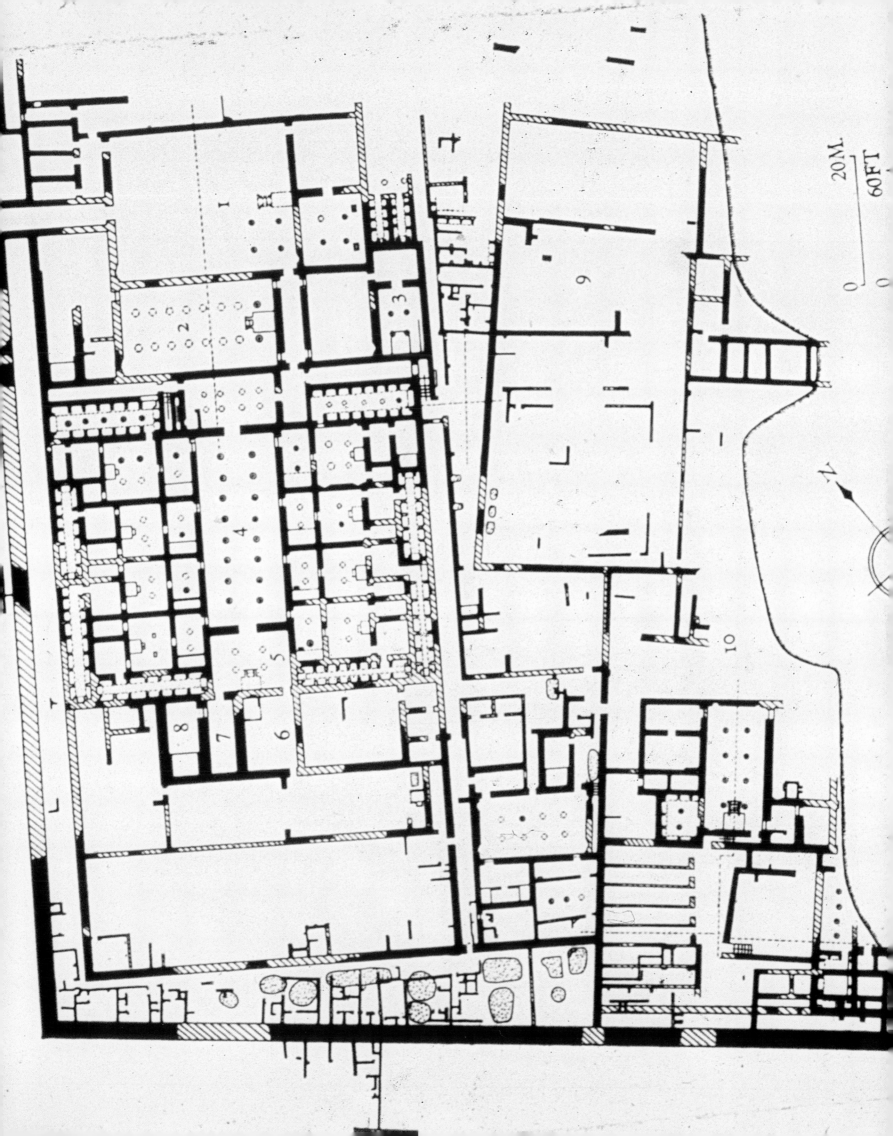

IV
LOVE AND MARRIAGE

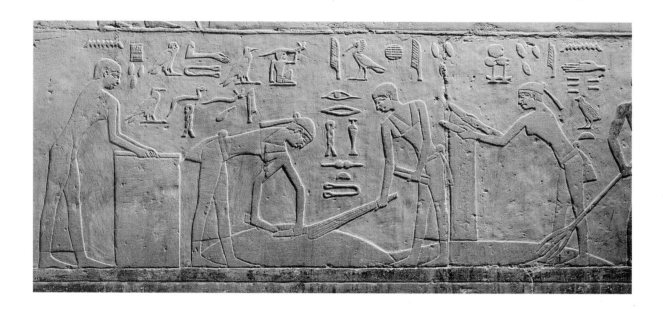

Like many traditional cultures, the nucleus of ancient Egyptian society was the family. As modern psychiatrists have discovered, the Egyptians knew that a stable and happy family produces secure and contented children, children who would realize their full potential as adults and contribute positively to their society. Hence marriage, as the fundamental basis of the family, was very highly regarded and universally practiced. Indeed, through their role in establishing and maintaining the family and through the care of children, tomorrow's adults, Egyptian women can rightly be said to have contributed to those areas of Egyptian culture—literature, mathematics, technology, and so on—which were apparently monopolized by men.

Early marriage was desirable and universal and its aim was to establish a family. Children were all important, especially a son who would carry out the funerary rituals for his parents. From the books of instructions which were written in the Old Kingdom and later, we can get an idea of how the ancient Egyptians themselves viewed marriage, with the proviso that these compositions were always authored by men and addressed to other men, usually the pupil of the writer. Nowhere do we have comparable texts written by or for women. This source then, though useful, may well be biased.

Most marriages seem to have been within the same social stratum and no doubt this helped to keep property and professions within the family. One well-documented example from the 6th century gives an account of how a priest of Amun-Re in the Fayoum was asked by a young relative from Thebes for a priestly appointment in the Fayoum as well as for his daughter in marriage. Both requests were eventually conceded. We have no idea if the young lady in question had any say in the matter.

Other records suggest that the father was involved in his daughter's marriage arrangements.

Male and female figures winnowing grain. Part of a harvest sequence in the tomb of Ti at Saqqara. Old Kingdom.

Golden amulet of the goddess Hathor, mistress of love and beauty. Egyptian Museum, Cairo.

For example, Ankhsheshonq advises his son to 'take a wise man for your daughter and not a rich man,' implying that the father had the final say in the choice of bridegroom. The scribe Any wrote for his son:

'Take a wife while you're young,

That she make a son for you;

She should bear for you while you're youthful,

It is proper to make people.'

Another later text recommends marrying at the age of twenty, again, in order to have a son while young. Low-life expectancy was obviously one factor to recommend this practice, but the desire to avoid illicit unions, and in particular, illegitimate children was very strong. Most responsible fathers would therefore see that their daughters were married soon after puberty, probably at an age of between twelve and fourteen. Until marriage, girls lived with their parents, but were certainly not all confined to the house. Girls from low-income families helped with the household chores, which included fetching water from the river or well, taking the animals to graze, running errands, helping with the harvest, and so on, giving them ample opportunity to review the local talent when prospecting for a future spouse. The middle- and upper-class women were probably more confined, and their contacts with the opposite sex were more likely to have been restricted to their extended family. As in modern rural Egypt, the first cousin marriage was very popular in antiquity, but other close-kin marriages such as uncles and nieces were tolerated then, although they would not be now. Brother and sister unions were usually restricted to the royal family, although isolated cases of marriage between half brother and sister have been demonstrated from records of common people.

Painted wooden box of Kabakent and his wife. National
Museum, Copenhagen. New Kingdom.

Young men probably married somewhat later in their early 20s, at least amongst the educated classes, when their careers were well enough advanced to set up their own household. The educated ones were less tied to the parental home as their careers could take them further afield, even abroad, and their field of choice in theory was therefore much wider, although family approval was still needed.

We are lucky that a rich body of love poetry has survived, written on papyrus and pottery and now preserved in Turin, London, and Cairo. These are literary compositions rather than spontaneous poetry, and they present an ideal which may have been removed from reality, but which nevertheless must lie within social conventions of the time. They present a rather different picture from that obtained from wisdom literature or other records, and are probably the closest we will get to an idea of the preliminaries to marriage.

In these poems, lovers address each other as 'brother' and 'sister,' used loosely as terms of endearment rather than implying family kinship. They convey the idea that young men and women had the opportunity to meet and fall in love, and indicate that, as long as they could get family approval, they had some degree of choice in their future partner. Young girls as well as men are able to speak openly of their feelings, and one famous cycle of songs from the Chester Beatty Papyrus takes the form of stanzas sung alternately by male and female singers. It starts with a description of the woman's beauty:

'Shining bright, fair of skin,
Lovely the look of her eyes,
Sweet the speech of her lips…
Upright neck, shining breast

Scene showing the tomb owner Inherkhau with his family.
Tomb of Inherkhau, Deir al-Madina. New Kingdom.

Hair true lapis lazuli;
Heavy thighs, narrow waist,
Her legs parade her beauty;
With graceful steps she treads the ground,
Captures my heart by her movements.'

In the next stanza, the young girl admits that she also is smitten: 'My brother torments my heart with his voice, He makes sickness take hold of me.' Further on, she complains that she cannot control her heart: 'My heart flutters hastily, When I think of my love of you;' and describes all the symptoms of lovesickness, ending in despair; 'My heart, do not flutter!'

The young man is suffering likewise:
'Seven days since I saw my sister,
And sickness invaded me...
When the physicians come to me,
My heart rejects their remedies;
My sister is better than all prescriptions...
The sight of her makes me well!'

In another song cycle, the lover complains that his girl is playing hard to get: 'How well she knows to cast the noose, And yet not pay the cattle tax!' And elsewhere, he has to resort to a ruse to see her:
'I shall lie down at home,
And pretend to be ill;

A woman carrying flowers and ducks. Tomb of Menna,
Western Thebes. New Kingdom.

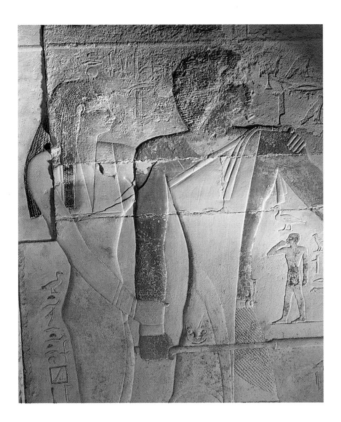

Then enter the neighbors to see me,

Then comes my sister with them.'

The goddess Hathor, the 'Golden One,' was the Mistress of Love and Beauty and the protector of lovers, able to aid and abet them:

'I praise the Golden [One],

I worship her majesty,

I extol the Lady of Heaven;

I give adoration to Hathor…

I called to her, she heard my plea

She sent my mistress to me.'

The ancient Egyptians were also sensitive to the beauty of nature: gardens, the river Nile, trees, and birds were evoked in the love poems. 'I belong to you like this plot of ground, That I planted with flowers, And sweet-smelling herbs.' Or, more explicitly:

'The voice of the dove is calling,

It says: "It's day! Where are you?"

O bird, stop scolding me!

I found my brother on his bed,

My heart was overjoyed:

Each said: "I shall not leave you,

My hand is in your hand:

A recently discovered tomb west of the Great Pyramid shows Kai followed by his wife who holds his hand in a gesture of love and affection. Tomb of Kai, Giza. Old Kingdom.

You and I shall wander,

In all the places fair.'"

This and other similar examples imply a certain freedom for young people before marriage but we have no means of knowing whether this was normal or exceptional, although it does seem to apply to girls as well as young men.

In practice, one suspects that most marriages were arranged between families who knew each other or who were related. Records show that it was normal for a young man to approach the father for permission to marry his daughter. But the girl, although perhaps not free to marry without permission, could certainly try persuasion, especially to win her mother's agreement:

'He knows not my wish to embrace him,

Or he would write to my mother...

Come to me that I see your beauty,

Father, Mother will rejoice!

My people will hail you all together,

They will hail you, O my brother!'

Clearly, if these poems are indicative of the normal expression of feelings of young people they had some say in the choice of partner, although the final outcome needed family support. The emphasis on mutual love and respect between husband and wife expressed elsewhere was an ideal to aspire to. It may have discouraged forced marriages, but no evidence either way has survived. Not every romance can have had a happy ending, however, and there must have been many unrequited love affairs:

'I made my brother's love my sole concern,

About him my heart is not silent;

It sends me a fleet-footed messenger

Who comes and goes to tell me:

"He deceives you, in other words,

He found another woman,

She is dazzling to his eyes."'

Apart from poetry, we have little material about the preliminaries to marriage. Scenes in the tombs do not apparently touch on this side of life, but only depict the outcome, with husband and wife participating together or separately in a variety of activities. Even the marriage ceremony, if they had one, is never shown; in fact, nothing has survived to tell us exactly what happened at a wedding. One of the ancient Egyptian terms for marriage—'to establish a household'—has been taken by some scholars to indicate that the setting-up of an independant house and cohabiting was the sole significant act, without any legal or religious ceremony. But although there are no texts which mention marriage formalities, legal documents clearly show that married men and women had well-defined responsibilities towards each other and their married status must have been formally acknowleged to distinguish them from unmarried people.

Another term for marriage was 'to take as wife' which implies some formal procedure. This may have been only a spoken declaration or oath by the man alone or with the bride's father in the presence of witnesses, probably family members. In some cases, the bride's father bestowed some of his property on his daughter. Items she might bring with her into the marriage would be domestic equipment, textiles, and sometimes a donkey, the chief means of transport. There is also mention in some documents of the husband's gift to the wife of items of jewelry or commodities.

We have no record of a religious ceremony to mark the occasion, but considering the religious nature of the society, it is likely that some of the protective deities, particularly the goddess Hathor, were invoked to ensure a happy outcome. After a celebration, probably involving dancing, singing, feasting,

and story-telling, the bride would be conveyed to the bridegroom's house in the evening.

Contracts defining property rights within the marriage are first mentioned in the New Kingdom, but the earliest examples which actually survive date from the Third Intermediate Period. Some of these are between husband and father-in-law, and record the material rights of the wife, sometimes even specifying the amount of food and clothing her husband should provide annually, and what would happen in the event of divorce. These are not marriage contracts per se, as some of the couples named seem to have been married some time and already have children, but rather economic statements of the rights of each partner. In the case of divorce the wife usually received one third of the joint property as well as whatever she brought with her. By the Late Period, it was stated that the wife as well as the husband had the right to initiate divorce, a right which shocked the misogynist Greeks of that time!

A married woman was expected to be chaste and not have affairs outside the marriage. This was obviously so that the husband could be sure of the paternity of her children; maternity can never be in doubt, but the father's role is less visible. Usually the marriages were monogamous, although the king was expected to have many wives. In fact there were no legal or social constraints on a man taking more than one wife if he could afford it. Even so, it seems that most marriages were monogamous, perhaps influenced by the ideal example of the divine couple, Isis and Osiris. The high incidence of death in childbirth, however, meant that a man could have more than one wife during his lifetime. Scenes in tomb paintings which show more than one wife may record consecutive marriages after the death of a spouse, rather than concurrent wives.

Amongst the records from Deir al-Madina, the village which housed the artisans and scribes who built and decorated the royal tombs, are fragments of a register of the occupants of each house. The owner is listed, with his parental affiliation, then his wife and her affiliation, if he is married, and their children. None of the surviving fragments lists more than one wife, although if the modern system applied that each wife should have her own house, polygamy would not show up in this type of register. Nevertheless, in other records of the New Kingdom we have two examples of men with two wives each. One of these identifies herself as ' I am one of four wives, two being dead and another still alive.' By the Late Period contracts do not suggest that a man could take a second wife without divorcing the first.

Women were only allowed one husband, although again, death or divorce might mean more than one partner over a lifetime. She was also expected to be faithful to her husband. Men might have been more free to have sexual relations with women other than their own wives, but affairs with married women were greatly criticised and generally not tolerated by society. Several cases are known from Deir al-Madina where individuals are accused of affairs with married women. For example, in an attempt to remove an especially unsavoury character named Paneb from his office of chief workman, he was accused, amongst other charges, of sexual relations with several married women. Another Deir al-Madina workman complained to the court that his wife was having an affair with one Merysekhmet. Rather than divorcing his wife, the workman tried to stop the liaison. Merysekhmet swore an oath in court that he would not see her again, but then resumed his liaison; the next time, it was his own father who took him to court in an attempt to stop him. Clearly his behavior was not approved of by his family or by his community.

Another text tells of a married man, Nesamenemipet, who had been having an affair with a woman for eight months. Both the woman (who does not seem to be married) and the man aroused social criticism because he had been visiting her regularly without first divorcing his own wife. He was told to swear an oath in court with his wife, presumably to divorce her, so that his relations with other woman could be regularized. The indignation that this affair aroused suggests that responsibilities towards the marriage partner were taken seriously, and that social pressure could be exerted to ensure conformity.

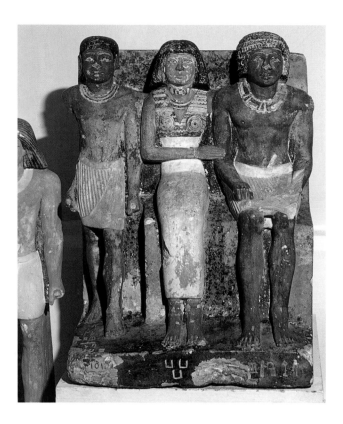

There are some hints that adultery, in theory at least, was punishable by death. In The Instructions of Ptahhotep the advice is given:

'If you want friendship to endure

In the house you enter

As master, brother or friend,

In what ever place you enter,

Beware of approaching the women!

Unhappy is the place where it is done,

Unwelcome is he who intrudes upon them…

A short moment like a dream,

Then death comes from having known them.'

Some of the stories such as The Tale of the Two Brothers also indicates that death could be the punishment for adultery, but in practice, divorce was more likely. If the husband was the offender, then he was legally obliged to compensate his wife adequately. That meant returning everything she had brought with her, as well as relinquishing a third of their joint property and whatever had been put aside for the children. No wonder Nesamenemipet was reluctant to divorce his wife despite his affair with the other woman! If, on the other hand, the wife was at fault, she received no financial compensation.

Divorce was not uncommon, and seems, like marriage, to have been a private affair, unless it was contested, in which case the partners might be subjected to an embarrassing interrogation before the local council of elders. The usual grounds for divorce were adultery, barrenness, the wish to marry someone

Painted limestone statue of the official Seked-Kau and his
family. Egyptian Museum, Cairo. Old Kingdom.

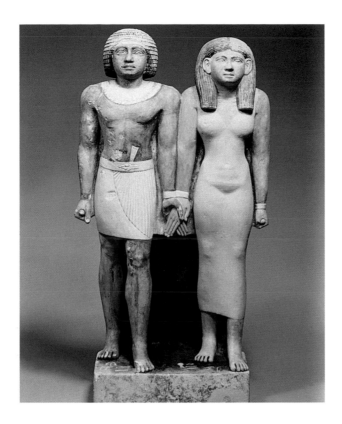

else, or simply incompatibility. Both parties could remarry. The property contracts which detail a woman's share of joint property in the case of divorce were safeguards so that she was not left destitute, or a burden on her father's household to which she would presumably return. They also must have been a deterrent to a hasty repudiation of a spouse.

Despite all this, the ancient Egyptians had an idealistic view of marriage, as shown by the advice given in the wisdom literature (always, of course, from the man's point of view) which advises on conjugal harmony and respect. In The Instructions of Ptahhotep, the author counsels his 'son' (i.e. pupil) to care for his wife:

'When you prosper and found your house,
And love your wife with ardor,
Fill her belly, clothe her back,
Ointment soothes her body,
Gladden her heart as long as you live,
She is a fertile field for her lord.'

But he also cannot resist adding: 'Keep her from power, restrain her—her eye is her storm when she gazes—thus will you make her stay in your house.' What we lack to balance this male-oriented picture are the instructions of the women, but these, if they existed, must have been oral and have not survived.

At a later date the scribe Any says: 'It is a joy when your hand is with her, there are many who don't know this.' Indeed, statues and tomb paintings illustrate the close relationship of the ideal conjugal partnership by showing the couple hand in hand or with the wife's arm around her husband's shoulders.

Teti and his wife, hand in hand. Painted limestone statue.
Berlin Museum. Dynasty 5.

V
MOTHERHOOD AND CHILDREN

For the ancient Egyptians, the prime purpose of marriage was to establish a family. Children were much desired for their own sake, but also for the security they would bring for their parents in old age. The eldest son in particular was sometimes referred to as the 'staff of old age' who would look after an aged parent and take over his father's work. Parents were, quite literally, the source of life and deserved respect and honor: 'Praise god for your father, your mother,

Who set you on the path of life!

This is what I put before you,

Your children and their children.'

Children were thus seen as the link with future generations, but they were also expected to reciprocate the care they received from their parents, particularly their mother:

'Double the food you give to your mother,

Support her as she supported you;

She had a heavy load in you,

But she did not abandon you.'

As well as caring for their parents in their old age, children were expected to carry out the principal roles in their funerary rites when they died. But their responsibilities did not end there. The dead ancestors were part of the extended family, and it was the duty of the living family to look after them. They needed offerings of food and drink which were presented at the tomb periodically and especially at the great feasts. Children were thus not only much loved for their own sakes, they were essential to the welfare of the parents and ancestors. And the more the merrier, as the scribe Any wrote: 'Happy is the man whose people are many, He is saluted on account of his progeny.'

Pottery figure vase in the form of a mother and child. Museum of Fine Arts, Boston.
New Kingdom.

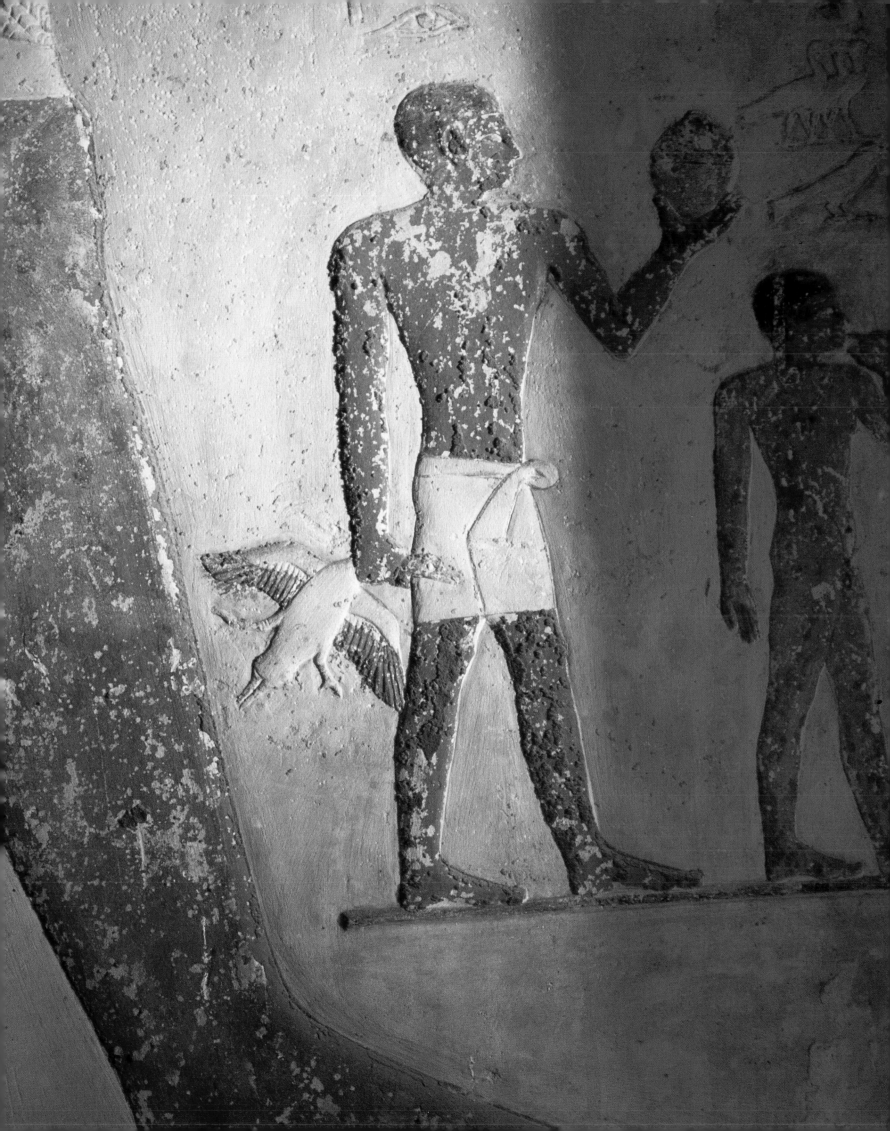

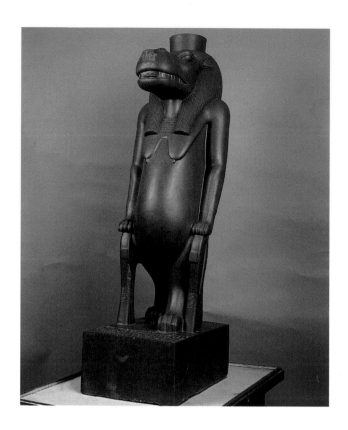

PREGNANCY

Early marriage was considered desirable in order to have children while young. Several medical papyri have survived which deal with aspects of pregnancy and gynaecological problems and although these are often obscure, and some of the terms are not fully understood, they contain a lot of information. There were several tests to see if a woman was capable of conceiving. One of these was to place either an onion or garlic in the woman's vagina and note whether her breath smelled of it the next day. Other tests included milk from a woman who had borne a male child mixed with other ingredients; if the woman who swallowed this vomited, then she was not sterile.

Early signs of pregnancy included changes in skin and eye color, a hot neck and a cold back. The urine of a pregnant woman was thought to stimulate the growth of plants and the Egyptians even thought they could tell the sex of the unborn child from this. If she urinated every day on wheat and barley grains, and they germinated, then she was pregnant. If wheat sprouted before barley, then the baby was female, if the barley sprouted first, it was male. If neither germinated, she was not pregnant. Some years ago this was tested at Ain Shams University in Cairo and found to be completely ineffective, although growth hormones present during pregnancy would be excreted in the urine, and might be expected to promote plant growth.

Barrenness was dreaded. If a woman could not conceive, pleas were made to the deities connected with fertility and childbirth, such as Bes, Taweret, and above all, Hathor. Votive objects, such as phalluses, or figures of a woman with a child lying on a bed, were dedicated at temples of Hathor accompanied by prayers. The dead ancestors could also be petitioned. One man wrote a letter to his dead father ask-

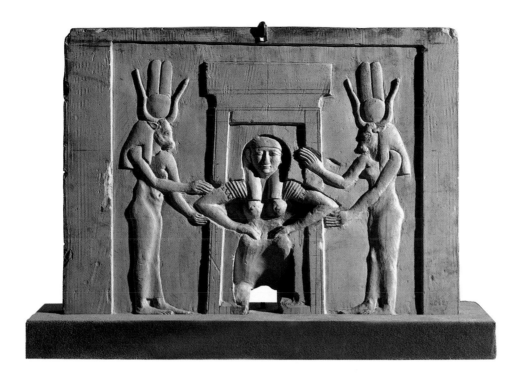

ing for help so that his wife could bear a son. A figurine of a woman carrying a child bears an inscription 'May a birth be granted to your daughter Seh' which is thought to be a petition to a dead father to help his daughter conceive.

Spells and amulets were also used as well as herbal concoctions. Frogs were a symbol of fertility, and an inscribed dish on whose rim sat little frogs was doubtless used for holding a fertility potion. Egyptian doctors were renown for their skill in medicine including administering such concoctions. In the 13th century BC, the Hittite king requested from Rameses II a doctor to attend to his married sister who had no children. Rameses II was reluctant, and replied, 'Now see, as for Matanazi, my Brother's sister, the king your brother knows her. Fifty is she? Never! She's sixty for sure!... No-one can produce medicine for her to have children. But, of course, if the Sun-God and the Storm-god should will it... But I will send a good magician and an able physician, and they can prepare some birth drugs for her (anyway).'

If none of these methods worked, a childless couple could resort to adoption. Indeed, it was considered the proper course of action. A letter of the Rameside period accuses a man without children of being mean because he does not adopt: 'You abound in being exceedingly stingy. You give no-one anything. As for him who has no children, he adopts an orphan instead [to] bring him up. It is his responsibility to pour water onto your hands as one's eldest son.'

Several cases of adoption are known from the Deir al-Madina records. In one such example, the chief workman Neferhotep and his wife were childless, and, after some deliberation, adopted a slave as their heir. He later dedicated a stela to Neferhotep, and called his son and daughter after his benefactors. In another document, known as the Adoption Papyrus, a childless couple, Nebnefer and Rennefer, purchase a slave girl who bore three children, which presumably Nebnefer had fathered. After the death of

A squatting woman giving birth, assisted by the cow-headed goddess Hathor,
on both sides. Temple of Hathor at Dendera. Egyptian Museum, Cairo.

Nebnefer, Rennefer emancipated these children and adopted them as her heirs. She also arranged for the marriage of the eldest daughter to a male relative.

Although children were highly desired, there must have been occasions when pregnancy was not wanted, as there are recipes for contraceptives for women. One such was a mixture of honey and ground acacia tips. Another was a mixture of crocodile dung, natron (a natural sodium compound) and honey. They were inserted into the vagina and probably had some measure of success as they would create a hostile environment in the womb, preventing fertilization. It was also recognized that lactation would delay another pregnancy.

CHILDBIRTH

All things being well, the mother would expect to deliver after a pregnancy which was calculated at about 271 days from conception. Various spells and charms protected against miscarriage, and herbal remedies included a mixture of honey and wine, or various herbs, to stop any bleeding.

The medical papyri have little to say about actual childbirth. It was considered a normal event and was attended by midwives rather than by doctors. The actual delivery was depicted only rarely. In the divine birth scenes in Ptolemaic temples, the mother is shown squatting to deliver, assisted on either side by goddesses. The hieroglyph for birth is determined by a kneeling woman with the head and arms of the baby appearing below her. Sometimes birthing bricks are also shown, on which the woman would squat or kneel to deliver. These bricks are distant echoes of the birthing stools which are now coming

Wooden "paddle doll" with a wig of strands of beads. Used as a fertility charm. National Museum, Copenhagen. Middle Kingdom.

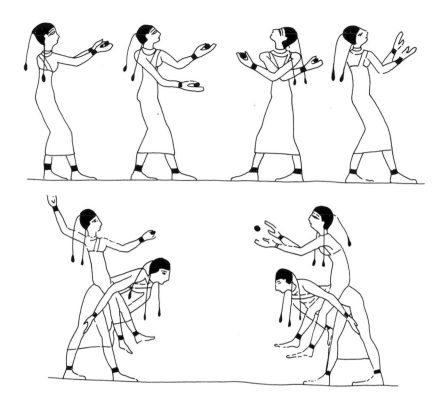

back into use. It is interesting also, that the squatting or kneeling position is often recommended today for delivery as being the most natural and efficient position for giving birth.

There were various remedies to speed up delivery and to ease the pain of childbirth. Dates mixed with wheat and herbs were bandaged under the stomach to free the child from the womb. Saffron powder mixed with beer was massaged into the stomach to assuage the pains. Sometimes the mother was given intoxicating drinks, such as beer. Other remedies, applied in the vagina, included potsherds from a new vessel that had been ground up in oil and heated, or a mixture of juniper fruit and pine-tree resin.

A Middle Kingdom story describes the birth of three royal triplets who were destined to be the first three kings of Dynasty 5. 'On one of those days, Ruddedet felt the pangs and her labor was difficult. Then said the Majesty of Re, Lord of Sakhebu, to Isis, Nephthys, Meskhenet and Khnum: "Please go, deliver Ruddedet of the three children who are in her womb, who will assume this beneficent office in this whole land..." These gods set out, having changed their appearance to dancing girls, with Khnum as their porter. When they reached the house of Rawoser...he said to them: "My ladies, look, it is the woman who is in pain: her labor is difficult." They said: "Let us see her. We understand childbirth." ...Isis placed herself before her, Nephthys behind her, Heket hastened the birth... The child slid into her arms... They washed him, having cut his naval cord, and laid him on a pillow of cloth.' The birth of two more babies is described in the same way.

The goddess Isis and her child Horus were frequently invoked to ensure a safe and speedy delivery. The mother was often identified with Isis and prayers and spells, such as one entitled 'For speeding up the childbirth of Isis,' were recited during a difficult labour. Hathor was another goddess invoked and identified with the mother: 'Rejoicing, rejoicing in heaven, in heaven! Birth giving is

Group of girls playing with balls from a tomb at Beni
Hassan. Middle Kingdom.

accelerated! Come to me, Hathor, my mistress, in my fine pavilion, in this happy hour.'

Other deities were also present at a birth. Taweret, the hippopotamus goddess with the head of a crocodile and the feet of a lion, was the chief protector of pregnant women. She is often depicted with the *sa* sign of protection or a magical knife, and her ferocious appearance was designed to ward off any threat. Her assistant was the bandy-legged dwarf god, Bes, who also often holds a knife, and whose ugly lion-like head scared away evil forces. The goddess Meskhenet delivered the child and foretold its future, while the frog-headed Hekat assisted. Amulets of these deities were often worn by pregnant women and mothers for protection.

In the story of Ruddedet, the birth takes place in the privacy of a closed room in the house. Several ostraca and fragmentary wall scenes from houses from Deir al-Madina show women seated under a light canopy decorated with climbing plants which may represent the pavilion or 'birthing arbour' mentioned in some of the texts. Under this flowery canopy, a woman is shown naked seated on a bed or stool and nursing her baby while young girls wait on her. But if, as has been suggested, this structure was built in the garden or on the roof of the house, it is hardly likely to be for the actual delivery. This would surely take place in the seclusion and security of an inner room, rather than in a location exposed to all the vagaries of the Egyptian climate—sun, flies and sand in summer, and bitterly cold winds in winter—and the eyes of the neighbors. It is more likely that such a pavilion would serve for the purification ceremony after childbirth.

In the days before modern drugs and surgery, childbirth was a hazardous event and difficult deliveries must often have brought death for both the mother and child. Evidence from mummies and skeletons confirms this. For example, the fragmentary remains of Queen Mutnodjmet indicate that she probably died giving birth. Studies of her bones show that she had already undergone several difficult deliveries in an attempt to give her husband, King Horemheb, an heir. The lower life expectancy of women in the ancient world reflects the higher mortality rate due to the risks of childbearing. On average, women lived about four years less than men.

INFANCY

Infants also were at risk and child mortality was high, particularly in the first few weeks of life. Many died from intestinal infections. Weak and sickly babies, or those born with deformities, would have less chance of survival. The newborn's first cry was thought to indicate whether it would live or not; if the baby cried 'ni' then it would live, but if it cried 'ba,' or cried loudly, it would die.

Spells and amulets were used to protect the newborn who was identified with Horus, son of Isis: 'My arms are over this child—the arms of Isis are over him, as she puts her arms over her son Horus,' and 'You are Horus, you have awakened as Horus…I drive out the illness which is in your body and the pain which is in your limbs…' Other spells to drive out the demons of illness were recited over amulets which were then placed round the neck of the child. One such spell involved forty-one beads, including one of gold, and a carnelian seal-stone inscribed with a crocodile and a hand. After a spell had been recited over them, they were placed around the neck of the child. Another remedy, presumably for an older child, was to give the invalid cooked mouse to eat. Then the bones were threaded onto a strip of fine linen in which seven knots were made. This charm was then placed around the child's neck.

The cause of illness was seen as an intrusive force which should be driven out by means of spells:
'Come on out, visitor from the darkness, who crawls along with your nose and face
on the back of your head, not knowing why you are here!
Have you come to kiss this child? I forbid you to do so!
Have you come to cosset this child? I forbid you to!
Have you come to do it harm? I forbid this!
Have you come to take it away from me? I forbid you to!

I have made ready for its protection a potion from the poisonous afat herb, from
garlic which is bad for you, from honey which is sweet for the living but bitter for
the dead, from the droppings and entrails of fish and beast and from the spine of the
perch.'

In the Middle Kingdom magical wands, often made from hippopotamus ivory, were decorated with figures of protective deities and symbols, fabulous animals, and demons who would ward off danger. Taweret and Bes appear frequently with symbols of protection, like the wadjet eye and the *sa*, or the ankh of life. Some of the wands bear inscriptions which make clear their protective character, such as: 'protection by night, protection by day,' or 'cut off the head of the enemy when he enters the chamber of the children whom the lady ... has borne.'

Despite these remedies and spells, infant mortality was high, especially in the first few days of life. Newborn babies who died were often buried under the floor of the house, sometimes within a large jar. When mother and baby died at the same time, they were interred together. In the tomb of Tutankhamun, the mummified foetuses of his two still-born daughters were buried with him. Their mother, Ankhsenamun, survived to be married to the next king, Ay.

Older children who died were often buried with much care and expense, testifying their parent's affection and sorrow. Amulets, charms and protections to serve in the Underworld were buried with them, as well as food supplies and sometimes toys. Rich families had their dead children mummified and did everything in their power to ensure a safe passage to the realms of the dead. A Late Period stele records the death of a young girl, Isenkhebe:

'...Harm is what befell me,

When I was but a child!

A faultless one reports it.

I lie in the vale, a young girl,

I thirst with water beside me!

I was driven from childhood too early!

Turned away from my house as a youngster,

Before I had my fill in it!

The dark, a child's terror, engulfed me,

While the breast was in my mouth!

The demons of this hall bar everyone from me,

I am too young to be alone!

My heart enjoyed seeing many people,

I was one who loved gaiety!

O King of Gods, lord of eternity, to whom all people come!

Give me bread, milk, incense, water that come from your altar,

I am a young girl without fault!'

Babies were usually breastfed for about three years, thus increasing the infant's chances of survival through the immunity received with the mother's milk. Lactation would also delay another pregnancy and helped to space out children. Various concoctions were supposed to increase the supply of milk. The mother's back could be rubbed with oil in which the fin of a fish had been boiled; or she could eat barley bread mixed with poppy plant while sitting cross-legged. Inflammation of the breast could be eased with an ointment made of calamine, bile of an ox, and fly dung.

Pottery jars in the shape of a kneeling woman holding one breast are thought to be vessels for holding mother's milk, perhaps for medical purposes. They would hold about as much as one breast produces at one feed. Several prescriptions call for milk from a woman who had borne a male child, which was considered to be a potent ingredient in remedies for intestinal complaints, infants' colds, and sleeplessness.

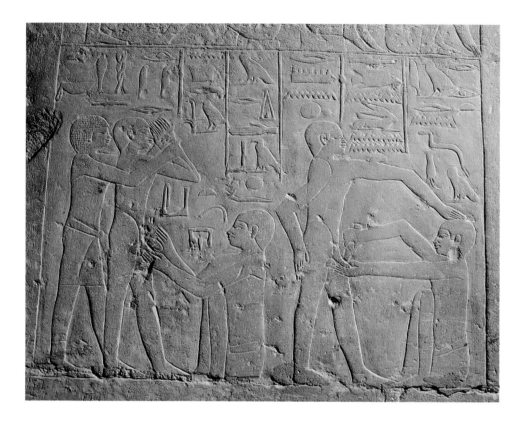

Nurses and Wet-nurses

The care of young children was usually delegated to female nurses, although men were employed as tutors or guardians for older children. One job that could only be fulfilled by a woman was that of wet-nurse. From the famous Instructions of Any, it is clear that it was normal for a woman to suckle her children:

'When you were born after your months,

She was not yet yoked [to you],

Her breast in your mouth for three years.

As you grew and your excrement disgusted,

She was not disgusted, saying: "What shall I do!"'

But babies whose own mother had died, or whose mother could or would not nurse them, could only survive with a wet-nurse.

A wet-nurse had to be a woman who had recently borne a child and so was lactating; either her own child had died or she was able to feed two at once. In the New Kingdom, the title 'wet-nurse of the king' usually designated a lady of high rank who had been chosen to nurse the royal heir. The close relationship thus formed with the royal family would no doubt bring preferment. Queen Hatshepsut even allowed her wet-nurse, a woman called In, to prepare a tomb for herself in the Valley of the Kings, an honor rarely accorded to non-royalty. Hatshepsut also honored In by having a statue of her nursing the child-queen sculpted. The remains of the statue were found at Deir al-Bahari.

Another non-royal couple who seem to have been granted burial in the Valley of the Kings were Sennefer and his wife Senetnay, who was also a royal wet-nurse. This tomb was actually built for Thutmose

Scene of circumcision performed on boys in the tomb of
Ankh-Mahor, Saqqara. Old Kingdom.

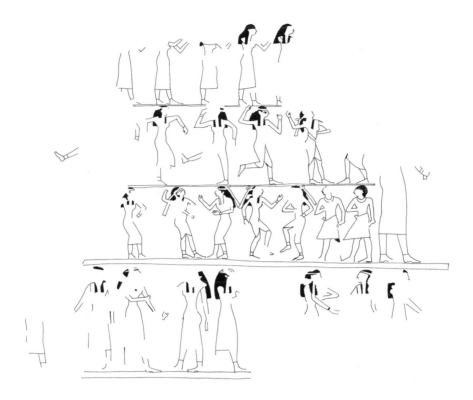

II but was never used by the king. The nurse was buried in one of the tomb passages, and her canopic jars have been found. We know that Sennefer was the mayor of Thebes, and his tomb, known as the 'Tomb of Grapes,' dates from the reign of Amenhotep II.

In addition to such personal favors, the nurse's own children often grew up with the royal children and formed part of their intimate circle of associates in later life. Thutmose III even married the daughter of his wet-nurse, with whom he may well have played when they were children.

Contracts between parents and wet-nurses have survived. One such agreement stipulates for how long the nurse was to be employed and what her obligations were. She was to provide milk of the proper quality, she was not to nurse another child except her own, she was to avoid sexual activity and pregnancy, and if the infant became ill, she was to tend it. The parents were to provide clothing and massage oil for the child and regular payments to the nurse to cover the cost of her milk and her food. In one case, details of the payment have survived, but without an indication of what time period it covers. This was calculated as thirty deben of copper and actually paid as: three necklaces of jasper; one ivory comb; one pair of sandals; one basket; one block of wood, and half a litre of fat.

This was a job that carried more prestige than that of an ordinary children's nurse, and involved responsibility for the infant's well-being over a period that was probably not less than three years. It is clear from the way in which the wet-nurses are honored in funerary monuments that they often established very close and affectionate relationships with their charges that were maintained long after their prime job—that of suckling the infant—had ceased.

The tomb of Maya, the wet-nurse of King Tutankhamun, was recently found at Saqqara. The nurse held the titles of 'Royal wet-nurse, who feeds the body of the pharaoh,' and 'beloved by the Lord of the

A scene showing girls being trained to dance. The girls are shown practicing various steps and movements, instructed by two men. Dra Abu al-Naga. New Kingdom.

Two Lands [the king].' Reliefs found at the entrance of the tomb show Maya seated with Tutankhamun sitting on her lap. He looks younger than in other portraits of him, but nevertheless he wears all the royal symbols. The king's name is written inside a cartouche, and his dog can be seen under the king's seat. The scene also includes a number of members of the king's court and Ay, who became king after Tutankhamun's death, Horemheb, who ruled Egypt at the end of Dynasty 18, and Rameses I, the first king of Dynasty 19, are all possibly depicted. Inside the tomb can be seen religious scenes in front of the sarcophagus of Maya before her burial, and the priests and ladies from the royal court carrying offerings and bouquets of flowers to be presented to Maya. The tomb also contains a hall with pillars.

It is likely that Maya served as the wet-nurse of King Tutankhamun in the area of Memphis; a rest-house used by the king when he went hunting in the valley of Gazelles near the Sphinx has been discovered to the south of the valley temple of Khafre.

CHILDHOOD

Although the first few days of a newborn's life were probably the most difficult, being breast-fed gave it some immunity for the first three years. When it was weaned, it would be more exposed to infection, and this was another critical time. Childhood diseases treated in the medical papyri include eczema, tonsillitis, and swollen lymphatic glands. Severe anemia is observable on some skeletons, and patterns observable in bone tissue reveal periods of serious malnutrition or illness.

Children stayed close to their mother for the first few years of life. If she left the house, the baby

An amulet in the form of Bes, protector of
pregnant women.

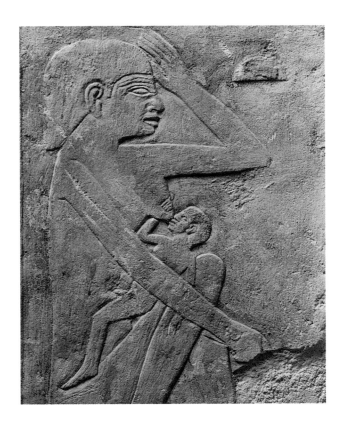

would be carried in a sling on her back or over one shoulder, or just on her hip. Older children would soon be expected to help around the house or at busy times, such as harvesting, just as village children in Egypt help their parents today.

Although in tomb reliefs and statues, children are nearly always depicted naked, in practice this would be impossible in the winter when the weather can be quite cold. Children's clothing was usually a miniature version of adult dress. A Dynasty 1 child's dress from Tarkhan was made from pleated linen, and shaped like a simple tunic with long sleeves and a keyhole opening for the neck. In Tutankhamun's tomb nearly fifty children's garments were found, presumably his, including a baby's robe, shawls, caps, and gloves.

Very often a sidelock of hair was allowed to grow on the right side of the head, especially on girls, while the rest of the head was shaved or the hair cut very short. This 'sidelock of youth' was cut off at puberty. A childhood fashion in the New Kingdom was to shave part of the head, leaving tufts of hair. Adolescent girls are sometimes shown with several pony tails rather than the full wig of the adult women.

Although children from ordinary backgrounds would be expected to help their parents at an early age, their lives were by no means all work. Representations of lively games are found, as well as toys. These include whipping tops, rattles, and skittles. Little girls had simple dolls made from a peg, or a flat piece of wood painted with a face; these they would swathe in cloth. A number of wooden animal figures have survived, occasionally made with moving jaws or tails. Ball games were popular, and many balls have been found in excavations, stuffed with palm or papyrus fiber, or straw, and covered in sewn leather or cloth. Scenes from the tombs at Dra Abu al-Naga show groups of girls clev-

A woman suckling her child while sitting before an oven. Tomb of
Niankh-Khnum and Khnum-hotep, Saqqara. Dynasty 6.

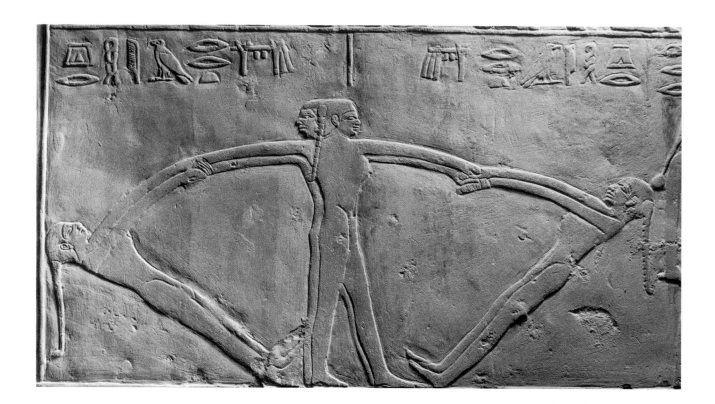

erly juggling with two or three balls at once or playing a game of catch while mounted piggy-back on a companion.

A depiction of a girl practising archery and shooting at three targets shows that some of the martial arts associated with boys were also enjoyed by young women. Girls also learned to swim, and a favorite design of this period was naked girls swimming among lotus flowers and fishes in a pool.

In the Old Kingdom tomb of Mereruke, girls are twirled round by the arms in a game described as 'pressing the grapes.' It is a pity that we have no more details than this illustration. Nearby, holding mirrors and rattles, others are performing 'Hathor's dancing game.' Dancing was important in Egyptian culture, both for celebrations and for religious events. There are many depictions of girls performing the energetic *muu* dance during funeral celebrations, clad in just a kilt and a long hat or pony tail with a disc at the end.

A scene showing girls being trained to dance is found at Beni Hassan; the girls are shown practising various steps and movements, instructed by two men. Daughters of elite families would also be taught to sing and play a musical instrument, so that as adults they would be able to participate in an essential part of temple ritual.

There is no evidence for the formal education of girls. Scribal schools existed, attached usually to temples or royal establishments, but they were for boys and we have no record of girls being taught there. Girls, if they were educated at all, would have been instructed by a tutor or a literate mother. Some princesses, such as Neferure, the daughter of Queen Hatshepsut, are known to have had tutors, but we do not know if this was the rule or the exception. Letters by and to queens, princesses, and ordinary women exist but we have no means of telling whether they penned them themselves or employed a scribe to write or read them.

Girls and boys forming a 'living roundabout,' a game described in the
inscription as pressing the grapes. Tomb of Mereruke, Saqqara. Old Kingdom.

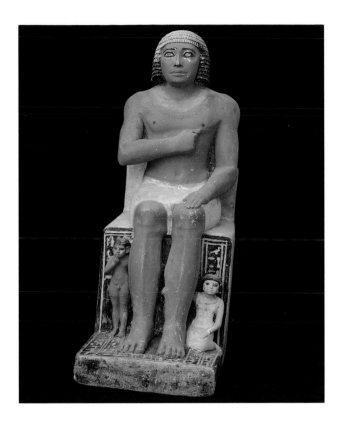

The occasional occurrence of the female term for scribe, *seshat*, in the Middle Kingdom does imply some female literacy amongst the elite classes, but it is impossible to tell how common it was. No teaching texts have survived that were written for female students in contrast to the many and varied educational texts compiled expressly for boys. The lack of female signatures on legal documents also indicates that literacy among women was probably unusual and confined to the upper classes.

In effect, most girls probably received all the education they were going to get by example from their parents, particularly their mothers. They would be gradually initiated into the vital tasks of housekeeping, baking and brewing, and textile weaving. As in Egyptian villages today, preparation for motherhood would start early by looking after younger siblings. At puberty, some boys were circumcised, and it may be that this operation was also carried out on girls. An obscure text refers to an 'uncircumcised female,' indicating that the modern practice of clitoridectomy was known in this part of Africa in ancient times and perhaps originated in the Nile valley.

Children feature frequently in tomb paintings and on funerary stelae. Although the sons and daughters played a vital role in the funerary rites, such scenes also illustrate the closeness of family ties. Even though emotions are rarely depicted in the formal tomb art, little gestures of affection are often included. Scenes such as the one depicting Mereruke with his hands held by his two grown sons illustrate the affection linking the family members. The awareness of how vulnerable children were to illness and death must have enhanced their value.

A tomb that appears to be that of the sons of Rameses II, and one of the largest ever found in Egypt, was recently discovered in the Valley of the Kings by Egyptologist Kent Weeks.

Painted limestone statue of Kai with his two children sitting beside his legs
(discovered by the author). Tomb of Kai, Western Cemetery, Giza. Old Kingdom.

The tomb was dated to the reign of Rameses II from the king's cartouche that appears on the tomb wall and from the overall design of the tomb. The entrance to the tomb of the sons of Rameses II, which lies just in front of that of their father, leads to a mausoleum of about 62 rooms.

Clues to the identity of the occupants of the tomb were hieroglyphic inscriptions with the names of Rameses II's first and second sons, Amun-her-khepeshef and Rameses 'junior,' found in the tomb. Pottery shards inscribed with the name of Mery-Amun, the fifteenth son of Rameses, found earlier, supported this evidence. Farther inside the tomb, pieces of canopic jars, and other fragments thought to bear the name of Seti II, the seventh son of Rameses II, were discovered.

Deeper still, steps descend to a grand central hall, supported by ten columns, and another passageway leads to an astonishing array of 48 rooms, arranged in a T-shape. In the middle is a large carved relief of Osiris, god of the Afterlife and the underworld was found. Human remains were also found.

Weeks believes this tomb was used by the sons of Rameses; however, other scholars believe that the tomb had only a symbolic function for the family of Rameses, and was connected with the god Osiris. The reasons put forward for this are the following: the size of the chapels found inside the tomb are very small and cannot fit a sarcophagus and a coffin; the existence of the statue of the god Osiris inside the tomb seems to confirm the symbolic function theory; other sons of Ramses II were buried elsewhere, such as in the Valley of the Queens, and furthermore the Valley of the Kings would not have been the proper place for the burial of the family of Rameses; and lastly, while no other such examples are known to have existed in ancient Egypt, symbolic tombs connected with Osiris have been found.

A woman carrying her child in a sling while selling sycamore
figs. Tomb of Menna, Western Thebes. New Kingdom.

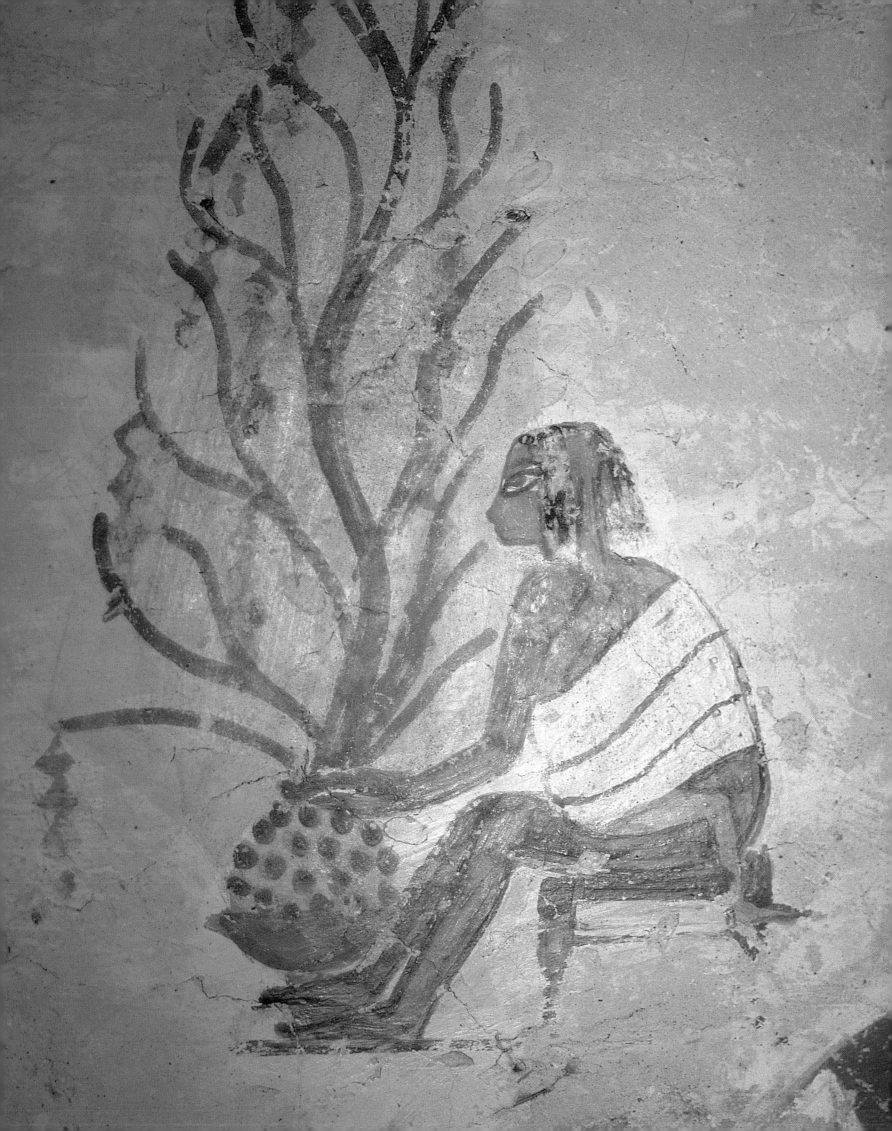

VI
THE LADY OF THE HOUSE

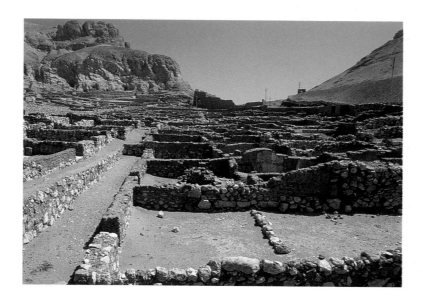

While the men are depicted and recorded engaged in activities outside the home—farming, craftwork, administration—women rarely pursue such occupations. Their chief role in society was to provide heirs, and most women must have spent much of their relatively short lives pregnant or nursing babies and bringing up children. They were of necessity more tied to the house but we have no reason to think they did not accept this willingly. The more children, the greater was the status of the mother in the eyes of her husband and society in general. Motherhood was therefore highly esteemed, and children were brought up to respect their mother as well as their father. The standard funerary formula says, 'I was one loved by his father, praised by his mother.'

The husband was expected to provide a home for his new bride. Sharing with relatives was definitely not recommended, as the scribe, Any says:

'Build a house, or find and buy one,
Shun [contention].
Don't say: "My mother's father has a house…"
When you come to share it with your brothers,
Your portion may be a storeroom.'

This house would be the wife's domain, reflected in the most common title for married women in ancient Egypt, *nebet per*, 'the lady of the house.' Even in the male-oriented Wisdom Literature, the woman's authority at home is acknowledged:

'Do not control your wife in her house,
When you know she is efficient;

House ruins of the workers' village at Deir al-Madina, Western Thebes. New Kingdom.

Limestone statue of a servant woman straining beer. Egyptian Museum, Cairo. Old Kingdom.

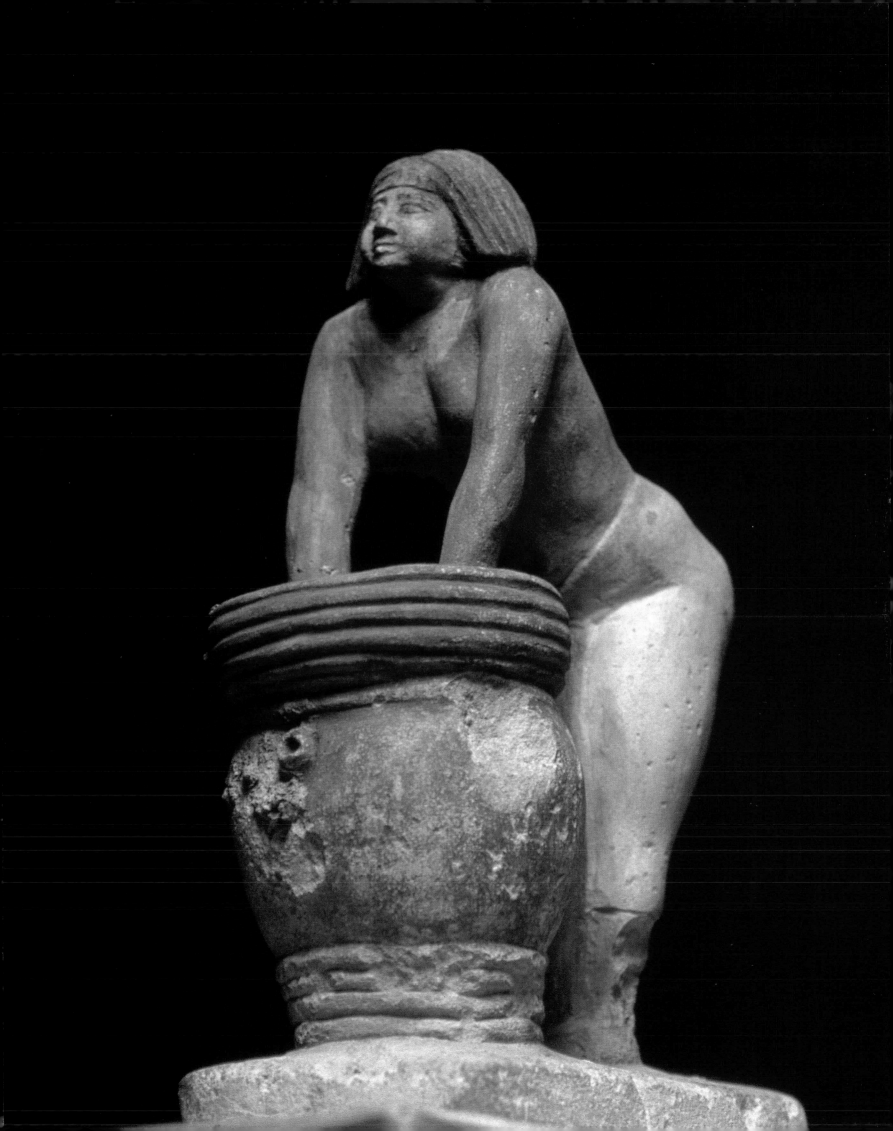

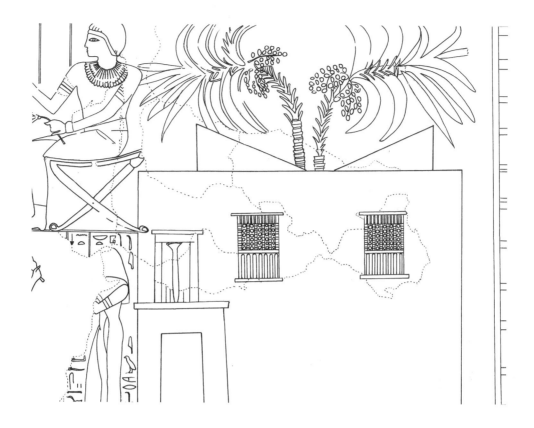

Don't say to her: "Where is it? Get it!"
When she has put it in the right place.
Let your eye observe in silence,
Then you recognize her skill.'

The houses the ancient Egyptians lived in were built of mud-brick roofed with palm logs; rooms were small and plastered, and sometimes painted. Settlements were usually sited in the fertile valley on high ground that lay above the level of the annual inundation. Most large towns were situated near the Nile as the main highway was the river. Many of them now lie buried under centuries of silt, or under modern towns, and our knowledge of them is consequently very limited.

Sites built in the desert, however, such as Kahun, Deir al-Madina, and Amarna, have received the attention they deserve. They have provided a mine of information about the layout and organization of towns as well as details about the individual houses. Each of these three examples, however, represents a royal establishment, and as such, probably differs from an ordinary market town or district center.

HOUSES

At the Middle Kingdom town of Kahun, the workers who maintained the pyramid of Senwosret II and his funerary cult were housed in a large walled town that was divided into two unequal sections. On the west side were rows of back-to-back houses for the workers, some of them extremely small with as few as three rooms. Occasionally, two houses have been joined together by knocking down an inter-

The house of the chief of police 'Neb-Amun' from his
tomb at Western Thebes. New Kingdom.

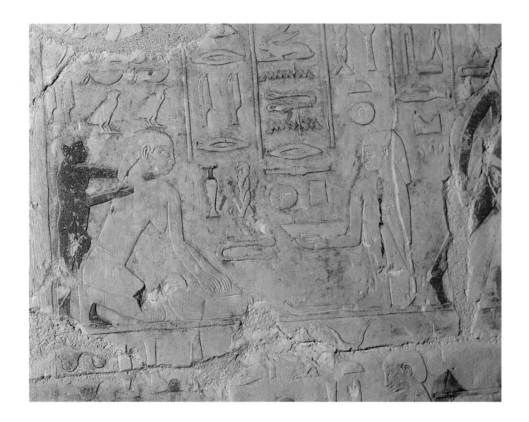

vening wall and inserting columns. By contrast, the much bigger eastern section of the town contained just a few large houses for officials and administrators. These were built around a garden court with porticos, and included separate women's and servants' quarters, kitchen area, guest rooms, and the owner's private rooms. The larger houses contained up to seventy rooms, including granaries and store-rooms, which, in those days before minted money, probably contained rations for the payments of work-ers and lesser officials. Other rooms may have been workshops for the manufacture of textiles.

Like the pyramid town of Kahun, Deir al-Madina housed a specialized community, in this case the artisans and workmen who built and decorated the royal tombs of the New Kingdom. Located against the desert cliffs and enclosed within a wall, the village was divided by two parallel streets off which opened rows of deep, narrow houses. Each house had an entrance room which often contained a niche that served as the domestic shrine. Beyond lay a larger central room with a raised platform for sitting during the day and for sleeping at night. The back rooms could be used for storage or for bedrooms and included a courtyard that also served as a kitchen. A staircase led to the roof or a second floor and there were often small cellars dug below the floors for storing pottery or valuables. In some of the houses, in-fant burials were discovered below the floor of the main room.

In contrast to these compact, walled villages, when Akhenaten moved his capital in the mid 14th cen-tury BC to Akhetaten (modern Amarna), a large, sprawling mudbrick town quickly grew up along the desert fringes. The main street running parallel with the river connected the central administrative area with its temples, record offices and reception buildings to the separate suburbs and residential palaces to the north and south. Again, social differences in the size and situation of houses were marked. The wealthier houses, set in their own walled gardens, were entered through a loggia into a central recep-

Two maid servants, one of them grinding grain and the other winnowing.
Tomb of Niankh-Khnum and Khnum-hotep. Saqqara. Old Kingdom.

tion hall off which opened smaller rooms and bedrooms. A staircase went up to a second floor and the roof. Some of the bedrooms were en suite with a simple bathroom lined with limestone with a drain in one corner. At the back, a courtyard contained the service and storage areas with the kitchen and ovens at the far end. Formal gardens with grape pergolas and rectangular pools often contained a separate domestic shrine. It is interesting that the size of the rooms of even these wealthier houses was small compared with modern living space.

Smaller houses, with less regular layouts, were often squeezed between the large villas, or filled whole quarters. Away from the city in the desert, a small walled village of row houses accommodated the workmen who were engaged in constructing the royal tombs.

Illustrations of houses, especially town houses, supplement the archaeological evidence. One particularly informative painting shows the three-storey town house of Djehuty-nefer and the activities going on in the different rooms. In the basement is a spinning and weaving workshop; on the ground floor, servants carry trays of food through a columned room to an inner room where the owner sits, attended by his wife. A staircase on one side leads to storage areas on the roof and to another columned room where the owner is again shown seated, with servants fanning him.

Another depiction of a wealthy official's house is that of Nebamun, the Chief of Police, who is shown seated outside his residence. The front door is framed by red jambs and a red lintel. The house is painted in pastel colors and has a high window or balcony, and date palms can be seen growing from a central garden court. Some town houses, like this one, are shown with triangular structures sticking out of the roof of the house. These are wind towers, a feature of Egyptians houses until this century, by which the cooling north wind was brought down into the house.

Painted wooden box. Egyptian Museum,
Cairo. New Kingdom.

All these houses, large and small, would have been rather dark, lit only by small, high windows. Window glass was unknown and shutters or screens must have been used to keep out some of the wind-borne dust and sand. Lamps were used in the evenings, usually simple pottery bowls filled with oil, sometimes with a pinched side in which a cloth wick was placed. More elaborate lamps were placed on tall stands, or made from translucent stone and carved into fantastic shapes, like the alabaster lamps from the tomb of Tutankhamun.

FURNITURE

These substantial houses of the officials and administrators of the New Kingdom were well furnished with a variety of chairs, stools and beds, often with elaborately carved animal-shaped legs. Examples of these have survived in the tombs and testify to the skill of the wood workers. Good wood has always been scarce in Egypt and the best timber was imported from Lebanon or from further south in Africa. Well-made furniture was therefore an expensive item which only the elite could afford; most houses would probably have contained little more than a few stools and mats.

Stools were the most common piece of furniture in use and vary from the simple three-legged variety, suitable for an uneven mud floor, to the elaborate carved folding stools of Tutankhamun. In the New Kingdom, the most popular type of stool had a corded seat which curved up at the corners; around the sides a lattice of braces connected the legs and strengthened the frame. Chairs were for the elite and denoted status. The types depicted in the Old and Middle Kingdoms were versions of a stool with a

Garden with a rectangular pool filled with lotus flowers,
ducks, and fish. Western Thebes. New Kingdom.

straight back and were probably rather hard as they are shown with cushions over the back and seat. Later examples have a more comfortable angled back made of batons, eliminating the need for cushions. Tables were generally small and we have no evidence that the ancient Egyptians actually sat round them to eat; they were rather used just to hold food.

Beds evolved from mats spread over poles or a wooden frame into elaborate frames with legs across which reed or palm fiber string was woven to form the webbing. Unlike our beds, the board was at the foot and the frame often sloped down slightly from the head. Instead of a pillow, a headrest carved of wood, or occasionally of stone or ivory was used. Beds were definitely a luxury item; most people would sleep on a mat on the floor or on a bench.

Boxes, sometimes inlaid with different colored woods, held precious things, jewelry, and cosmetic items such as razors, tweezers, combs, and a variety of ointments. Larger chests would have held the family supply of linen and clothes. Free-standing cupboards were unknown, but niches in the mudbrick walls would have served the same purpose. Houses, even wealthy ones, would probably seem sparsely furnished to modern eyes.

GARDENS

Town houses were no doubt as cramped as they are today, but even so, the larger ones might have had an open courtyard in the center with flowers, a few trees, like Nebamun's date palms, and perhaps a decorative pool. The country villas at Amarna had large ornamental gardens with a variety of flowering and fruit trees, such as the persea, jujube, plum, dom palm, fig, willow, and pomegranate. Other popular trees included the sycamore fig, sacred to the goddess Hathor, and the ubiquitous date palm. Vine arbours furnished grapes for wine as well as providing shade. In the center of the garden a rectangular pool was filled with lotus flowers, ducks, and fish. Gardeners are shown bringing water in jars from the river or raising it from a canal with a shadouf; excavated gardens show that the ground was divided into small square plots by irrigation channels.

Flowers were much appreciated and cultivated. In his Instructions, Any wrote:

'Fill your hand with all the flowers

That your eye can see;

One has need of all of them,

It is good fortune not to lose them.'

The gardens of the wealthy would have provided some exotic fruits and wine, but the vegetable plots where much of the food was cultivated are rarely depicted. We know from representations of food, particularly the offerings presented to the dead, that the Egyptians ate a wide variety of vegetables, including lettuce, onions, garlic, artichokes, leeks, cucumbers, and courgettes. Several types of beans and lentils are named in the texts and, for the poor, would have been staple fare, along with onions and bread and the occasional fish from the river. Food storage was a problem. Fish could be salted and dried to preserve it, as was meat and fowl, and then pack into large pottery vessels which were sealed with mud. Beans, lentils, even cheeses were stored in this way to keep out rodents and ants.

The basic food for everyone was bread and beer. Both were made from wheat or barley, the main crops of ancient Egypt. These were planted when the flood receded, leaving the wet, fertile fields ready for sowing. The harvest was ready in April and, after being threshed and winnowed, the grain was stored in circular, domed granaries in temple and palace storehouses. From there it was distributed to official depots, which often lay within the house of an administrator who rationed it out as part of the monthly salaries of government workers. In the absence of minted money, sacks of grain were often used as payment for other goods.

Baking

The preparation of bread, and often of beer as well, was a woman's task, and unless it could be delegated to a servant girl, would have taken much of the housewife's time and energy. The grain grown then did not lose its husk as easily as modern varieties. It had to be pounded in a stone mortar to dehusk it before it could be ground up into flour on a flat, hard stone using a cylindrical stone roller. Sieving would take out the larger bits, but the flour was usually rather coarse. To make the leavening agent needed for bread, a sour-dough mixture could be prepared by leaving a mix of flour and water overnight to attract wild yeasts. Or the bakers could use the yeasty froth, called balm, which collects on fermenting beer. This would be added to the right amount of flour and water and left again for the yeasts to work.

The bakers then moulded the dough into the desired shape ready for baking. Domestic ovens, found in the courtyards of even quite small houses, were circular domed constructions of mud. Flat, round loaves were placed on the oven shelf to bake, or even slapped against its hot walls. This type of bread was very similar to the aish baladi produced today.

Brewing

Beer was also produced at home from crushed grain or partly baked loaves, which were crumbled, mixed with water and perhaps some crushed, malted grain and allowed to ferment. The result was a thick soup-like liquid that was passed through a sieve into a large bowl and then stored in smaller jars to mature. It could then be seasoned with spices, safflower or dates. The alcoholic content was probably quite high in comparison to modern beer, certainly enough to cause inebriation when drunk in large quantities. It was the most common drink, and the standard offering formula at the tomb was 'a thousand loaves of bread, a thousand jugs of beer.' In one of the popular tales, a powerful magician, Djedi, is described as 'a man of a hundred and ten years who eats five hundred loaves of bread, half an ox for meat, and drinks one hundred jugs of beer to this very day.' In the first century BC, Diodorus Siculus described Egyptian beer as almost as good as wine.

Food Preparation

Information about how food was cooked comes from actual examples from tombs or from depictions; no recipes have survived. Tomb paintings and models show meat and fowl roasted on spits or grilled over an open fire. Cooking pots were placed on a hearth to make stews and broth from meat, or porridge from wheat or barley. We have little idea about how food was combined, but the wide range of herbs and spices available, similar to those used in Egypt today, would have made the flavors interesting and varied. An unusually large funerary meal in a 2nd Dynasty tomb at Saqqara provided the deceased woman with a variety of dishes: porridge of ground barley, barley and wheat breads, fish, pigeon stew, roast quail, two cooked kidneys, beef ribs, cheese, honey cakes, stewed fruit, and jars of either beer or wine.

Meat in the form of beef was probably eaten regularly by the wealthy, but it would have featured little in the poor man's diet. Although goats, sheep, and pigs appear much less frequently than cattle in the tomb paintings, excavation of rubbish pits outside settlements has shown that their meat was regularly eaten by the ordinary people. In fact, on the rubbish heaps outside the workmen's village at Amarna, a series of small pens and huts were identified as pigsties. The inhabitants were clearly augmenting their income by rearing pigs on the rubbish dumps outside the village.

Pigeon, ducks, and geese were also valued for meat as well as for their eggs, and the domestic chicken probably made its appearance in the New Kingdom. Wild birds, especially migratory ducks, geese, and quails, were trapped in elaborate bird nets in the marshes along the desert fringes. Like fish, these were often preserved by drying them in the sun.

Several different types of oils are mentioned in the texts though it is not always easy to identify them. The most common cooking oils were extracted from seeds of sesame, radish, the fruit of Egyptian balsam and the 'sweet' oil of the moringa tree pods. Linseed oil and castor oil were also used and olive oil was imported from Syria and Mycenaean Greece.

The most important sweetening agent, at a time when sugar was unknown, was honey, a luxury item stored in jars sealed with wax. Cheaper substitutes would have been dates or date juice or other fruit juices and purees, such as pomegranates or figs. Carob was also known and has been found at Kahun and Deir al-Madina.

Most cooking was done outside or in a courtyard on a simple open hearth or in domed ovens. Pans were made of coarse pottery and, judging from the number of sherds found on ancient sites, had a short life-span. Utensils were simple; wooden spoons and spatulas, and knives of bronze or flint.

To serve the meal, the food was placed on fine pottery dishes, or for royalty, gold and silver dishes, and brought to the table. For the less wealthy, a basket or a mat on the ground would suffice instead of a table. Some of the decorated blocks from Amarna show porters and workmen eating vegetables and bread from baskets. Representations of food being eaten are not common, but it seems that individual dishes were not used, everyone helping themselves from the serving bowl. No eating utensils are depicted and the food was all eaten with the fingers.

Scene showing a gardener irrigating a garden with a
shaduf. Tomb of Ipuy at Deir al-Madina. New Kingdom.

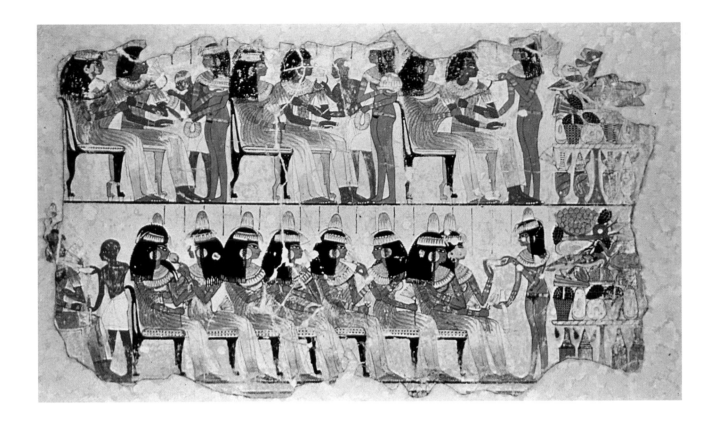

As well as baking the bread and preparing the main meal, which was probably eaten in the evening, housewives would have sent out food to husbands and sons working away from home. At the workmen's village of Deir al-Madina, the men worked a shift of eight days in the Valley of the Kings and would send home if they needed extra rations. For example: 'Nebneteru to his mother Henut-nefret: Have brought to me some bread, also whatever [else] you have by you, urgently, urgently!…' This would have been packed into a basket, perhaps covered by a cloth, as the villagers do today, and been dispatched to the Valley.

Although looking after her children and preparing food would have occupied much of the housewife's day, she would have to include in her schedule chores like fetching water from the river or the nearest well and washing the family clothes and dishes. The women of the workmen's community at Deir al-Madina were more fortunate than most as the government provided water carriers and washermen as well as slave-women to grind the grain. Many women also found the time to spin and weave, providing their family with clothes and using any surplus to exchange for other goods.

RECREATION

The tedium of housework would not affect the wealthy classes who employed servants and slaves to do the manual work. These women must have had plenty of leisure time but how they filled it can only be guessed as the tomb paintings, concerned mainly with the male side of life, are not very informative here. A few scenes show husband and wife together, sitting with their children and their pet cat

Guests at a banquet. Tomb of Nebamun, Western Thebes.
British Museum, London. New Kingdom.

1 2 3

or monkey. Another scene where the wife usually appears with her husband is that of hunting and fishing in the papyrus marshes. While the man spears fish or stuns waterbirds with a throwstick, his wife and often his daughter sit near him in their small papyrus boat. This has all the outward signs of a pleasure trip but it has recently been interpreted as a coded reference to fertility, both in this life and the Afterlife.

Board games were popular among the elite, particularly the game of *senet* which was played with two people. The name derives from the word meaning 'to pass by,' and the object was to move one's own pieces around the board and block the other player so that he or she could be overtaken. The number of squares differed at different periods but the most common was a board of three rows of ten squares. Instead of dice, knucklebones or sticks were used to determine how many squares each piece travelled. The *senet* board was sometimes made as a long box in which a drawer held all the pieces. Sometimes, on the reverse side was another game of 'twenty squares,' probably played like the modern pachisi.

By the New Kingdom, this game had an allegorical meaning and a symbol of the struggle to attain immortality. The board was decorated with symbols of the gods and religious texts and the last five squares, called 'houses,' were particularly important. The fifth one from the end was inscribed 'good' but the fourth square was the 'house of water' in which one could drown. The third square carried the images of three gods of the necropolis and on the later boards, the last two squares carried images of the sun god in his aspects as Atum, the setting sun, and Re-Horakhti, the renewed sun rising in the east. It was frequently depicted in the tombs, the deceased playing against fate; by winning, the tomb owner could claim immortality.

1. Wooden chair of Queen Hetepheres. Egyptian Museum, Cairo. Old Kingdom. 2. Folding stool with crossed legs. Berlin Museum. New Kingdom. 3. Wooden stool with four legs. British Museum, London. New Kingdom

CELEBRATIONS

The ancient Egyptians believed in enjoying life. As the scribe, Ptahhotep, recommended to his son:

'Don't waste time on daily cares
Beyond providing for your household;
When wealth comes, follow your heart,
Wealth does no good if one is glum!'

Religious festivals were one excuse for a celebration. From the records of the Deir al-Madina community, we know that the whole village would turn out, especially on the feast day of their patron, the deified King Amenhotep I: '...the gang made merry before him for four full days, drinking with their wives and children—60 people from inside [the village] and 60 people from outside.' The amount of beer consumed on such occasions must have been enormous, but perhaps not so large as that imbibed on the feasts of the goddess Hathor, patron of love, pleasure, and inebriation. Drunkenness was tolerated as a state of ecstasy, making communication with the spirit world possible. But some writers of the moral precepts so popular at this time condemned it:

'Don't indulge in drinking beer,
Lest you utter evil speech
And don't know what you're saying.
If you fall and hurt your body,
None holds out a hand to you;

Wooden box for the game of senet decorated with faience
and paint. Museum of Fine Arts, Boston. New Kingdom.

Your companions in the drinking
Stand up saying: "Out with the drunk!"'

Other occasions for celebration would be the New Year Feast and the Harvest Festival. During the Beautiful Feast of the Valley, the dead were honored and families visited relatives' tombs and shared a meal with them. Numerous representations in the New Kingdom tombs showing rows of elaborately dressed guests may depict one of these celebrations, or they may show the funerary banquet served to relatives and guests after the funeral. In some of these scenes, the guests are segregated into men and women, in others they are sitting in couples. Men and women wear their best garments and jewelry, the ladies clad in the semi-transparent dresses so popular in the New Kingdom.

Young maid servants, often wearing little but a girdle and a collar of lotus flowers, attend them, offering water and a towel to wash their hands, or placing collars of sweet-smelling lotus petals around their necks. The guests are anointed with conical cones of perfumed wax or fat which gradually melted during the festivities, giving out its scent. Sweet-smelling lotus flowers or mandrake fruits were often held to the nose and offered to neighbors. The lotus was a symbol of rebirth, and the mandrake fruit has hallucinatory properties, and was considered an aphrodisiac. In other scenes, wine or beer is offered, and guests sometimes took too much, as witnessed by the scene of one young lady being sick! Another scene records a lady requesting yet another drink: 'Give me a beaker of wine, my throat is dry!' But her companion replies: 'You have already had nineteen beakers of wine, so pass the beaker to me!'

It is interesting that there is no sign of food actually being consumed, although beside the rows of guests tables are loaded with every imaginable delicacy; joints of meat, roast ducks, bread, and bowls of fruit. Nearby, the elaborate blue-painted amphorae that hold the wine are decorated with garlands of flowers. Presumably the servants offered round the dishes of food to the guests who ate with their fingers. Indeed, an ostracon from Amarna shows a little princess, seated on a cushion, nibbling a whole roast quail or pigeon which she holds in her hand. In front of her is a table piled with food.

Music and Dancing

The guests were entertained by dancers and acrobats accompanied by singers and musicians. We have no idea of the music of ancient Egypt as there was no musical notation. In the early periods, musical troupes play flutes and large harps to accompany singers and dancers. In the tomb of Ti, clapping girls keep the rhythm while two rows of dancers perform in unison. Sometimes the wife of the deceased entertains her husband by playing the harp, in one example, seated on the bed.

By the New Kingdom, a wide variety of instruments were in fashion, many of them originally from Syria. Troupes of musicians, usually female, but sometimes male, performed together at the banquets, playing different instruments. Depictions show several types of harp, a seven-stringed lyre, a long-necked lute, and the double pipes. The hand gestures made by the leader communicated changes in melody, tone or rhythm to the other performers. Tambourines, drums, and clappers beat out the rhythm to accompany the dancers.

These musicians seem to have been professionals belonging to musical troupes attached to palaces and harems. A scene from the tomb of Ay at Amarna shows a separate building beside the palace where musicians and singers, all female, are practising in columned halls. Behind are the rooms where their instruments are stored, harps, lyres, and lutes of different sizes. In the nearby palace, arrangements for a feast are being finished. The courtyards are being swept and watered down and in two pillared halls, the beer and wine jars are being arranged on stands and the food is being piled onto tables. Despite the quantities, only two chairs are depicted in each room; was all this food and drink just for the king and

queen and their daughters? Another depiction of the same musicians' house shows the door-keepers and some of the women eating from baskets or deep dishes; perhaps the entertainment had finished and it was their turn to relax.

This particular scene shows only musicians but other banqueting scenes of the New Kingdom include dancers as well. These are usually female; if there are male dancers as well, they do not dance together. Some of the women wear only a short kilt, suitable for performing acrobatic turns and back bends. Others wear practically nothing at all except a girdle; their movements seem to be sinuous and graceful, perhaps even a little provocative?

Some of the songs were written down and have survived. The early ones often have a religious content and are more like hymns. In the Middle Kingdom, guests were encouraged to enjoy life while it lasts:

'Dress in fine linen,

Anoint yourself with oils fit for a god.

Heap up your joys,

Let your heart not sink!...

Make holiday,

Do not weary of it!

Lo, none is allowed to take his goods with him,

Lo, none who departs comes back again!'

By the New Kingdom more secular themes were popular, like the love poems. These dwell on the beauties of the loved one, the pains of separation, and assignations between lovers, songs which, if they were sung by the scantily clad singers and dancers depicted, must add another dimension to these banqueting scenes!

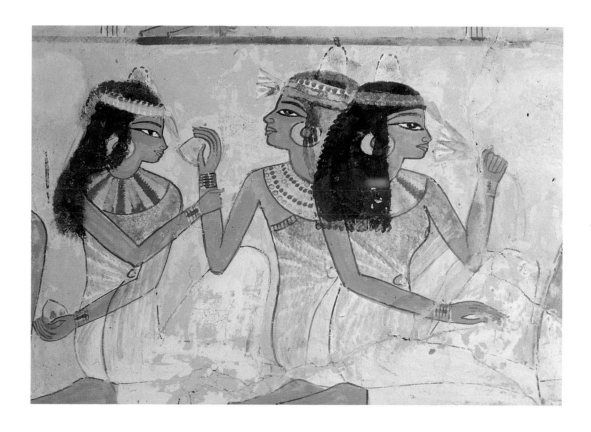

Ladies smelling lotus flowers and mandrake fruits at a
banquet. Tomb of Nakht, Western Thebes. New Kingdom.

111

VII
DRESS AND ADORNMENT

The remark of Herodotus that the Egyptians 'wear linen clothes, always freshly washed' was as true in the predynastic period as it was in the 5th century BC when the Greek historian visited Egypt. The ancient Egyptians prided themselves on their pristine white garments and the high quality of their linen cloth.

Plain white linen was always the preferred material for clothing and was well suited to hot weather as linen absorbs moisture well (hence the modern use of linen tea-towels!). Wool was never depicted or placed in tombs as it was considered impure, although there is evidence that it was actually worn. Occasionally, the plain white of the usual linen dress was depicted with bands of color, usually red and blue, round the top and bottom. These may represent colored woven borders or embroidery.

COSTUME IN THE OLD AND MIDDLE KINGDOMS

The classic dress for women from the Old Kingdom to the early New Kingdom was a sheath of white linen. This is shown in statuary and reliefs as an improbably tight but elegant tube that revealed the body beneath as well as allowing it movement. Reaching to below the bust, it was held in place by two straps that passed over the breasts. By the Middle Kingdom, a single strap was more popular, passing from one side across one of the shoulders to the opposite side at the back and leaving both breasts bare. Such a garment was an artistic convention to enable all the contours of the body below to be shown. Linen has little elasticity and does not cling like silk. The actual garment worn must have been much

Beaded net dress from Giza.
Museum of Fine Arts, Boston. Old Kingdom.

A beautiful woman wearing a heavy elaborate wig.
Tomb of Nakht, Western Thebes. New Kingdom.

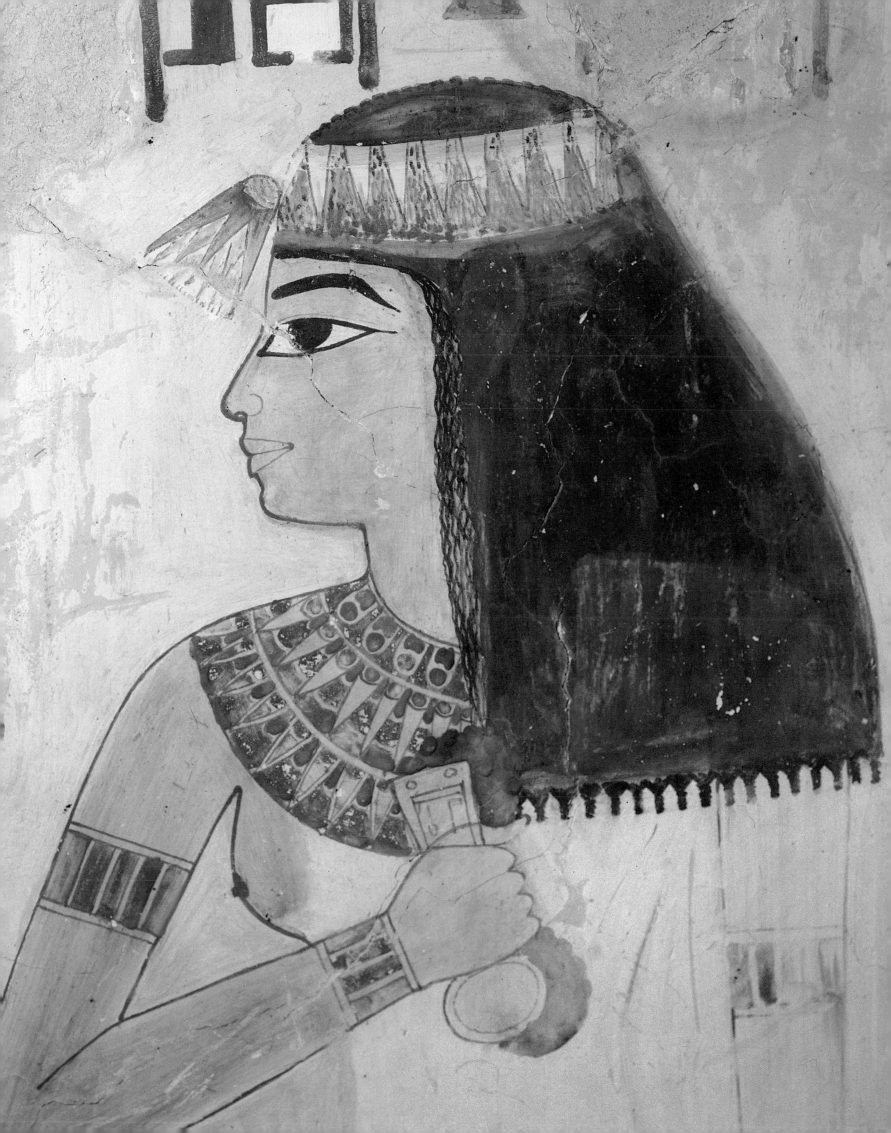

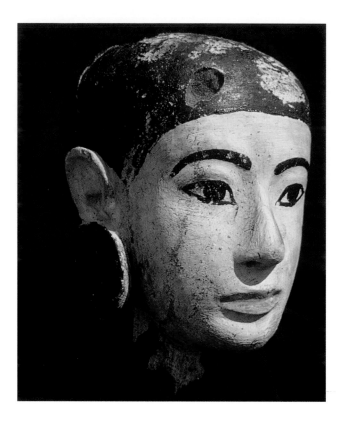

fuller than these representations suggest as women are shown in them kneeling with one knee raised, dancing or performing other activities.

Shawls and wraps were undoubtedly used, especially in the winter, but they are not often depicted. An exception is the 4th Dynasty statue of Nefret whose figure is wrapped in a shawl which perhaps harks back to an earlier period. The Middle Kingdom relief of Kawit shows a light scarf draped over her shoulders.

A leopard-skin dress was sometimes worn by high ranking ladies in the Old Kingdom but this had a ritual significance. Princess Nefret-Iabtet is depicted in one on her stela from Giza. This garment covered one shoulder and arm, leaving the other shoulder bare. The lower part is depicted in the conventional tube shape.

For special occasions, an open-work bead dress could be worn on top, adding color and decoration. Such dresses were often depicted, especially on goddesses, and an actual example was found in a Dynasty 5 tomb at Giza. A story from the Middle Kingdom mentions these bead dresses in a tale of good King Sneferu and the magician, Djadja-em-ankh. Looking for a diversion one hot afternoon, the king was advised to proceed to the lake of the palace where he commanded: 'Let there be brought to me twenty women with the shapeliest bodies, breasts and braids, who have not yet given birth. Also let there be brought to me twenty nets and give those nets to these women in place of their clothes!' His majesty then amused himself while the young women rowed him up and down the lake.

Although no representation exists of a bead dress worn without an under garment, the ancient Egyptians were not disturbed by nakedness in either sex. Men, especially workers, are often depicted naked in the Old Kingdom. Women are shown bare-breasted and servant girls frequently wear nothing

Head of a young woman used as support for a wig.
Wood and stucco. Saqqara. New Kingdom.

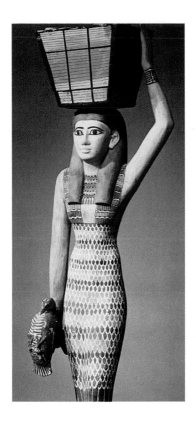

but a girdle of beads in the New Kingdom. But in this story, the bead dresses clearly enhanced the naked beauty of the young women and have decidedly erotic implications.

Colored dresses are not frequent in artistic representations before the Middle Kingdom when blue and green dresses are shown as well as the traditional white. Some of them appear to have beadwork along the borders and up the straps, similar to modern Nubian beading. These beads must have been made of blue-glazed faience or of some natural material such as bone.

Brightly colored wooden statues of servants and offering bearers frequently wear patterned and multi-colored dresses, always of the same figure-hugging shape. Some of the designs, such as lozenges, meanders, and other geometric shapes may indicate imported cloth. A rare depiction in the tomb of Khnum-hotep at Beni Hassan shows visiting Asiatics in brightly colored garments. It is interesting that the clothes worn by the visitors are shown much fuller than their Egyptian counterparts, presumably because, as foreigners, they were outside the traditional form of representation.

THE DRESS OF NON-ROYALTY

A sculpture of Lady Neferefmenkhes shows her wearing a tied dress which covers both breasts, with wide straps in the shape of the letter V. All outer lines of the garment are a reddish-brown color, and the straps are decorated in reddish-brown, white, and blue, the Egyptian blue color highlighting the *wesekh* collar that decorates the woman's neck. This dress seems to be the style of clothing worn by the common people and the style a woman would choose to wear in the Afterlife.

An offering bearer wearing a multi-coloured dress. Tomb of Meketre.
Metropolitan Museum of Art, New York. Middle Kingdom.

The artist portrays the lady wearing a net overdress, which was made from long beads tied in a cross pattern. This type of dress was, however, very rare.

NEW KINGDOM COSTUME

The luxury and opulence of the New Kingdom were reflected not only in the lavish funerary equipment of this time, but also in new fashions of clothing and adornment. For a while, the classic sheath dress was superseded by a longer, fuller tunic, with a keyhole opening at the neck and sometimes with wide short sleeves. Actual examples of this 'bag tunic,' as it is unfortunately called today, have survived. It was made from a single length of cloth, folded in half and sewn up at the sides with holes left for the arms and a key-hole-shaped opening for the head. Sleeves were often added. This garment was worn by both sexes. Men wore a shorter version reaching to the knee or mid-calf. It was worn either belted over a short kilt, or as a shirt beneath a full long kilt which was pleated with care, and elaborately folded at the front.

Women wore this tunic on its own, reaching down below the ankles. It was embellished with borders and rosettes which were probably embroidered. Over this, a sheer overgarment was often worn. This was a large rectangle of transparent linen, usually fringed down the side, which was cleverly draped round the body, over the shoulders and upper arms, and knotted in front. Sometimes it went over only one shoulder and arm, leaving the other arm and breast bare. A broad colored sash or belt held it in place. Both this garment and the tunic below fell to the feet, covering the ankles and creating the impression of luxuriously flowing robes. Occasionally, the old-fashioned one-strap sheath was worn below this flowing overgarment.

Goddesses are never shown in these new-fangled fashions. Instead, they are consistently portrayed wearing the classic tight sheath dress with two shoulder straps, now frequently colored red or blue with designs that may represent beadwork or embroidery.

Samples of more elaborate garments were found in the tomb of Tutankhamun. A variety of overgarments were decorated with gold sequins and colored beadwork in elaborate designs. A superb tunic was decorated with panels and borders of woven and embroidered motifs whose colors have now faded from the original brilliant blues, greens, reds, and yellows. These costumes were probably only worn on special ritual occasions. They may even have been normally handed down to the next officiant, as are the exquisitely embroidered robes used today in the Christian churches. This would explain why more specimens have not been found in tombs.

THE LATER PERIODS

In the following periods, priestesses are often shown wearing elaborately embroidered garments. A bronze statuette of the 'god's wife of Amun,' Karomama, used a damascening of gold, silver, and electrum to represent a richly embroidered pattern of feathered wings. Other seated and standing statues of this time have elaborate designs of gods and symbols on their costumes, depicting richly embroidered costumes. The dress worn by these women are similar to the 'bag tunic' of the New Kingdom. Some had wide short sleeves and a tight skirt reaching above the ankles. The sheer, flowing overgarment disappeared at the end of the Rameside Period.

The bag tunic seems to have remained the standard costume for women, although some of the Late Period reliefs depict women wearing the Old Kingdom type sheath with two shoulder straps. Whether this was an actual fashion or simply an archaising artistic motif is impossible to say.

Hairstyles and Wigs

From the beginning of the dynastic period, depictions of royalty and courtiers show that ceremonial wigs were already in use. Living hair was close-cropped for both men and women of the elite classes, perhaps for reasons of coolness in the summer, or for personal hygiene. Priests were obliged to shave off all their body hair for the period when they were on duty in the temples and in the later periods, kept their heads shaven all the time. Herodotus is again worth quoting: 'the priests shave their whole bodies every other day, so that when they conduct rituals they will be free of lice and other uncleanliness.' Lice and their eggs have been found on many mummies, and fine-toothed combs were used to rid the hair of parasites. No doubt, the use of wigs on close-cropped or shaven heads helped to reduce their activities. Fleas, however, flourished in both living hair and in wigs.

More information on hair care was found in Eberes' papyrus, which explains one of the oldest prescriptions for strengthening the roots of the hair. During the reign of King Teti of Dynasty 6, Khui, the chief physician, prescribed drugs for the hair of Shesy, the king's mother.

In the later periods, one obvious advantage of a wig was that the hair on it could be styled more easily into the incredibly elaborate fashions of the time and would stay that way for some time. Traces of bees' wax have been found on some of the surviving wigs. It was undoubtedly used to aid the crimping and braiding necessary to produce these fashions and to make them last longer. A scissors-like implement with one pointed blade was another aid for curling and tucking in the ends of the tresses.

Wigs were usually made of human hair, black or very dark brown, and were occasionally thickened out with plant fibers. Tufts of hair were strung on threads or fibers and knotted into a net that formed the foundation of the wig. A unique model head was found in the Theban necropolis with black lines showing the basic form and attachments for a wig.

Like the dresses, hairstyles changed through the ages. In the Old Kingdom, women are sometimes shown with short-cropped hair which is probably their own. But more commonly, they wear a thick, ear-length wig held in place with a ribbon or circlet that came across the brow. Sometimes, a thin line of their own hair appears below the wig. A more formal hairstyle was a longer wig coming low over the brow and tucked behind the ears. Two thick tresses fell in front of the shoulders. In the early periods, the hair is usually depicted straight. Although its length could vary, this so-called tripartite wig remained the classic style for most of Egypt's history.

In the Middle Kingdom, a style with two bouffant tresses, each ending in a big curl in front of the shoulders was popular—the so-called 'Hathor' hairstyle. The tripartite hairstyle remained the normal one, but it is not always clear whether a wig was being represented or living hair. A relief of Queen Nefret, wife of Senwosret II of Dynasty 12, shows an attendant twisting or braiding a lock of her long hair; if this had been a wig, it would surely have been styled off the head.

As in earlier times, the living hair is usually shown very short and curly as in the depiction of Queen Kawit on her sarcophagus. She is shown seated, dipping her hand into a jar of scented unguent whose perfume is being wafted towards her by an attendant waving a bird's wing fan. Another famous scene from the same sarcophagus shows the queen looking into a mirror while her attendant is adding extra braided locks to her own short hair. Two of the additional locks can be seen impaled on a hairpin. The result was a hairstyle in the manner of modern African fashions. The addition of extra hair is also known from mummies where the thinning locks of older women were sometimes thickened out.

In the New Kingdom, simple, close-cropped hair is sometimes seen, as on the Amarna princesses where a single thick lock on the right side of the head was allowed to grow. This was the 'sidelock of youth' which was shaved off at puberty. A hairstyle popular with adolescent girls was a high pony tail with a number of braids falling in front of the ears. The many variations of this style make one suspect that it was the living hair, not a wig.

117

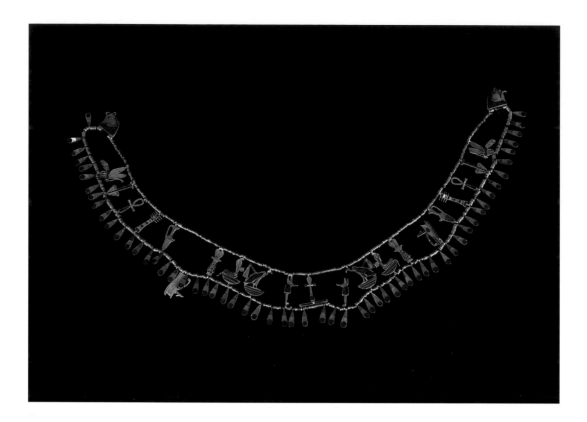

Matrons appear in the classic tripartite wig, or in a new variant; a much thicker, more bouffant style that completely covered the shoulders and concealed the ears. Both types are shown crimped or braided, each thin plait tightly bound at the ends to prevent it coming undone. In the tomb of Queen Nefertari, the binding at the end is colored gold and was perhaps done with gold thread.

These heavy wigs must have been hot and rather uncomfortable. They were worn on ceremonial and festive occasions such as the banqueting scenes shown in the tomb chapels. Hair and wigs had an erotic connotation, but along opposite lines to the modern Western expression of 'letting one's hair down.' Donning a wig, or braiding the hair is mentioned in stories and love poems as a preliminary to love-making!

On top of these heavy hairstyles, court women often wore elaborate hair ornaments and crowns. Tubular gold hair rings have been found which were threaded onto tresses. A very elaborate headdress belonging to a queen of Thutmose III has a heavy centerpiece from which were suspended strings of gold beads and inlaid rosettes. Queens often wore a close-fitting vulture crown whose wings came down around the ears. On top of this was sometimes a circular gold disc on which were fitted two tall plumes. The tall blue crown of Nefertiti seems to be unique; no other queen is shown wearing it.

For lesser mortals, the favorite hair ornament was a fillet of lotus petals or simply a lotus flower alone. The daughters of a provincial Middle Kingdom nobleman are shown with elaborate fillets round their hair into which lotus flowers and buds have been pinned. For the wealthy, diadems in gold or silver imitated the ribbons and floral wreaths that served both to decorate the hair and hold it away from the face. The sort of headdress depicted on the statue of Nefret, with rosettes and stylized papyrus formed of carnelian and turquoise cloisons, was popular at all times. An actual example found at

The necklace of Princess Khnumit.
Egyptian Museum, Cairo. Middle Kingdom.

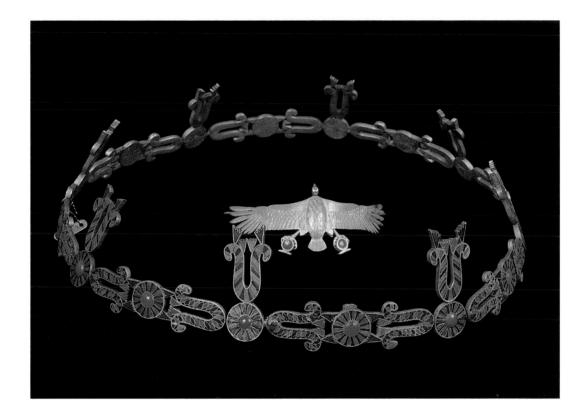

Dahshur also includes a small inlaid figure of the vulture goddess Nekhbet, stretching her wings in an arc between one rosette and another. Another charming diadem of unusual design imitates a garland of flowers with intertwined gold threads strung with tiny inlaid rosettes of blue and red. Flower designs for headbands remained popular in the later periods as demonstrated by a Rameside circlet of open flower blossoms of gold.

During the New Kingdom, scented cones of unguent were placed on the head during festivals. These would gradually melt, coating the hair and the upper body with a perfumed oil. Such a custom is still known among the Sudanese. In the dry atmosphere of the Nile valley, oils and creams helped to keep the skin and hair from drying out too much. Herbal compounds were used for greying or thinning hair.

JEWELRY

The brightly colored jewelry worn by both men and women of this period was set off best by the pristine white linen of the classic garment. Only semi-precious stones were used. Carnelian, amethyst, quartz, and jasper came from the deserts in Egypt; turquoise was mined in Sinai and lapis lazuli was traded from Afghanistan. Gold was first discovered in the predynastic period in the valleys of the Eastern Desert. When these sources had eventually been exhausted, great quantities of gold were mined in Nubia and sent to Egypt to fill the royal treasuries. The wealth of Egypt became legendary; to the Asiatic princelings writing to Pharaoh: 'gold is as dust beneath your feet.'

'White gold' was a natural compound of silver containing up to 40% gold that occurs in Egypt and

The crown of Princess Khnumit.
Egyptian Museum, Cairo. Middle Kingdom.

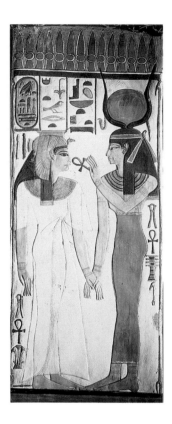

was highly prized. Pure silver was imported and at times was considered more valuable than gold. Unlike gold, pure silver will tarnish, and was associated with the moon. Gold was the immutable color of the gods and in the early period was very closely associated with kingship and the divine world. It was the color of the sun-god Re, and its extraction was under the protection of the goddess Hathor, daughter of Re.

Gold could be worked cold and hammered into shape. As pure gold is very soft, various alloys were used to render it stronger. Chased and repoussé designs were made by mounting sheets of thin gold over a bed of yielding wax and pressing the design into the back or the front with a bone tool. Solders were made of a mixture of copper and gold which has a lower melting point than pure gold. It was used to join pieces together such as the little strips of metal attached to a base plate that formed the cells used in cloisonné work. Silver could also be cold-worked. By the New Kingdom, the niello technique of blackening silver with sulphur as a background for an etched design was known.

Beads were shaped, polished and pierced with a bow-drill. The beads themselves were threaded on strings, or the shaped stones could be inlaid into little gold cells or cloisons, forming patterns or hieroglyphic designs. From the earliest periods, there are depictions of bracelets, anklets, pectorals, and multi-stranded 'broad collars' using these semi-precious stones. The blue of turquoise and the red of carnelian were particularly favored colors.

In the Old Kingdom, the wearing of jewelry seems to be rather discreet. Bracelets are occasionally shown as is a choker necklace. The usual ornament is the 'broad collar.' This multi-stranded necklace, known as the *wesekh*, was symbolic and protective. The several strands of beads could be all of one color, or multi-colored. The most common were tube-shaped, but flower, leaf, and fruit-shaped beads were

Different types of dresses in the New Kingdom: The goddess Isis holding an ankh to Nefertari's mouth, giving her the breath of life. The goddess wears a traditional dress while the queen wears a modern dress of her time. Tomb of Nefertari, Valley of the Queens, Western Thebes.

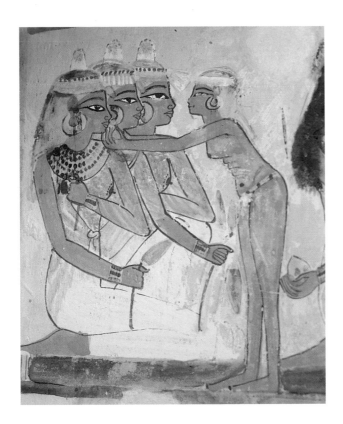

also threaded into rows, separated by tiny spacer beads. The strands were held in place with triangular end-pieces that could be shaped like lotus blossoms or a hawk's head. At the back hung a key-shaped counterpoise called the menit. The whole necklace was loaded with symbolism and was especially connected with the goddess Hathor. Priestesses and singers in her cult carried these necklaces as a badge of office that would be shaken and rattled during celebrations.

Much of our knowledge of jewelry comes from representations on statues and reliefs. The pieces that have survived are those few that escaped the very efficient tomb robbers. Luckily, several wonderful pieces were found in the burials of certain Middle Kingdom princesses. A variety of diadems, bracelets, anklets and girdles were found. A number of exquisite pectorals have complex and delicate designs in inlaid stones, such as the figure of the king smiting his enemies. Each stone was cut to the required shape and then fitted into a gold cell.

The cloisonné method remained popular throughout the New Kingdom. The jewelry of Queen Ahhotep shows continuity in design and technique, such as the armband with an inlaid figure of the vulture of Nekhbet. A bracelet of turquoise, lapis lazuli, carnelian, and gold beads, threaded into a design imitating basket-work, is closed with a gold clasp bearing the name of her husband, King Ahmose. Among her treasure was a necklace of gold flies, a reward for valor and persistence!

Gold became more common in this period as the gold bearing desert valleys of Nubia were exploited. The king's officials and friends were rewarded with the 'gold of honor,' a heavy collar of gold discs. As official rewards to the male bureaucracy, these necklaces are not associated with women.

During the New Kingdom, the use of faience and glass for beads became very widespread. Blue-glazed faience was known from the very early periods and was used to make beads and amulets. Its clear

Beautiful women wearing a scented cone of unguent on their wigs
at a banquet. Tomb of Nakht, Western Thebes. New Kingdom.

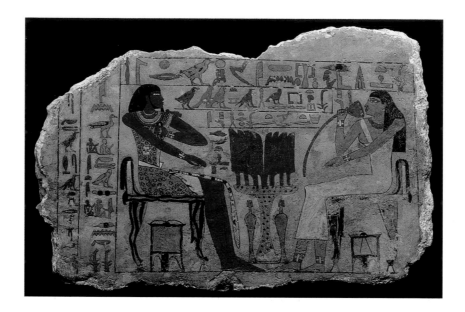

blue color associated it with turquoise. It was not until the New Kingdom that red, yellow, and green faience was used to imitate other semi-precious stones. Broad collars, amulets of every shape and size, necklaces of disc beads, and finger rings were then mass produced. Now even the less wealthy could afford some adornment. Tiny beads of many colors were used for ornamental beadwork, and disc beads imitated the form of the gold discs used in the 'gold of honor.'

Even more than faience, the clear translucent colors of glass were prized. The knowledge of how to make this was introduced from Asia early in the New Kingdom. Faience and glass were often used to make jewelry destined for the tomb; they were cheaper to produce, and through the belief in magic, were just as effective as the real stones.

Earrings first appeared at this time and were probably another Asiatic novelty. A variety of hoop and disc earrings were worn, usually of gold, sometimes beautifully inlaid with colored stones. Ear studs in gold or glass were also popular and ear plugs with a diameter of up to six centimeters have also been found. Although it is hard to believe that they were ever worn, mummies with correspondingly enormous holes in their earlobes confirm that they were. The statue of Queen Meryt-Amun wears huge gold discs of this type in her ears.

In the later periods, jewelry became heavier and more ostentatious. The burials of royalty of Dynasties 21 and 22 at Tanis produced necklaces of massive silver and gold ball beads, huge hoop earrings with pendants and large heavy pectorals inlaid with different colored stones in the traditional symbolic designs. More silver was used and niello work and fine inlaid designs in gold, silver and copper are evidence of the skilled craftsmanship of this period.

Amulets became more and more popular during these later periods. Made of gold or silver, semi-precious stones, glass or faience, they represented little figures of protective deities or their symbols. Isis and Hathor were particularly favored by women. Sometimes the amulet was the centerpiece of a bead necklace, sometimes it was hung on its own. A whole series of charms could be strung together. Late Period mummies often have many amulets tucked into different places in the mummy wrappings as protective charms.

The deceased and his wife sitting in front of an offering table. The wife wears a linen dress with one strap that leaves both breasts bare. Hildesheim Museum. Early Middle Kingdom.

Cosmetics

From the earliest times, men and women used eye paint. Green eye-paint was ground from Sinai malachite (hydrated copper carbonate). The black kohl was more common and derived from galena ore (lead sulphide) found in the Eastern Desert. It was ground up on palettes and stored as a powder or a paste mixed with gum arabic and oil. Lumps of both malachite and galena were found in Tutankhamun's tomb. As today, eye-paint was applied with a stick on the inside of both upper and lower eyelids and extended in a line towards the ear. It was associated with purity, and protected the eyes against infection and flies. Priests wore it and anointed the statues of the divinities with it during the morning ceremony. It was named as one of the items in the offering lists for the dead.

Kohl was stored in small narrow pots or tubes, made of stone, faience or glass. Often decorated with lotus blossoms, it was an essential item in any lady's toilet box, in which she would also store other objects: copper or bronze tweezers, blades for cutting the nails or hair, and an oval mirror made of a copper or bronze disc. Other cosmetics such as red ochre were also used to color the cheeks and lips. Henna was also employed, as it is today, to color the hands and hair.

Other important items were scented oils and unguents, essential to keep the skin from drying. Pliny the Elder, a Roman writer of the 1st century AD, said that Egyptian perfume was the best and most expensive. It was made by steeping flowers in oil until the scent was transferred. The technique of distilling essences was not yet known. These scented oils were treasured and stored in elaborate and beautiful pots and jars. They were so highly prized that they were among the first items taken by the robbers who entered Tutankhamun's tomb.

Personal cleanliness was emphasized, especially for the priesthood who had to bathe twice a day while on duty. Wealthy houses had plastered bathrooms and an attendant with a jar of water served as a shower. For the poorer people, the river and canals sufficed. Teeth were kept clean by chewing resin or frankincense.

Mirror of Sat-Hathor-yunet, its handle decorated with the face of
the goddess Hathor. Egyptian Museum, Cairo. Middle Kingdom.

VIII
WOMEN IN SOCIETY

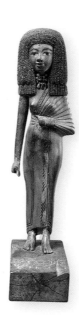

Despite the segregated nature of ancient Egyptian society, women seem to have enjoyed considerable legal rights. Before the law, they were regarded as the equals of men. They could own property and land, administer it themselves and dispose of it as they wished. This gave women the possibility of economic independence, if not real power, and was a key element in their social position. They could initiate a court case themselves, act as a witnesses, and be punished for a crime. In short, they were treated, at least in theory, as responsible and respected members of society.

Their Greek and Roman 'sisters,' by contrast, led a life much more restricted by custom and legal status. Considered legally incompetent, these women lived their lives in the shadows of their male 'protectors'—fathers, husbands or brothers—who kept and disposed of them and their property as they wished. Until the emancipation movement at the beginning of this century, the women of ancient Egypt had considerably more economic independence and legal rights than European women.

No codified law texts have survived from ancient Egypt. In tomb depictions of judgement scenes, a number of papyrus scrolls are usually shown next to the judge. These may have been codified texts which have not survived, or, more likely, legal cases which were used as precedents for a judgement. The basis of this 'common law' was accepted social and religious custom which was seen to originate ultimately in the king. He was the earthly source of *maat*, the divine order, and so he promulgated the laws and was the supreme judge. Serious cases which drew capital punishment had to be heard by him or his viziers. He also had the right to pardon.

Lesser offences were heard in local courts in the administrative centers presided over by the local chief or mayor. These were mostly civil cases involving property rights and disputes. Records of cases

Painted wooden statue of the housekeeper Tia. Metropolitan Museum of Art, New York. New Kingdom.

In his tomb at Saqqara, Mose celebrates his legal victory in a property dispute. Now in the Egyptian Museum, Cairo. New Kingdom.

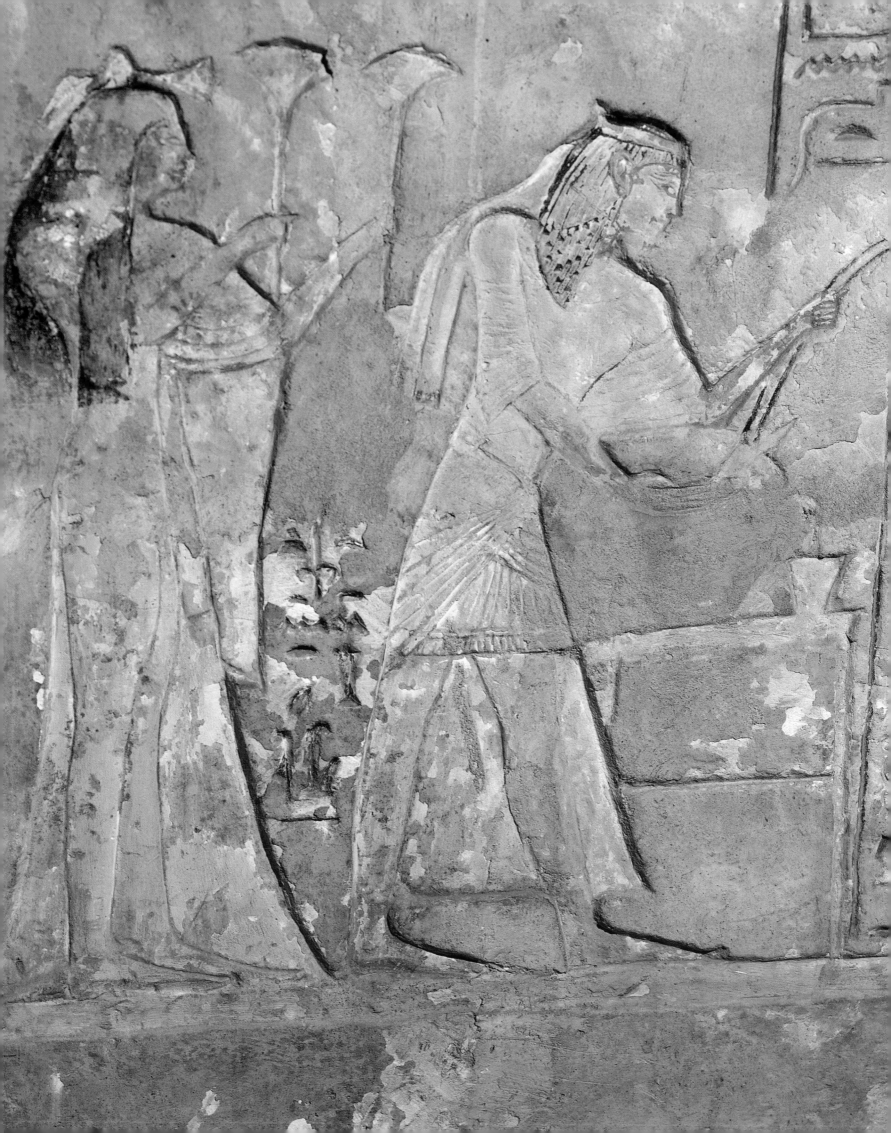

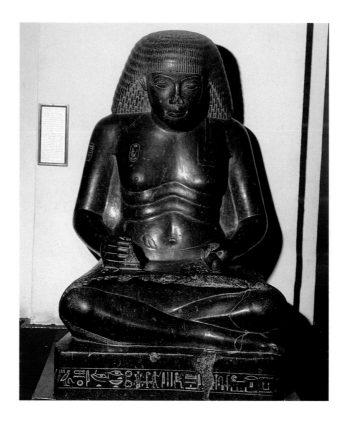

were filed in the archives and could be consulted and successfully challenged by women as well as by men. The bench of judges was composed of local dignitaries appointed by the vizier of the pharaoh. Village courts were made up of officials and trusted members of the community. Only one example is known where women are mentioned as members of the court and cannot be taken as an indication that women were regularly included among the judges. Legal documents, such as wills, property transfers, contracts and the like, which had to be witnessed occasionally include women's signatures but they do not appear as frequently as those of men. This may be due to low literacy among women, rather than absence of legal status as witnesses.

It is easy to paint too rosy a picture of order and justice, especially as applied to women. Ancient Egyptian society was totally hierarchical. The tiny percentage of the elite section of society who administered justice would take good care of their peers, but records show that they were not impervious to persuasion and bribery. For people lower down on the economic scale, justice may have been more elusive. A poor man or woman would probably not expect much success in trying to redress an injury or offence committed by a superior. Their only hope was to rally the support of their extended families or close village communities to take concerted action. In particular, widows and divorcees, especially those with young children to support, must have been particularly vulnerable.

Many of the legal texts which have survived were important cases which came before the high courts presided over by the king or his viziers. But documents of lesser cases, many of which came from the Deir al-Madina archive, also exist. It is these more mundane cases—wills, property contracts, family disputes, and court hearings—which provide us with much of our information about the range and application of women's legal rights.

Amenhotep, a typical New Kingdom official, and son of Hapy, depicted in a typical
scribal position with an open papyrus roll on his knee. Egyptian Museum, Cairo.

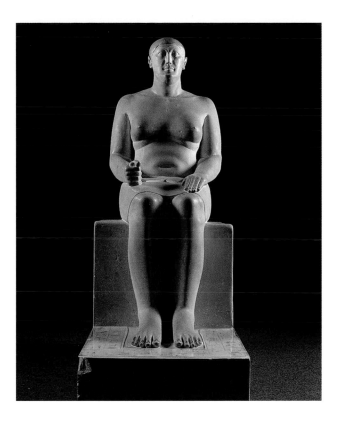

WOMEN'S TITLES

The main political role of the princesses throughout the history of ancient Egypt was to transfer the rule from one king to another. This kept political change within Egypt at bay, since there was always an heir to the throne.

The kings of ancient Egypt used to marry the daughters of kings, the heir to the throne choosing his chief wife from among those princesses with pure royal blood, thereby insuring that his child—particularly his son—came from pure royal blood. In this way, succession to the throne was not only regularized, but was also in accordance with the myth of Isis and Osiris.

An example of this peaceful change of power from one dynasty to another is that from Dynasty 3 to 4 through Princess Hetepheres I, the daughter of Huni by his chief wife. However, Sneferu, the first king of Dynasty 4, was Huni's son by a secondary wife. Therefore, Sneferu married his half-sister, thus giving himself the legitimate right to the throne and also to supervise the burial of his father Huni.

Another king who married a princess of the preceding dynasty was Teti, the first king of Dynasty 6, who married both Iput I, the daugher of King Unas, the last king of Dynasty 5, and Khuit, the daughter of King Isisi of Dynasty 5.

By these two marriages, Teti took the throne easily; indeed, the high officials of Unas also served Teti—another example of the stability that was maintained in the changeover from one dynasty to another.

Menkaure, son of Khafre of Dynasty 4 initiated a new marriage custom by having the children of his officials educated alongside his sons, thereby securing the loyalty of their fathers and also according the

Statue of Hemiunu, architect of the Great Pyramid at Giza.

Hildesheim Museum. Old Kingdom

children the same position as their fathers. Menkaure's son Shepseskaf carried on this practice, and as a consequence of this his reign saw the first marriage of a princess from the royal court to an official, his eldest daughter Khamaat marrying the vizier Shepsesptah, who was raised in the palace and fell in love with the princess.

This story shows us the extent to which the king wanted the complete loyalty of his officials and also one of the ways in which the political situation was made stable. On the other hand, however, one cannot help wondering to what extent the king planned this: it seems likely that the princess fell in love with the official and the king had no choice.

During Dynasties 5 and 6 it was common for princesses to marry outside the royal court. Pepi I married non-royal women, and this weakened the idea of the divine kingship known in Dynasty 4.

The royal title Satnesut, literally 'daughter of the king,' was simply one that connected the princesses with the royal court, and did not have an official function. However, the title Iwat, meaning 'elder heir' or 'great heir,' appeared in Dynasty 3 and was held by Princess Hetep Mernpty, the daughter of Djoser of Dynasty 3. This title disappeared after this dynasty, but began to appear again in Dynasty 18 of the New Kingdom. It is believed that the title meant that the princess should be the legal heir to the throne.

It seems that the title could not give the princess the real power to come to the throne, but was simply an honorific title or one which gave her more privilege than the other princesses. On the tomb of Queen Mersyankh III, nomes given to her through her grandfather Khufu and transferred to her through her mother Hetepheres II can be seen.

In Dynasty 2, princesses were given the title Satnesut, and other epithets were later added to it, as follows:

-Satnesut meretef: the king's daughter, who he loves
-Satnesut net ghetef: the king's daughter of his body
-Satnesut net ghetef meretef: the king's daughter of his body, who he loves
-Satnesut bity: the daughter of the king of Upper and Lower Egypt
-Satnesut semset weret: the king's eldest great daughter
-Satnesut weret meretef: the king's great daugher who he loves
-Satnesut net ghetef semset weret: the king's great eldest daughter of his body
-Satnesut semset weret meretef net ghetef: the king's eldest great daughter who he loves of his body

The epithets added to the title Satnesut were meant to show that the princess was dear to her father, and also placed her in the royal court as the eldest daughter of the king.

The princesses upon whom the above titles were bestowed did not have any specific function within the court. However, functional titles were given to princesses during the Old Kingdom, and in Dynasty 4 the daughter of the king bore the functional title hemet-neter ('wife of the god').

KHEREP SESHMET IMAT: THE DIRECTOR OF HAREM AFFAIRS

This title appeared in Dynasty 4, and was held by both Queen Hetepheres II and her daughter Queen Mersyankh III. It is difficult to know what exactly the role of these women was, and we also do not know if a woman held this title before or after she became the king's wife.

It is believed that this title could have a religious function connected with the harem. It is known that there was a place inside the royal palace known as Ipet nesut, which means the place where the queen stays. The harem was also the place where the royal children were taught and the secondary wives of the king lived.

Ghekret nesut: Ornament of the King

Princesses held this title from the beginning of Dynasty 4. One such princess was Ny-seger-ka, Khu-fu's daughter. Opinion is, however, divided as to the function of this title. Some scholars believe the title reads 'ornament of the king,' connecting this title to the king's mistress and also those women the king liked to see all the time. Others assert that the title means 'adorned of the king,' denoting those women who were in charge of dressing the king and preparing what was neccessary when he left the palace. Yet another theory is that this title is connected with the cult of Hathor and those women who were priestesses of Hathor. This title may also have been for secondary wives.

Women also bore the title Neferut which means 'beauty' and may have been given to women who played music or danced to please the king. A reference to these women is made in the Westcar papyrus, which tells how King Sneferu had forty women row and sing for him in the palace lake.

Property Ownership

There seems to have been no restriction on what or how much property a woman could own. It could be property inherited from a parent or husband, or acquired through purchase. Women could accumulate capital through bartering agricultural produce and home-made items such as textiles and clothing. With this, they could purchase land or houses, or, as we know from one case, slaves. Unmarried women were not at all restricted in acquiring their own property as we know from a Dynasty 27 papyrus which records the purchase of a piece of land by an unmarried woman called Ruru.

Documents show that loans were frequently taken. For example, in the second century BC, a woman called Renpet-Nefret borrowed ten deben from a certain Andronikos. The loan had to be paid within a year and a piece of land was held in security on the repayment.

At the workers' community of Deir al-Madina, women are often recorded buying and selling houses and storerooms. It seems that the main village houses were the property of the government and were given to the workmen with their jobs. A widowed or divorced woman might therefore find herself without a roof over her head, and acquiring a private dwelling was probably quite high on the list of priorities. Some of the transfers of these private houses have survived. One such house changed hands several times; it was acquired from a woman by the mother of one Padikhonsu, who inherited it on her death. When Padikhonsu died, his wife mortgaged the house and all her property. Failing to meet her debts, the house became the property of her creditor, Pamreh, and was later sold to a woman called Taynetjeruy.

Inheritance

A married woman automatically inherited a third of her husband's property on his death. This was also payable if she was the innocent party in a divorce, but if she was repudiated for adultery or some other offence, she received nothing. If the husband so wished, he could leave her all his property, and wills expressing this intention and signed by witnesses have survived. Such a will was made in the Middle Kingdom by a man called Wah, who having inherited property from his brother, bequeathed everything to his wife, Teti. It appears that he and his wife had not yet had any children because the text goes on: 'She shall bequeath it as she pleases to (any) one of the children that she will bear to me.' He also left her three Asiatic slaves and his house and stipulated that she was to be buried in his tomb.

As indicated by the will of Wah, a woman was able to dispose of an inheritance as she wished. The earliest sign of this is the Dynasty 3 official named Methen who recorded that he inherited about 30 feddans of land from his mother.

From the Rameside period, a famous will has survived of a woman called Naunakht who inherited property from her father and her first husband. She remarried and had eight children by her second husband. In this will, she distinguishes between her own property and that belonging to her second husband. A third of his property would go to her as his wife. The remaining two-thirds would automatically be shared between all the children. In naming her heirs, however, Naunakht complained that some of her children had not cared for her in her old age. These she cut out of her will, bequeathing all her own property to the four who had looked after her. This will was witnessed by all her children before the local council. The care that was taken in compiling it and making it legal may indicate that its contents were rather unusual.

PROPERTY DISPUTES

One of the most common complaints brought to court were disputes about property. A tomb of the Rameside period records one of the most famous and long-running legal contests that we know of. It concerned a piece of land which a certain Neshi had received as a reward for military service in the reign of Ahmose. The land had been bequeathed to his children, both sons and daughters inheriting equal shares. As frequently happened, they chose to administer the inheritance jointly, rather than splitting it up, and one of the heirs was chosen to manage it. All went well for the first three hundred years

A naked girl, accompanied by a small child, purchasing figs from a fruit seller. Detail from a market scene in the tomb of Niankh-Khnum and Khnum-hotep, Saqqara. Old Kingdom.

or so until, in the reign of Horemheb, the guardianship of the land was disputed. A woman named Wernero, a descendant of Neshi, won a court case to become the legal manager on behalf of five other heirs. Her position was soon contested by her sister, Takhero, who initially won her case, but soon found that the decision had been overturned in favor of Wernero and her son Huy.

For a while, all went smoothly until Huy died, leaving a wife and small son, Mose, as his heirs. A certain Khay, perhaps another relative, now stepped in and contested the right of Huy's wife, Nubnefret, to administer the estate. Yet again, the dispute was taken to court. Nubnefret attempted to back up her claim by asking for the official registers to be consulted. But Khay had forged official documents and letters which convinced the court that Huy's family had no right to the land. Khay was given the guardianship of the estate and expelled Nubnefret and Mose.

It was not until Mose had grown up that the fifth, and presumably final, court case was brought before the council. Mose claimed that he was a true descendant of Neshi and accused Khay of falsifying the records. In the end, Mose appealed to the people of his community, who, one by one, swore an oath that Mose's father Huy was the son of Wernero who had legally cultivated these lands, and that Wernero in turn was a descendant of Neshi. Various documents were brought in to substantiate the claim, and in the end, the court decided in his favor. Mose celebrated the final triumph of this dispute which had been rumbling on for over a century by recording it in great detail in his tomb chapel at Saqqara.

This case is important in understanding many facets of the workings of Egyptian law. It is clear that registers of land property went back for several hundred years, and were available for consultation and, unfortunately, for falsification also. Women were able to administer estates on behalf of other members of the family, including men. They were also able to initiate court cases themselves.

A woman receiving flour for baking. Detail from a market scene in the tomb of Niankh-Khnum and Khnum-hotep, Saqqara. Old Kingdom.

COURT CASES

There is also evidence from other documents that women could bring legal disputes to court. The accusation could be made against another woman or a man. A Dynasty 13 papyrus records a claim made by a woman, Tahenwet, that her father had illegally bestowed some of her property on his second wife. She contested that her father had given to his wife fifteen slaves which actually belonged to her and had been given to her by her husband. The outcome of this case is not known, but its importance lies in the clear statement that a woman could take her father to court.

A later document from Deir al-Madina records a case between two women. In the early years of the reign of Rameses II, the wife of a local official, Irynefret, decided to purchase a slave girl worth 4 deben 1 kite, and paid for her in a variety of commodities. But almost before she had had time to appreciate her new purchase, her neighbor, Bakmut, claimed that some of her property had been used to complete the purchase, and she therefore had a claim on the unfortunate slave girl. Eventually, she took her claim to court, and both women produced witnesses to back up their different stories. Irynefret had to swear an oath: 'If witnesses establish against me that any property of the lady Bakmut was included in the silver I paid for this slave-girl, and I have concealed the fact, then I shall be liable for 100 strokes, having also forfeited her (the girl).'

Our records break off while Bakmut's witnesses substantiate her claim and the outcome is not known. If Irynefret did lose her case, her punishment would have been severe indeed. Other court cases indicate that women no less than men could be subjected to harsh penalties.

Wooden figurine of a Nubian slave girl carrying a large dish supported on the head of a monkey. University College, London. New Kingdom.

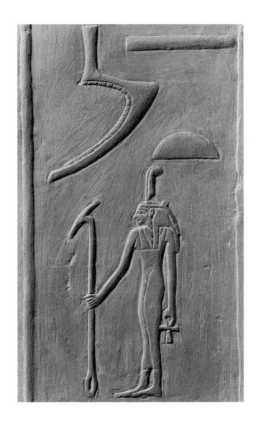

Several cases are known from Deir al-Madina of women accused of stealing property. A woman named Heria was accused of stealing a copper axe which belonged to one of the workmen. She denied the accusation and swore an oath that she had not stolen it. However, when her house was searched, the tool was found as well as several other stolen items including temple equipment. Her crime was considered serious as the theft had been compounded by blasphemy. The court accused her of being 'a great false one, worthy of death.' The death penalty, however, could only be imposed by the vizier or king, and so her case was referred to a higher court.

The text that we have was probably a draft of the report sent to the vizier and it cites an earlier case of theft by a woman as a precedent. The verdict on this woman, who was accused of stealing a bronze vase, was: 'The vizier had the scribe Hatiay come. He had her taken to the river bank.' We are not sure what this means, but in Mamluk times, executions were carried out on the river bank.

Another Deir al-Madina ostracon documents a case which occured in the reign of the vizier Nefer-renpet. A woman named Tanjmhms was accused of stealing copper tools worth one and a half deben. The woman denied the claim and was therefore taken to the vizier. The scribe told the vizier that she should be punished to discourage other women from doing the same. The scribe drew the vizier's attention to another woman named Shaka who stole something worth one and a half deben and said to the vizier: 'My lord ordered that punishment should be meted out on this woman because no other woman will do such a thing again.'

The address of a certain Nakhtmin to the court regarding a crime perpetrated by a woman is also documented. He explained that he was sitting in the chapels of the goddess Taweret during her feast

Hieroglyph symbolizing Maat, goddess of Truth. Detail from
the false door of Ptah-hotep II at Saqqara. Old Kingdom.

when a lady named Tankhsy stole his cake. She confessed to her crime after ten days. It is believed that this cake was an offering to Taweret.

The women of Deir al-Madina were also brought before the court in order to pay a debt. An ostracon now in Berlin states that the court ordered a woman to pay 20 deben for a chair, the text explaining that she then went in the company of a guard to the court of the temple of Rameses II and there the court ordered her to pay 30 deben. It seems this latter decision was made because she was late in paying the debt.

In another case, a groom complained that his bride had betrayed him because he saw her in bed with a man named Merysekhmet one morning. But the groom's demands for justice were not met, and instead the officials of Deir al-Madina ordered that he should be beaten.

Inherka, the overseer of the workmen, was very upset that the groom's claims were thrown out of court. Inherka therefore ordered that Merysekhmet should swear that he would not talk to the woman again and that if he did, he would be punished.

Other cases of domestic strife found on an ostracon include that of a woman who took her husband to court because he beat her, and that recorded on a Turin ostracon that reveals a fight between a scribe and a woman over a dress. In the latter case, the court's decision went in favor of the man and gave him the dress.

Despite the presence of these recorded cases, on the whole, women feature much less frequently in legal texts than men. This may be because, on the whole, they owned less property than men and much of the legal wrangling was about possessions. Nevertheless, women clearly could take legal action in their own right, answer charges in court, take oaths, and bear witness. They also had to suffer the same severe punishments for their crimes.

CAREERS AND OCCUPATIONS

The right to own and dispose of property themselves gave women the possibilities of economic independence and authority, within the restrictions imposed by obligations to the family and to the state. But for women of the elite class, however wealthy, there were few 'career' opportunities open to them.

The highly centralized government bureaucracy worked through a network of educated scribes, all of them men. Educated at schools from which girls were normally excluded, these scribes usually inherited their office from their fathers or a close relative. They considered themselves an elite group, and many of them acquired rank and fortune. Their funerary monuments give details of their careers and titles, the source of much of our information about the state bureaucracy. Sometimes all we have are lists of titles; occasionally details of the responsibilities connected with each office are included. As administrative documents have only rarely survived, the full structure of government is not well documented and titles often provide the only clue to how it functioned.

At the top of a vast, pyramidal hierarchy was the vizier, the deputy of the king and second only to him in power. For a short while in Dynasty 4, the kings' sons and close relatives filled this office, but in later dynasties the viziers were drawn from the nobility. The vizier supervised all the government departments and reported daily to the king. Under him were all the provincial officials, who administered their own districts and were responsible for collecting and delivering the taxes, paid in kind.

Chief among the government departments was the treasury. This was controlled by the 'overseer of the house of silver' or chancellor who handled vast amounts of revenue from the king's estates and from taxes. In the New Kingdom, foreign tribute and trade also enriched the pharaoh's coffers. This was all delivered in kind, as raw materials, agricultural produce, and finished articles. The overseer of the granaries supervised the collecting and storage of grain, the most important single commodity in ancient Egypt. The army and priesthood were other significant departments, and it was common for one man to move from one government section to another, or hold a priestly office as well as a civil service ap-

pointment. Below the high-ranking officials, an army of lesser bureaucrats and scribes implemented government orders and requisitions.

Through this hierarchical system, educated boys would expect to inherit their fathers' posts and had a chance to improve their fortunes by their own merit and hard work. Careers in the army or the bureaucracy could provide advancement and every now and then we hear of an official from a lowly background who rose to the highest offices.

However, official positions of authority open to women were very few. The only regular occupation for upper class women was as priestesses of the goddesses Hathor or Neith or as musicians in the temples. Other titles of high-ranking women are often connected with the king, such as 'noblewoman of the king' or 'she who is known to the king;' whether the holders had any official obligations is unknown. They may have been required to play certain roles in the elaborate court ceremonies, as were those who held the titles 'lady-in-waiting' and 'sole lady-in-waiting.' Or perhaps the titles may indicate rank rather than office, such as that of 'royal ornament,' which applied to those who had been brought up at court with the children of the king.

We hear of only one female vizier, in Dynasty 6. Except for this one example, even under the rare female rulers, the highest offices of the country were always given to men. Titles of administrative positions are rarely held by women. The number is greatest in the Old Kingdom when women held titles as keepers of storehouses and supplies of food and cloth. As is shown below, food provision and textile manufacture were areas in which women were closely involved. They are also recorded as supervisors of female dancers and musicians, wigs, and even in one case as a supervisor of doctors. It is likely that these women were in the service, not of the government, but of royal or high ranking ladies. Queens are known to have employed female managers for their households. The wife of a 6th Dynasty vizier, herself of royal blood, had a whole staff of female officials—a steward and superintendents of treasure, of ornaments, and of cloth.

In the Middle Kingdom, there are fewer examples of administrative titles held by women. Most of these pertain to the running of the household, and include titles like 'chief steward,' 'keeper of the chamber,' 'overseer of the kitchen,' and 'butler.' These are all offices usually held by men and, when applied to women, they probably signify that they were in the service of other women. Another title that gave its holder authority and was occasionally borne by women is that of 'sealer.' In the absence of locks on storerooms and boxes, doors and lids were closed with cords over which a lump of wet mud was placed. Into the mud a seal, often on a ring, was pushed leaving an impression, making it impossible for an unauthorised person to get in without breaking the seal. The holder of the seal was thus responsible for the security of possessions and supplies.

The most common titles for women at this time are that of 'priestess of Hathor' and 'sole lady-in-waiting,' both markers of high social status. Less common were feminine versions of their husbands' official titles of 'prince' and 'mayor.' These may have been gained simply by marriage, as is the case with modern aristocracy, or they may imply that the wife could participate in some way in her husband's official duties. Perhaps these were the feminists of their day, or capable women whose husbands appreciated their skills.

The New Kingdom has produced no evidence that women held any administrative titles at all. However, there is clear evidence in the late New Kingdom that a wife could act as a deputy for her husband in his office. Here, the wife of a scribe of the necropolis could apparently legitimately receive official revenues in the form of grain in her husband's absence. She did so as his deputy, however, and not in her own right. Another record tells of a woman accompanied by her daughter who entered a storehouse that used to be under her husband's authority. Her action was considered unlawful because her husband had been moved to another position. When he no longer held the position of overseer of the store, she herself lost any right to enter and remove items. Unfortunately, the records are too sparse to see whether it was customary for a wife to participate in her husband's official duties. It may well have been normal, in much the same way that diplomats' wives today are expected to undertake exacting social obligations and

projects to enhance their husbands' careers. The earlier Middle Kingdom titles of 'princess' and 'mayoress' may signify more of a partnership with the husband, rather than being merely honorary.

Occasionally in the Middle Kingdom, the title of 'female scribe' is encountered. The whole question of female literacy in ancient Egypt is a vexed one. It has been suggested that the reason why women were excluded from the official and ubiquitous state bureaucracy was because they were illiterate, at least in theory. The occurrence, even rarely, of this title of 'female scribe' is an indication that some women could read and write, but we have no certain means of assessing what proportion of the female population was literate. There are no depictions of working women scribes and the title becomes even more rare in subsequent periods. Although letters to women and by women have been found, we have no idea if they penned and read these themselves, or if they made use of the local scribe. The scribal schools that turned out candidates for government service were all for boys. Royal ladies and women from educated families may have been taught by private tutors or even by their parents, but they were clearly in the minority as shown by the scarcity of female signatures on documents. This apparent scarcity of education and the fact that their chief and most prestigious role was as child-bearer contrived to exclude most women from government office.

WOMEN OUTSIDE THE HOME

If the home were the domain of women, they were by no means confined to it. There is ample evidence of comings and goings between houses of neighbors, temples, and tombs of relatives. Fields, workshops, and markets were frequented by the lower income groups.

Agricultural work in the fields seems to have been mostly done by men, if the depictions on tomb walls are accurate. Women and children are only seen helping at busy times, particularly with the harvest, when wives are shown bringing refreshments to the reapers, gleaning the fallen ears of wheat or barley and winnowing the grain after it had been threshed. However, administrative documents do mention occasionally that women cultivated land themselves and they also record women acting as beaters to raise birds for hunters. One of the New Kingdom love song cycles is entitled: 'Beginning of the delightful, beautiful songs of your beloved sister as she comes from the fields.' In one of the songs, she talks about trapping wild birds. No male helper is mentioned and the birds are destined for her mother and home consumption, not for an employer:

'...I shall retrieve my nets,
But what do I tell my mother,
To whom I go daily,
Laden with bird catch?
I have spread no snares today,
I am caught in my love of you!'

So, it seems that women and girls did work in the fields and marshes in actuality although tomb depictions very rarely show this. From what we know, there was plenty to occupy a housewife in the home. Probably it was only when the husband was infirm or had died that women would have to undertake the cultivation of the fields as well as running the house.

MARKETS AND TRADING

In the Old Kingdom, market scenes usually show only men doing the trading. By the New Kingdom, however, women are just as often shown seated at the river bank with large baskets of provisions and exchanging what appears to be farm produce for commodities that are being brought off the boats. One

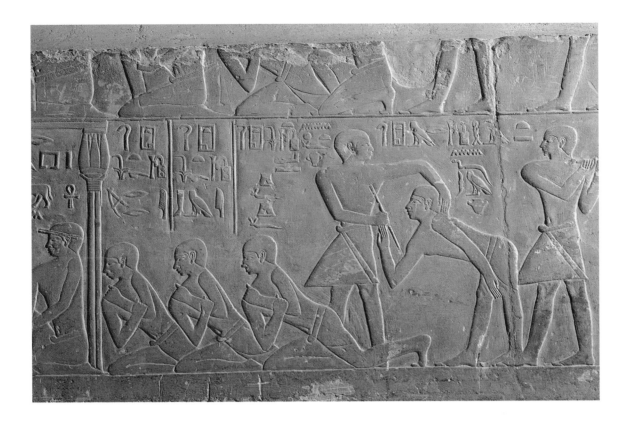

such scene may depict more than an informal market. It shows the traders sitting under booths that display a variety of items including sandals and cloth as well as food. It is possible that these are representations of actual shops. The commodities brought from the boats include jars of wine and sacks of grain, which, in the absence of money, were often used for barter.

The price of large items was usually estimated in terms of precious metals that had a known value, but could be paid in a variety of goods. For example, in the time of Rameses II, the wife of a district overseer, Irynefret, decided that after seven years of doing all her own housework and sewing, she could afford to purchase a Syrian slave girl. The price was calculated in silver, but was actually paid in a combination of fifteen linen garments, a shroud, a blanket, a pot of honey, a weight of copper, and six bronze vessels. The linen cloths would have been woven by the housewife and they and the metal vessels were her 'savings' for just such a purchase.

Although ordinary women could go out to market with their goods, women of property who wanted to trade would send an agent. Some of these traders plied the Nile in boats, exchanging goods for other items in markets up and down the country. They are known to have worked for women as well as men. It is clear that even wealthy households would not necessarily be self sufficient and might need to purchase essential requirements and luxury items. One can imagine the wealthy housewives of Thebes dispatching a trader with their surplus rolls of linen to purchase imported luxuries from Memphis or the Delta towns. He might come back with scented oils from Mycenaean Greece, medicinal opium from Cyprus or fine embroideries from Syria.

A law court scene. Scribes on the left record the verdicts, while supplicants kneel behind them.
An offender has been brought in by an official. Tomb of Mereruke, Saqqara. Old Kingdom.

IX
WORKING WOMEN

J ust as the options for careers and occupations were limited for the privileged women of the elite classes, so they were also for ordinary women. Mothers would teach their daughters their skills and there were relatively few opportunities for girls to move up the social ladder. Many of the avenues of advancement used by men, particularly the army and the government, were closed to women.

Daughters born to household servants would thus expect to follow their mother, either in the same household, or moving into another one. There tended to be a gender distinction in the type of work done by female servants. For example, they are rarely listed as gardeners or agricultural workers, never as carpenters, potters, or metal workers. Within the house, female servants are shown tending to women, and male servants to men. Skills such as manicuring and hairdressing would be necessary for personal servants, and are sometimes mentioned on their funerary monuments.

TEXTILE MANUFACTURE

Until the New Kingdom, spinning and weaving were essentially a woman's job. A fragment of linen dating from about 4000 BC is the earliest evidence for the manufacture of cloth in Egypt. A depiction on a pottery dish of a horizontal loom also comes from this early period. Techniques of spinning and weaving may have evolved first in the manufacture of baskets, cords, and mats out of readily available natural materials, such as palm leaves and fiber, halfa grass, and papyrus. Cord rope was made by twisting strands of palm fiber, halfa grass or other fibers together. Fine baskets, used as containers for almost anything, were woven from reeds or palm leaves.

A woman and men working in a bakery.
Tomb of Ti, Saqqara. Old Kingdom.

Two women straining beer.
Egyptian Museum, Cairo. Old Kingdom.

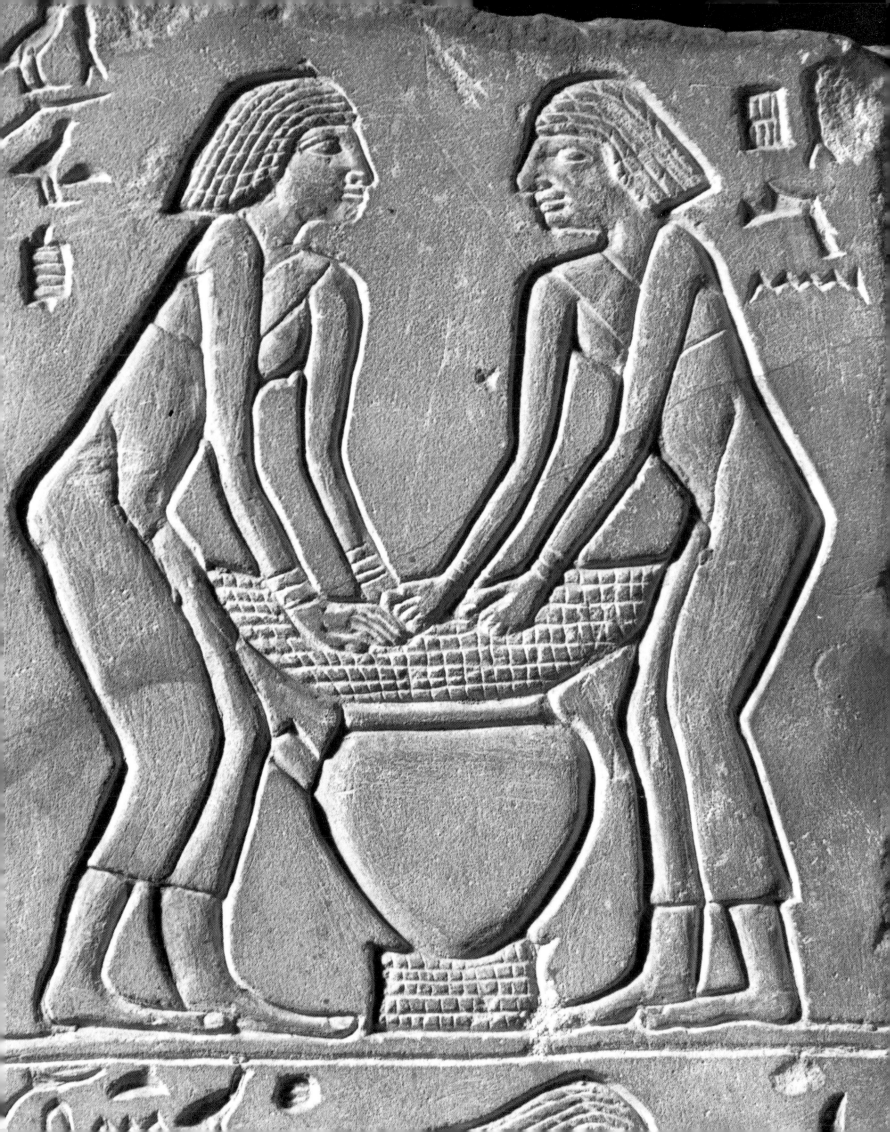

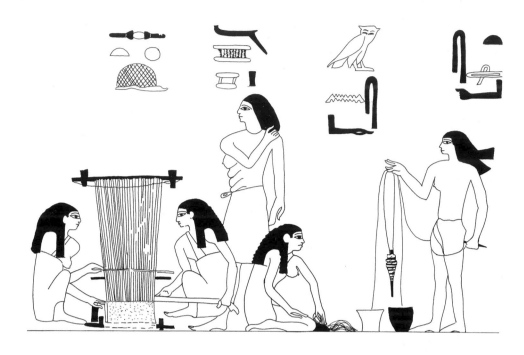

Woven rush mats were hung in doorways as well as placed on floors, and elaborately colored ones decorated house walls and niches. Painted replicas of such mats can be seen in the tombs of the Old Kingdom and on the walls of the burial chambers of the kings of Dynasties 5 and 6, as well as on the ceilings of some Middle and New Kingdom tombs.

As in modern Egypt, mats were undoubtedly used for simple cabins—on the roof, in the fields, or on boats. The famous boat of Khufu found next to the Great Pyramid had two canopy frames, one small one in the bows, another larger one in front of the deckhouse. Both were probably covered with mats, several of which were found in the upper layers of the pit that contained the boat's timbers.

The manufacture of mats and baskets was probably, like spinning and weaving, a woman's task. These jobs were usually done at home by the womenfolk who would supply the family needs. Any surplus could be set aside for a rainy day or used for barter, and the manufacture of linen was one way a housewife could earn a little 'pocket money.'

As well as domestic production, evidence from the tomb paintings and from actual excavations shows that weaving workshops were attached to wealthy households. Some of these employed a number of women, if the detailed tomb paintings from Beni Hassan are an accurate indication. Here, women and girls are shown working together on the different stages of cloth production, sometimes under the watchful eye of a male supervisor. Even when men became more involved in the weaving process in the New Kingdom, women still provided most of the workforce.

Lists of 'serfs' from the records of Middle Kingdom officials in Thebes and Kahun indicate that female 'clothmakers' were employed in these establishments. Many of these women have Asiatic names. Correspondence between some of the New Kingdom pharaohs and the rulers of the city

Women weaving on a horizontal loom, cleaning the fibers, and spinning with two spindles. Tomb of Khnum-hotep, Beni Hassan. Middle Kingdom.

states of Palestine and Syria records frequent requests for weaving women, implying that their skills were especially appreciated. They were presumably put to work in the royal workshops attached to the palaces where the demand for fine linen would have been great. They may also have been skilled at embroidery; an overgarment of Tutankhamun is richly embroidered in brightly colored Syrian designs.

In the eyes of the ancient Egyptians, linen was a special material and considered ritually pure. Its manufacture came under the protection of the goddess Tayt. Mythologically, it was given sanctity because the mummified body of Osiris had been wrapped in linen bandages woven by Isis and Nephthys. Likewise, the bodies of the dead were always wrapped in linen. Priests were allowed to wear only linen garments when on duty in the temples, and the statues of the gods were wrapped in fresh linen that was changed regularly.

Wool was considered impure and does not feature at all in the ideal world of gods and spirits depicted in the tombs and temples, nor is it found as a funerary item in the tombs before the Roman period. However, a few samples have been found on settlement sites. The discovery of a small domestic weaving workshop at Deir al-Ballas brought to light scraps of raw wool, woollen thread, and coarse wool textiles. This showed that wool was certainly used by ordinary people of the New Kingdom, even if it was not considered pure enough for divinities and the dead.

Silk and cotton were introduced much later. Cotton originated in India and is first attested in Egypt in Dynasty 26. By the Roman period it had become common and eventually superseded linen for garments and shrouds. Silk also appears at this time, when long-distance sea trade brought in luxury items from the Far East.

Reconstruction of the Giza bakery created by the National Geographic Society, showing the large mixing bowls and the hearth where the bread is baking inside the pots.

LINEN MANUFACTURE

The flax plant from which linen is made grows readily in Egypt and was planted after the flood waters had receded. It was harvested by pulling the long stems from the ground and leaving them in bundles to dry. Then the stalks were soaked in water for a number of days, in order to soften them and start the separation of the fibrous matter from the woody tissue. This process was completed by beating the stems with a wooden mallet so that the fibers could be drawn out lengthwise and loosely twisted following the natural direction to the left. As they are worked, these 'roves,' as they are called, gradually acquire the strength and elasticity needed for the finished thread as the individual fibers are pressed together and adhere by virtue of the irregularities on their surface.

Several detailed tomb paintings have given us many details about how the different stages in linen manufacture were accomplished. The roves were worked by women who knelt on the ground, rolling the fibers along their thighs, and winding the resulting yarn into balls.

Spinning was the next stage, to convert the rough yarn into fine thread. The balls of roves were placed in pottery bowls to prevent them rolling away. Some of these bowls, the so-called 'spinning bowls,' have internal handles through which the yarn passed. The rove was threaded onto the spindle which was then rotated, spinning the yarn tight to achieve a firm thread. The spindle was a long baton of wood weighted at its top end with a circular pottery or bone whorl. At the top end, the twisted fibers were wound into a deep spiral groove, later replaced with a simple hook. The rove was pulled up from the spinning bowl, the spindle was rotated with a flick of the hand or by being rolled along the thigh, and then was allowed to drop. The weight of the whorl helped to maintain the spin, twisting the attached thread. As each section of thread was finished, it was wound onto the lower part of the spindle under the whorl.

One of the most detailed representations of spinning is in the Middle Kingdom tomb of Khnumhotep at Beni Hassan. Women are shown kneeling on the ground, combing and cleaning the fibers and discarding the impurities. Nearby, the spinners are so skilled that they can manage two spindles at once, pulling the roves from separate pots. A child stands on an upturned pot or basket to increase her height and consequently the length of flax she can spin. Sometimes the twisted fiber was passed through a forked stick set upright in the ground, again apparently to spin a longer length each time. In the New Kingdom, the rove was passed round a pulley-like object set on the high frame, so that the spinner could stay seated while twisting a long length of thread.

Once the thread was fine and strong enough, it could be woven into fabric. The women of ancient Egypt were capable of weaving incredibly fine cloth that, in the quality and the number of threads, was not superseded until the invention of mechanical methods in the last century. Until the New Kingdom, this was done on a horizontal loom, set on a low frame parallel to the ground. These were made of wood and none have survived intact, probably because they were used until they fell to pieces. However, we have representations of them. In the Beni Hassan paintings, women are shown preparing a horizontal loom by wrapping the longitudinal threads, known as the warp, around the wooden beams at either end. The odd and even threads were kept apart by rods, and two women on either side of the loom threw across the shuttle with the weft thread. After each passage of the shuttle, the threads were pressed back with a comb, or later, a wooden rod.

In the New Kingdom, the more sophisticated vertical loom was introduced which was worked by men as well as women. An upright wooden frame stood on the ground and the weaver sat on a stool in front of it, working upwards from the bottom. As the work progressed, the completed portion was rolled up on the lower beam and the upper beam, with the warp threads, was gradually lowered. This type of loom was wider than the horizontal type and two people could work on it side by side.

Although the Egyptians usually wore white linen, colored and multi-colored fabrics were also made.

The art of dyeing was known as early as the predynastic period as a mat of that date is dyed red around the edges. Little is known about dyes of the pharaonic period, however, but several records dating from Roman times give us details of the processes involved and the materials used.

Most of the colors used were obtained from plants that were ground up and soaked or boiled in water for a certain time. The spun linen thread was then steeped in the resulting solution. For a light color, the thread would be immersed for a short time; for deeper tones, it would be left in longer. The blues that they used came from indigo or indigofora plants; the reds from madder, or some inorganic material such as red ochreous earth; and the yellows from safflower or iron. Greens, purples and blacks were obtained by double dyeing with different colors.

The difficulty of obtaining colors which did not run seems to have discouraged the use of patterned fabric. In order to 'fix' colors into the cloth, a chemical agent or 'mordant' is needed. The chief mordant available was alum which was found in the oases of the Libyan desert but its use in pharaonic times is not proven. Other possible but unattested mordents include vinegar and urine, both human and animal.

BAKING BREAD

Another area of production in which women were very much involved was that of baking bread and its companion task of brewing beer. Ordinary women would have supplied their household needs themselves, but wealthier families employed servants or slaves to do these tasks. Tomb reliefs occasionally show large workshops with many women involved in the different stages of production which were essentially the same as for domestic bread, but on a much larger scale. These were workshops connected with administrative centers, either government or temple. Here, there were certain jobs which only women carried out, such as grinding. Other tasks were performed by men as well as women such as putting the dough into pots, or fanning the flames of the fire.

Bread was considered the basic food per se and was fundamental for life not only in this world but also in the Afterlife and for the gods. Bread and beer were essential offerings to the dead and to the gods, and the hieroglyph for 'offering,' hetep, depicts a loaf of bread on a mat. Palaces, temples, and funerary establishments needed vast amounts of bread and large bakeries have been occasionally found next to such buildings.

In the Old and Middle Kingdoms, women were very much involved with all the stages of bread making, illustrated in numerous tomb reliefs and models. After the stones and impurities were picked out from the grain, it was de-husked in large deep mortars, often by men, and then sorted again on circular cribbles to extract the grain from the husks. The grain was then placed in handfuls on a dish-shaped quern, known as a saddle quern, to be rendered into flour by crushing it with a stone roller, a job only done by women. The querns were set on a slope away from the woman grinding so that the flour was pushed to the far end and caught in a container. Modern experiments have shown that it takes about two minutes for an inexperienced grinder to produce 15-20 ml. of coarse flour, slightly longer for finer flour. No doubt experienced grinders could work fast. Fragments of accounts from New Kingdom Memphis record a group of 26 women who in one day collected ten and a half sacks of wheat and turned them into seven and a quarter sacks of flour.

In the Old Kingdom, the querns were placed on the floor and the women knelt over them, a hard and tedious job for the housewife that no doubt was given to a servant whenever possible. Literary references indicate that this was a menial and little respected task. In his advice to his son, the scribe Ptahhotep says:

'Don't be proud of your knowledge,…
Good speech is more hidden than greenstone,
Yet may be found among maids at the grindstones.'

The implications here are that this was the last place where you would expect to find words of wisdom.

By the Middle Kingdom, quern emplacements were made at waist height, often just beside a wall against which the grinder could push to aid her in her task. The model bakery from the tomb of Meketre shows two such quern emplacements next to ovens and dough vats. After being ground, the flour was passed through rushwork sieves into a bowl. The sieves were presumably not very efficient as examples of ancient bread found in tombs show a high proportion of whole or partly crushed grains in the flour.

The dough was mixed in large vats, combining wheat or barley flour (or sometimes a mixture of both) with water and a leavening agent. A sour-dough mix is easily made by leaving a batter of flour and water to collect wild yeasts, as is done today in the countryside. When this begins to ferment it is used to raise the dough. By the New Kingdom and possibly earlier, bakers were also using a pure form of yeast probably obtained from balm, the yeasty froth that is skimmed off fermenting beer.

Once the basic dough was made, it could be flavored by adding spices or sweetening agents, or shaped into different forms. Over thirty different varieties of bread are listed in the texts, very few of which can be identified with actual remains. The hieroglyph for bread represents a round, domed loaf. Round, flat loaves similar to modern aish baladi were also common, as were triangular loaves. Bread could also be oval, rectangular, conical, stick-shaped or modelled like animals or human figures for special occasions. Some of the round loaves were indented on top to hold a garnish. Cakes were made by adding sweetening agents such as honey and dates, and milk, butter, and eggs.

The finished loaves were usually baked in domed ovens or even on top of a stove. Certain types of

Bread inside moulds.
Reconstruction by the National Geographic Society.

144

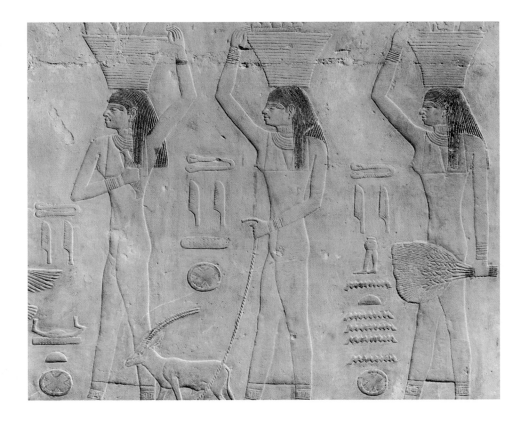

bread, however, were baked in pottery moulds on an open hearth. In the Old Kingdom, these were large cone-shaped loaves used for offerings, which are shown being made in baking scenes illustrated in contemporary tombs.

In the Middle and New Kingdoms, the usual moulded bread was stick-shaped and made in long, narrow pottery tubes that had to be broken in order to extract the loaves. Temple bakeries produced hundreds of these loaves for use in the daily offerings and, at Amarna, the ruins of the bakeries attached to the great temple are red with the broken fragments of the moulds. But the reliefs of this period and of the later 20th Dynasty tomb of Rameses III show that these bakeries were staffed by men, although the arduous task of grinding flour was still a woman's job.

An Old Kingdom Bakery

The ruins of a bakery recently discovered south of the Great Sphinx on the edge of the desert have added considerably to our knowledge of baking techniques. Here a team from Chicago uncovered two rooms containing several large vats sunk into the mud floor and a large number of pottery bread moulds. Next to them, an area marked off by a low wall contained rows of hollows, and turned out to be an open hearth. Everything was covered in layers of thick black ash.

With the help of the National Geographic Society, an attempt was made to reproduce the baking process illustrated in Old Kingdom tombs. Flour made from the types of emmer wheat and barley grown at that period was used. This was combined with the wild yeasts collected in a sour-dough mix.

Female offering bearers wearing linen dresses.
Tomb of Ti, Saqqara. Old Kingdom.

The resulting dough was put into large earthenware pots. Both the pots and the hearth were modern replicas of the ones found in the ancient bakery.

While the dough was 'proving,' the hearth was being heated until it was red-hot, like a barbecue. Then the ashes were raked aside and the heavy pots of dough were placed in the hollows in the hearth so that the heat would penetrate the thick walls of the mould and bake the bread. It was found that by inverting a second jar over the open bread mould a miniature oven was formed which improved the baking process by retaining moisture and heat. It was also discovered that if the pots were placed directly in the ashes, the heat was too great and the bread inside was burnt.

The bread produced by this method was edible but very solid as it had hardly risen at all. This may be inevitable, as the emmer wheat grown at that time differs from modern 'bread wheat' in that it has much less gluten and therefore less elasticity. But the Egyptians may have overcome this by using a different method of preparing the dough. According to the tomb reliefs, the prepared bread dough was not stiff but could be poured like a batter into the heavy pottery moulds that had previously been heated over a fire. If a liquid batter containing an active yeast, such as that collected from beer brewing, were poured into a heated pottery jar and then cooked in a hearth, the dough would bake like a large 'griddle cake' within its miniature oven.

Further excavation is needed to find out if this bakery stands alone, or with others. It may have been attached to an administrative building and served the workers who built the pyramids. Its size is too small to have provided bread for more than a small percentage of the work-gangs employed on the pyramids. However, the administration of food supplies and rations was often organized into many small units, rather than one central unit. It is possible, therefore, that this bakery was part of a modular administrative system where different groups and work-teams were served by their own storehouses and workshops.

BEER BREWING

Brewing was an operation closely related to baking and, according to the paintings and models, was often carried out in the same workshop. Here women are again involved in the first stages of production, the grinding and sifting of the grain, usually barley. The beer was made by breaking up partly baked bread into large vats and mixing it with water. Depictions show that this process was often done with the hands by men or women standing beside the vat. The result was left to ferment. When it was ready, it was poured into a sieve and kneaded to extract all the liquid which collected in a large bowl underneath. Finally the new beer was decanted into smaller pottery jars which could be sealed with a mud stopper. The ancient recipe is much like the bouza made by the farmers of Upper Egypt and Sudan today. The ancient Egyptians had several different sorts of beer, probably based on their color and strength or on flavorings added at the end of the process. On a recently discovered stele from the artisans' cemetery at Giza, four different sorts are listed as offerings.

The Egyptians were one of the best-fed peoples of antiquity. Bread and beer, and also fish, were the national diet for both king and commoner. An area for sorting salted fish to feed the workmen who built the pyramids at Giza has been found to the south of the Hait al-Ghurab ('wall of the crow').

SUPPORT SERVICES

As well as employment in state workshops or private households, women were also liable for obligatory state labour—the corvée. We know from a Dynasty 13 account that women who defaulted from

this obligation could be liable to a period of imprisonment. Most of the females listed in this particular document are described as weavers but it is easy to see that, when needed, women could have been called up to supply other services. Large building enterprises, for example, would have demanded a great deal of manpower obtained from the provinces. The local prince or mayor would receive a request for a certain number of able-bodied men and women who would be selected from the local population. While fulfilling their tasks, they would be fed and housed, perhaps even clothed, and a support system, probably staffed in part at least by women, would be needed to supply their needs.

The enormous amount of labour needed for large projects, such as the building of the pyramids, seems to have been organized into smaller, more manageable units, perhaps based on the workers' home districts. The workers were then divided into gangs of ten, each team working under an overseer. Pyramid building must have been continuous during most of Dynasty 4, but unfortunately, none of the administrative records has survived and we have no idea how many people were employed. Some of them, such as the skilled stone-masons and quarry workers, must have been permanent. The unskilled labour may well have been employed on a rotational basis, working only one month in four or five, as did temple staff. Even so, the numbers involved must have run into several thousands.

Support services must have been well organized, particularly the provision of the enormous quantity of bread needed to feed the workers. Here women would have been very much involved in baking and brewing. They were probably also engaged in making the baskets in which almost everything was carried and the mats on which the poorer people ate and slept. Their work, like that of the main labour force, may have been carried out by teams that worked in rotation.

Until recently, we had little idea where the workers were housed. Stone buildings west of the second pyramid were originally thought to be 'workmen's barracks' but they have been recently re-identified as artisans' workshops. Another small group of buildings in the quarry in front of the third pyramid may have housed specialist stone-masons, but certainly not the thousands of workmen who moved the stones. Where they were housed is not known for certain.

However, traces of a huge Old Kingdom settlement below the modern town at the foot of the pyramids has been uncovered by recent construction work there. The occupation stretches about four kilometers along the banks of an ancient Nile branch and is covered by four to eight meters of alluvial silts and modern buildings. In this urban environment, there is little chance of large-area excavation and it was only in the deep trenches of the waste water project that this ancient town could be traced. It seems reasonable to suppose that this town housed the engineers and administrators responsible for the building of the pyramids as well as many of the essential services, and probably also the construction workers.

X
WOMEN IN THE WORKMEN'S COMMUNITY AT GIZA

The recently discovered cemetery lying to the south-east of the great pyramids of Giza has revealed some interesting details about the relationship between women and men among lower classes of Old Kingdom society. The inscriptions show that these were the tombs of those who built, decorated, and maintained the pyramids and tombs of the Giza necropolis. It seems to be an Old Kingdom version of the cemetery at Deir al-Madina where the workers who excavated and decorated the royal tombs in the Valley of the Kings were buried.

These newly uncovered tombs belong to artisans as well as workmen and their overseers. The two groups of tombs are arranged at different levels on the desert hillside and are connected by a long ramp. There are some 30 larger tombs in which the overseers were buried, and about 600 smaller graves for the workers under them.

A distinctive feature of this cemetery is the range of different tomb styles chosen by their occupants. Long vaulted galleries stand beside simple rectangular mastabas and domed bee-hive tombs. In size, these tombs are miniature reflections of the great stone monuments of Dynasty 4 just a short distance to the north-west. Mastaba tombs have been reduced to a low mud platform, little over a meter long and about 30 centimeters high. Prominently featured are the tiny niches on the east face that serve as false doors and which were the focus for the offering ritual.

Another style of tomb is a circular structure with a high dome, like a bee-hive. This is probably the local version of a pyramid. The true pyramid, with its square base and four flat sides, was a form of monument strictly restricted to royal use at this early period. The bee-hive shape used here no doubt represents the primeval mound which mythologically contains the essence of all living things, no less than the true pyramid. It was therefore a suitable symbol for rebirth in another existence.

Different-shaped tombs in the Workmen's Cemetery at Giza.
In the background is the Great Pyramid of Khufu.

Painted limestone statue of a servant grinding grain.

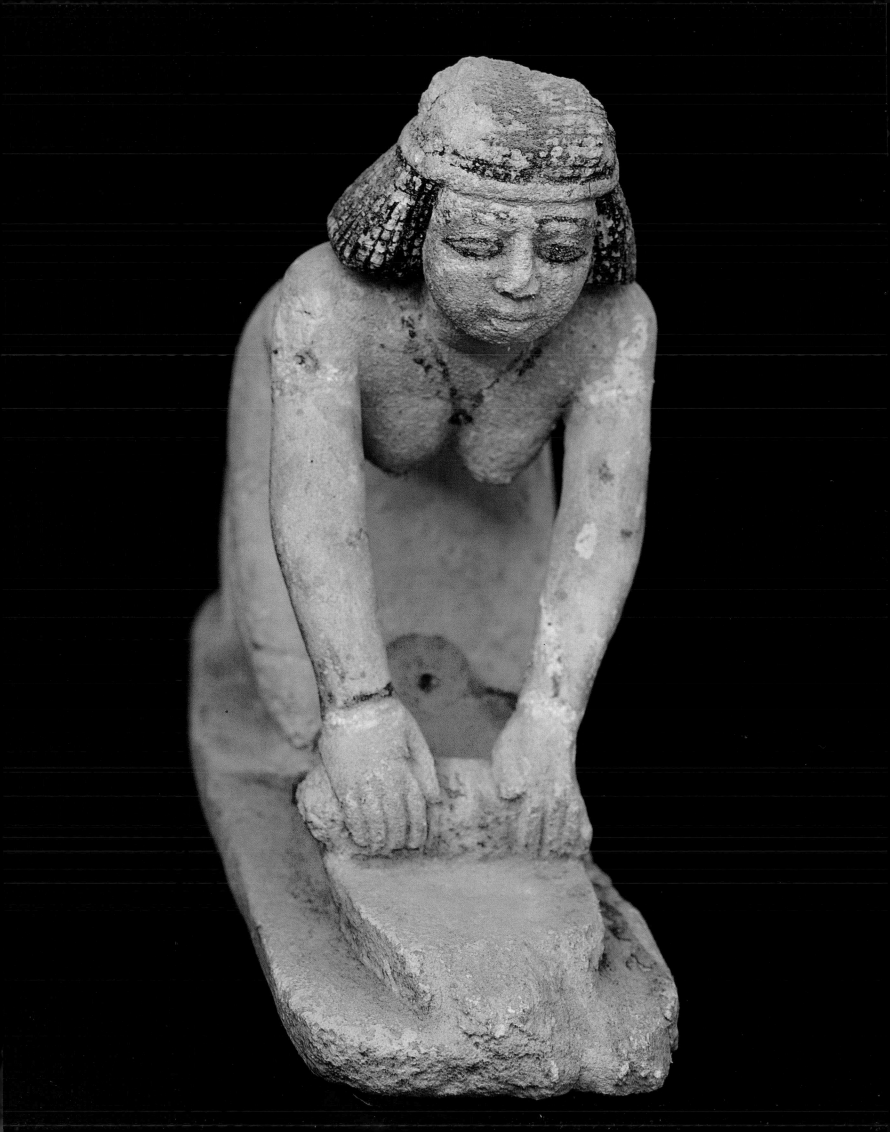

The materials used to build these miniature monuments are equally intriguing. Mudbrick is used extensively, but so are crude pieces of limestone, granite, basalt, and quartzite set in mud mortar. These stones are all 'debitage' from the construction of the nearby pyramids and elite tombs, discarded fragments of fine stones which these humbler people were clearly able to utilise in their own monuments.

THE LOWER CEMETERY

The majority of women's graves were either joint burials occupied by husbands and wives together or tombs placed side by side in a single unit. Two women, however, were found in their own tombs. One of them is identified by the small offering basin placed in front of her false door on which was written her name, Repyt-Hathor, and a title identifying her as a priestess of Hathor. The second was a priestess of the goddess Neith named Nubi whose tomb was considerably grander than that of Repyt-Hathor.

A number of small, well-crafted statuettes were found showing that their owners were able to command the work of skilled sculptors, perhaps from among their own community. A tomb at the southeast corner of the site revealed the burial of a man named Kay-Hep and his wife Hep-ni-Kaues. Three statues were found next to the tomb in a tiny box formed from three upright slabs of stone. The lady, Hep-ni-Kaues, is shown seated on a stool and wears the typical long, tight white dress and black shoulder-length hair. Her name is inscribed on both sides of the stool. Her husband is represented as a standing figure wearing a kilt.

The third small statue found here depicts a kneeling woman grinding flour. This is a type of servant

Detail of the offering table of Repyt-Hathor.
The Workmen's Cemetery, Giza.

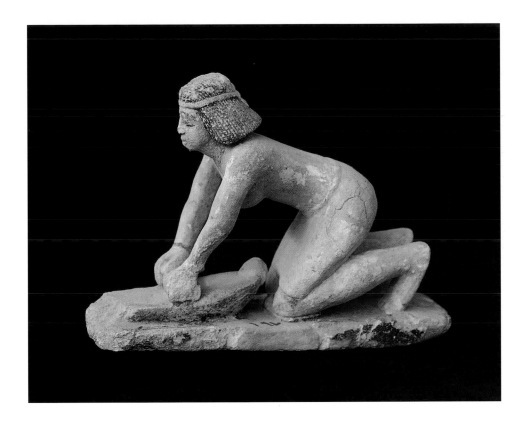

figure of which several examples are known from Dynasty 5 tombs at Giza and Saqqara. It is carefully made and remarkably well preserved. The woman has black hair and wears a short white dress, and the sculptor has suggested the strength in her shoulders and the action of grinding by depicting her right arm slightly longer than her left. The quern stone is slanted slightly forward. It is painted red in imitation of granite or quartzite with a white patch in the center to indicate the flour. Between her knees the woman has a small bag which probably contained the grain.

This piece is uninscribed and we have no idea who she was, yet it inspires an interesting debate about the role of such statues and the lifestyle of the people buried in these tombs. We do not know whether these labourers had servants of their own, or if, as government employees, they were supplied by the state with servants to do such menial tasks. Does this figure of a grinding woman depict Hep-ni-Kaues' servant or is this a chore that Hep-ni-Kaues herself would have had to do on many occasions? In this case the figure may represent her. Or perhaps its presence is merely an indication of the owner's hopes for servants and a better existence in the Afterlife. Whatever the correct understanding, the group of Kay-Hep, Hep-ni-Kaues, and their servant form a curiously domestic scene standing in the small compartment where they were buried together.

Another burial produced an unfinished pair-statue, carved from a single limestone block. It is unusual for having the normal position of the man and woman reversed with the woman standing on the man's right side. Like the figures of Kay-Hep and his wife this is a small statuette, standing only 32 cm high. Work was further advanced on the woman's figure than on the man's when the sculptor abandoned the piece. There are no inscriptions to tell us who the intended owners were, and as in most cases of unfinished work, the reason that it was left is unknown.

Painted limestone statue of a servant grinding grain.

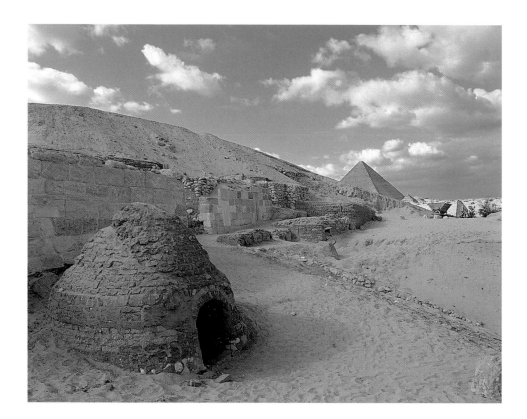

Two especially interesting burials were that of a dwarf woman, little more than one meter in height, who had apparently died in childbirth. The skeleton of her baby was found inside its mother's body. Another is that of a young lady approximately 15 years old at death who was buried holding a shell kohl pot in her hand. Kohl was used to line the eyes and has medicinal properties that protect them from infection. It was also associated with ritual purity and divine qualities that are reflected in the heavily outlined eyes of statues and reliefs.

THE UPPER CEMETERY

Higher up the hillside and connected by a stone ramp with the workers' tombs below, is a cemetery of larger and more elaborate tombs. Many of these are completely rock-cut or have a stone facade built in front of the cliff face. A large, impressive bee-hive tomb, the local variant of the pyramid form, stands prominently at the top of the ramp, reminiscent of a sheikh's tomb today. The size and location of these upper tombs indicates the higher status of those buried here. One tomb owner bore the title, 'Overseer of the Side of the Pyramid' and was clearly connected with the maintenance of the nearby royal monuments. Goodness knows what exactly he did, but the title sounds impressive. Another man buried here has a title which could be translated either as 'Overseer of the [Pyramid] Building' or as 'Overseer of the Workshops.'

Amongst the tombs here is one belonging to a man named Nefer-Theith and his two wives. The tomb contains a passage in which there are three false doors and an inscribed panel giving the name of

Upper level of the Workmen's Cemetery, Giza. In the foreground is a large beehive-shaped tomb and beyond it is the old stone ramp leading from the lower cemetery. In the background is the Great Pyramid of Khufu.

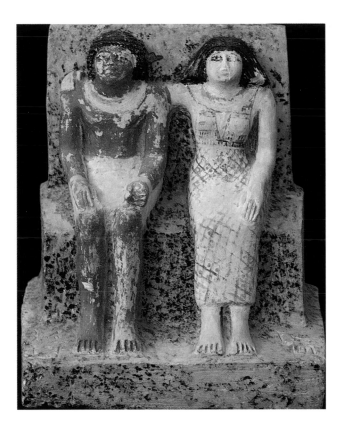

Nefer-Theith, the owner, and a list of ninety items to be offered in the tomb on the various festivals. Each wife had her own false door in the chapel where the names of her children were inscribed. Nefer-Hetepes, who was apparently the chief wife, had the title of In-Aut, 'weaver.' She had eleven children, eight boys and three girls. She appears several times in the tomb in scenes that show her standing behind her husband, of equal height, placing her hand on his shoulder. The second wife recorded seven children, four sons and three daughters. It is not known whether both wives were married to Nefer-Theith at the same time, or if one followed the other.

The northernmost of the three false doors shows Nefer-Theith on the outer panels accompanied by three different sons, one of whom offers incense to his father. Beneath both figures of Nefer-Theith at the base of the false door are small vignettes showing servants making bread and beer. On the left side a woman is straining the mash through a sieve while a man pours the beer into jars. Both the man and woman are unnamed. On the right side a kneeling woman called Khenut is grinding grain on a saddle quern, and facing her a man named Kakai-ankh stokes the fire under a pile of bread moulds while shading his face from the heat with his hand. The woman Khenut is a two-dimensional version of the statuette found in the tomb of Hep-ni-kaues.

On the inner panels of the false door Nefer-Theith and Nefer-Hetepes stand facing each other accompanied by sons. Beneath them are two men identified as ka-priests carrying baskets of food. The scenes of food preparation and ka-priests bringing provisions were undoubtedly intended to ensure magically a constant supply of offerings like scenes of food production in the elite tomb chapels of this time. However, the addition of these small scenes of brewing and baking to the standard false door and their position underneath the figures of the tomb owners is extremely unusual. An important detail for

Limestone statue of a craftsman and his wife.

dating this tomb is the name of the baker, Kakai-ankh, which is based on the name of Neferirkare-Kakai, the third king of Dynasty 5. This indicates that Nefer-Theith and his wife probably lived during his reign or just after.

The southernmost false door has similar small scenes at the bases of the outer panels. On the left is a kneeling woman named Inet grinding grain, while on the right side a squatting man is baking bread.

The central false door is inscribed for Nefer-Hetepes herself. It does not have the scenes of servants preparing food. She is shown standing in the usual skin-tight long dress which clearly delineates the contours of her body. Her hair falls behind and in front of her shoulders and she wears a broad collar about her neck. Her right arm is raised on her breast while her left hangs straight by her side. The formal inscription over her figure lists the offerings she is to receive and the special occasions of the various feasts when they should be presented. There is little difference between the treatment accorded this woman and that given her husband, each having equal status in the tomb chapel.

In contrast to the representations of Nefer-Theith and his wives, another artisan, Petty, and his wife, Nesy-Sokar, are only depicted separately. She was a priestess of the goddess Hathor, Mistress of the Sycamore, and is described as 'beloved of the goddess Neith.' One scene shows Nesy-Sokar and a daughter who holds a mirror and a bag. The reliefs of Nesy-Sokar are bold and striking. She is shown standing on the door jamb of the chapel in the traditional pose with one arm raised on her breast and the other by her side. She wears a tight dress, is bare breasted and has both a choker collar and broad bead necklace around her neck. Her hair is divided in front of and behind her shoulders. The artist has portrayed her with her head slightly tilted up and forward, perhaps a realistic touch caused by wearing the wide, tight collar. This gives her face a bold and confident expression enhanced by the darkly outlined eye.

Samples of vertebral bones showing symptoms of severe
stress due to a difficult lifestyle.

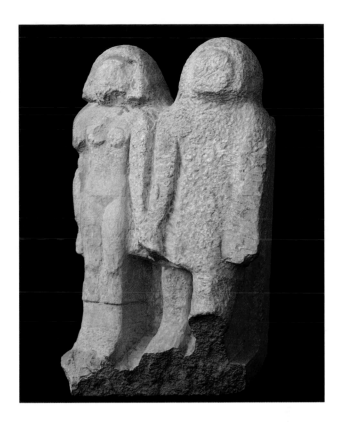

Another measure of her independence is suggested by a unique curse which occurs in two variants beside both her figure and that of her husband:

'O all people who enter this tomb,

Who will make evil against this tomb and destroy it:

May the crocodile be against them on water,

And snakes against them on land.

May the hippopotamus be against them on water,

The scorpion against them on land.'

In the husband's version he calls on the crocodile, lion and hippopotamus, while the lady added the snake and the scorpion.

These tombs are located along the hillside south of the Sphinx and the great stone embankment known as the Hait al-Ghurab. They overlook an area at the edge of Nazlit al-Samman where the bakery (described in the chapter on 'Working Women') and other service buildings have recently been found. These belong to a much more extensive Old Kingdom domestic settlement which is now known to lie under the modern houses nearby.

During the implementation of a wastewater project in the streets of the local towns, deep trenches revealed the remains of buildings. All that remains of this town are the fragments of mud-brick walls and quantities of broken pottery, but even with this slender evidence, certain areas could sometimes be identified. East of the Sphinx, a very large building of massive mudbrick walls and cleanly swept courts or rooms came to light. Fragments of limestone that may have come from wall-lining slabs, red-granite chips, and much fine pottery suggest an elite building. It is tempting

Unfinished statue of a man and his wife.
The Workmen's Cemetery, Giza.

to imagine an important administrative center here, but unfortunately the evidence is not sufficient to prove it.

Another area yielded a concentration of beer-jar fragments indicating the remains of a brewery. Next to this, thousands of broken pottery bread moulds, burnt clay and ash-laden soil must have come from a second bakery, similar to the one found at the edge of the cemetery about a kilometer away. The area between these two bakeries yielded evidence of mudbrick housing, some quite ephemeral, others deeply stratified and suggesting longer periods of occupation.

From the limited remains uncovered it is not possible to distinguish different sorts of housing or occupation. Thus we cannot know whether the social divisions apparent in the cemetery where artisans, overseers, and workers were buried in separate areas, reflect a similar segregation in the living quarters. There is no doubt, however, that at least some of the occupants of these tombs were inhabitants of the vast Old Kingdom town that developed to the east of the Giza pyramids.

THE PHYSICAL ANTHROPOLOGY OF THE ARTISANS AND WORKERS

The human remains found in the tombs were examined by physical anthropologist Dr. Azza Sarry el-Din who contributed the following report:

A sample of skeletons examined from the Workers' Cemetery at Giza showed that males and females were equally represented. A higher mortality was found in females than in males below the age of 30, a statistic undoubtedly reflecting the hazards accompanying childbirth. Amongst older age groups the mortality of females is highest between the ages of 35 to 39. On the whole the population represented were of relatively low stature. This is shown by a comparison with another group of contemporary skeletons from the Western Cemetery at Giza in which members of the elite classes were buried. Here the indications were of a healthier population in which women might expect to live on average five to ten years longer than the women of the artisans' and workers' community.

Degenerative joint diseases were frequent among the artisans and workers and more severe than in the upper class skeletons of the Western Cemetery. These diseases were found especially in the vertebral column, in particular in the lumbar region, and in the knees. The crucial factor determining the expression of degenerative disease in severe form at an early age is the presence of chronic severe functional stress. This implies a vigorous lifestyle for the artisans and workers, which may be the main cause of the degenerative arthritis found among them.

Fractures of the crania and extremities were frequent. Depressed fractures of the parietal bones were found in two female skulls. Both were left sided, indicating that the injury was done in face-to-face assaults by right-handed attackers. Extremity fractures were found in both the artisans and workers, and in the Western Cemetery, there were skeletons that showed healing and therefore survival after fracturing.

One of the more interesting cases is the female dwarf (see above). Dwarfism is a genetic disease which affects the growing ends of the bones. The pregnant female, aged about 20 to 25, had a total stature estimated at about one meter with limbs shorter than the trunk.

Limestone statue of Hep-ni-Kaues from her tomb
in the Workmen's Cemetery, Giza.

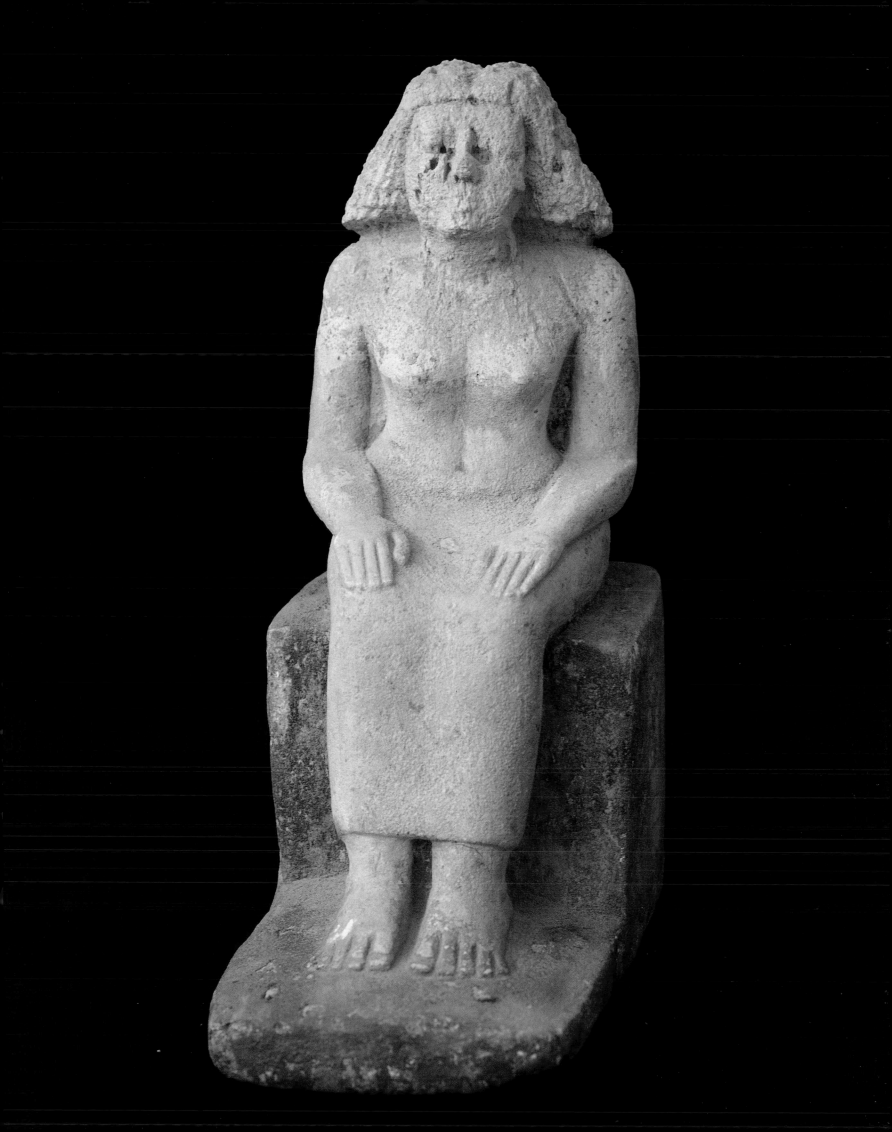

XI
RELIGIOUS LIFE

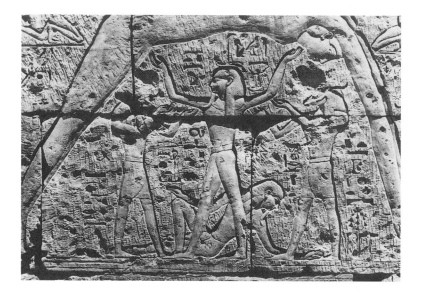

For the ancient Egyptians, religious belief was not a matter of personal conviction, it was a way of life. They perceived a world permeated by spiritual forces which controlled the natural environment and could manifest themselves in almost any form. Communication with these forces was possible through rituals and oracles. Although it was the divine king who was the chief intercessor with the gods, it was possible for the individual also to communicate through dreams and ecstatic experiences.

Humanity's task was to uphold the divine order which had been laid down at the beginning of time and to make sure that everything functioned according to *maat*, the cosmic truth. Temple rituals were part of this order. Preserving them played a central role in the functioning of Egyptian religion and was an important way of maintaining *maat*.

At a very early period, the physical forces that controlled life—the sun, the moon, the annual inundation, the fertility of the land or of the animals—were personified and worshipped. They were often depicted in animal form or with a human body and an animal head, and sometimes in purely human form. Each district was associated with a particular deity, the 'lord' of the area. Through the historical period, these local gods remained distinct, and although they might have been equated with other similar deities, they never completely lost their original identity. There was no attempt to synthesize the vast pantheon or to iron out the contradictions in mythology. They perceived truth as multifaceted and respected each version. Some of these local gods became so important that they were elevated to state gods. Amun of Thebes was one such district god who became the 'King of the Gods' when the Theban dynasties devoted to his worship promoted his cult. Other gods never achieved more than local popularity.

The god Shu supporting the body of the sky-goddess Nut. He is assisted by two figures of the god Khnum. At his feet is the earth-god Geb. New Kingdom.

A column, its capital shaped like the sacred rattle of Hathor (sistrum). Deir al-Bahari, Western Thebes. New Kingdom.

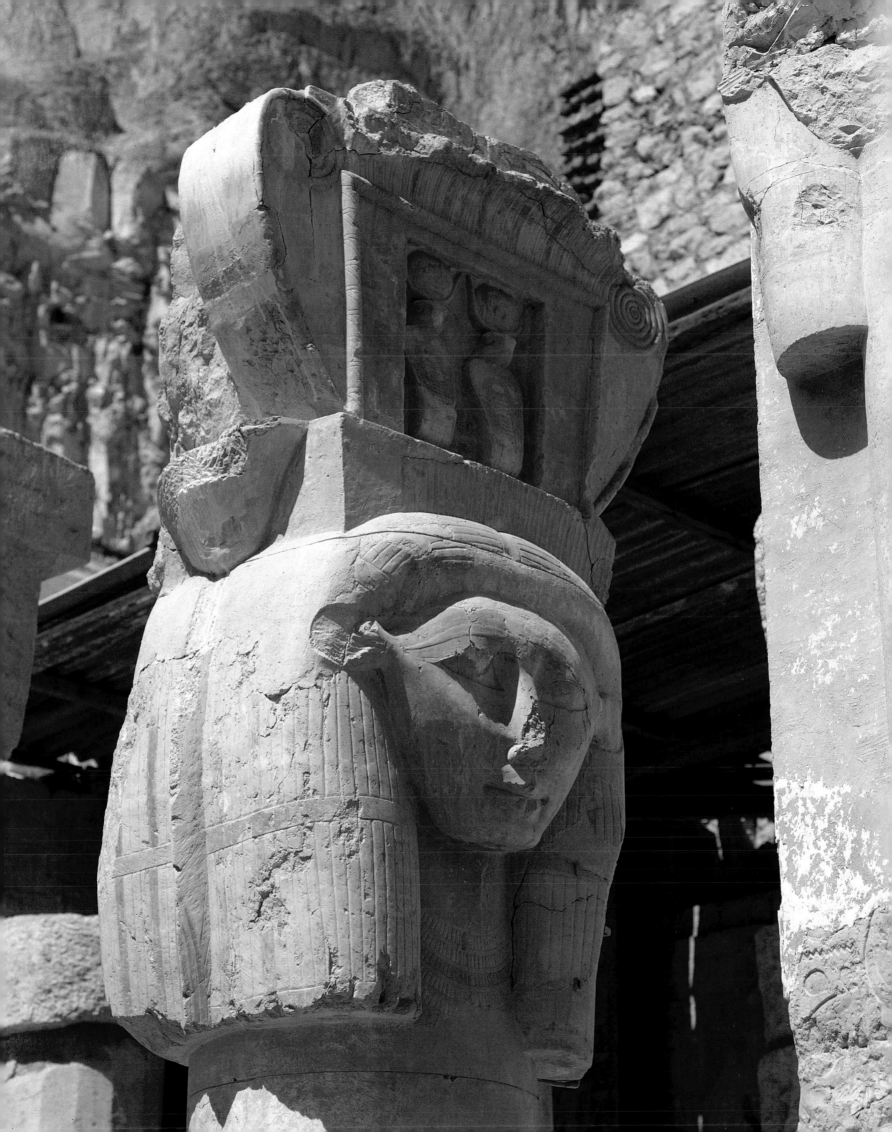

The regularity of the agricultural cycle—the desiccation of the summer, the inundation followed by the renewed fertility of the earth—so impressed the Egyptians that most of the different creation myths incorporated the image of a primeval mound arising out of the waters of chaos which existed before Time. Three distinct versions are recorded. In the Heliopolitan myth, a creator god, Atum, arose from the primeval mound and created two beings, Shu and Tefnut, who in turn, created the sky goddess, Nut, and the earth god, Geb. Their four children were Osiris, Isis, Nephthys, and Seth. Another version, that from Hermopolis, records the birth of the sun god on a lotus blossom, growing out of the primeval mound. The Memphis theology is more abstract; Ptah, the god of Memphis, arose on the primeval mound and created all the other deities and all beings in his heart and gave them form through his speech. It was also possible for the creative principle to be expressed through the feminine principle. Like Atum, Re, and Ptah, the goddess Neith of Sais brought the world into being without a partner, conceiving all of the deities and human beings in her heart.

All these deities were believed to reside within their temples from where their spiritual energy could be channeled into the human world. The temple, designed as a series of courts and chambers and cut off from the outside by a massive enclosure wall, served both to house the deity and to protect it from contamination by impurities. The mythical landscape of the first reed structure upon the primeval mound was recreated in the architecture. Columns shaped like bundles of papyrus, lotus blossoms or palm leaves supported ceilings covered with stars. Cornices and door mouldings resembled reed bundles. The shrine of the god, shaped like a reed cabin, was housed in the innermost part of the temple, and held a statue, often made of gold, in which the deity was believed to dwell.

Troupes of male and female dancers and musicians. Six female dancers are depicted doing an acrobatic dance below. Three women are shaking sistrum rattles. Red chapel of Hatshepsut, Karnak. New Kingdom.

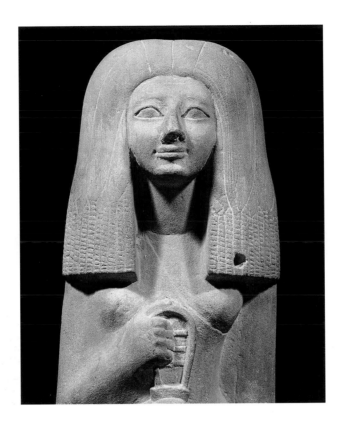

THE DAILY RITUAL

As the chief intermediary with the divine world, it was the king who, in theory, conducted the temple rituals; in practice he delegated this duty to the high priests of each temple. Nevertheless, the depictions of ceremonies around the walls of the temples show only the king communicating with the gods. In fact, the large temples were staffed by many categories of priests. At the top were various ranks of hemu-netjer, literally, 'servants of the god,' whose duties were to see to the needs of the deity and celebrate the ritual in the god's sanctuary. They were aided by wab priests who spent one month in four on duty. During this time they had to be ritually pure, abstaining from certain foods and any sexual activity, shaving all the hair of their bodies and bathing twice daily in the sacred lake. They were responsible for the daily running of the temple and included administrators, scribes, astronomers, and seers. Lector-priests read out the prayers for the day, accompanied by musicians and singers.

The temple ceremonies were private with only the ritually pure priesthood participating. The local populace was only allowed as far as the first court, and then only at certain times.

Very little information has survived about the temples of the local gods in the Old Kingdom. These must have been of modest size, built of mudbrick and located in the center of their town. We know from later inscriptions that they were altered and rebuilt over long periods until none of the earlier structures remained. Of the Middle Kingdom temples, a few small structures survive and indicate that the temple ritual was much the same as that illustrated in numerous temple reliefs of the New Kingdom and later.

Sandstone statue of Henuti holding the sacred rattle of Hathor (sistrum). Louvre Museum, Paris. New Kingdom.

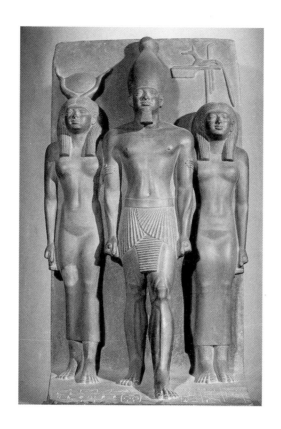

The daily ritual began at dawn when the king or his deputy was purified with water from the sacred lake by priests impersonating Horus and Thoth or Horus and Seth. Dressed in the appropriate garments, the officiating priest was conducted through the temple halls to the sanctuary of the god. Breaking the seals on the bolt, he opened the doors of the shrine, and entered. The statue of the god was then purified with incense before its adornments and garments were removed; it was purified again with incense and natron and fresh clothing was presented. Then, on an offering table before the shrine, the morning meal was laid out and each item was symbolically offered to the deity. After more incense was burnt, the doors of the shrine were closed, locked and sealed. The food offerings were removed and the sanctuary was swept to remove all footprints before being closed. A ceremony known as the 'reversion of offerings' then rededicated the same food to the spirits of the ruling king and his ancestors. The priests then carried the food out of the main halls of the temple and after a second reversion, it was distributed to them as part of their salaries.

Another offering ceremony took place at the end of the day and each temple had a full program of monthly festivals. On the most important feast days, the statue of the deity was brought out of the temple, usually enclosed within a portable shrine, and carried on the shoulders of the priests. On these occasions, the public could put questions to the deity who answered by causing a movement of the shrine, advancing or backing according to the reply.

Group statue of Menkaure and Hathor wearing the disc and horns. The female goddess on the right represents the goddess of a 'dog' nome. Egyptian Museum, Cairo. Old Kingdom.

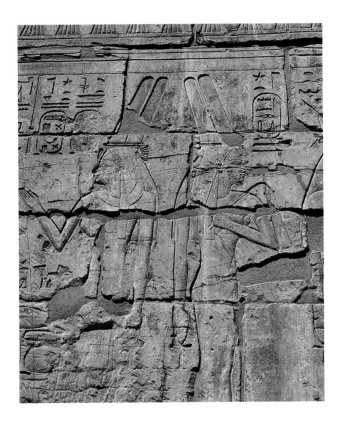

PRIESTESSES OF THE OLD AND MIDDLE KINGDOMS

In the Old and Middle Kingdoms, the priesthood was recruited from local dignitaries, officials, and their wives who would spend only part of their time performing priestly duties. The wab priests were divided into groups, each of which served in the temple for one month in four or five and followed their lay profession at other times. Women could also hold priestly office, and one of the most common titles for the upper classes was 'priestess of Hathor.' It seems that the cult of this great goddess was carried out principally by women, as very few male priests of Hathor are recorded at this time. Priestesses of the goddess Neith and other minor goddesses are also known in the Old Kingdom, and the grand-daughter of King Khufu unusually bore the title of 'Chief Priestess of Thoth.' This is a rare case of a woman serving as a priest of a male deity, as in the Old Kingdom women usually served female deities and men served male ones.

At least two ranks of priestesses are known: the hemet netjer, 'the female servant of the god,' and less commonly, the wabt or 'pure' priestess. These were responsible for carrying out the daily rituals and feasts of the goddess, but there is no evidence of women filling administrative posts in the temple. In addition to the actual presentation of offerings, hymns and litanies were sung or chanted, accompanied by rattles known as sistra. There were also dances performed in Hathor's honor, such as 'Hathor's dancing game' played with mirrors and clappers, as shown in some of the tomb paintings. During her feasts, a game was played in which a ball, representing the eye of the evil snake Apophis, was beaten by sticks symbolizing the rays of the sun.

The two god's wives of Amun, Shepenwepet and her adopted daughter
Amunerdis. Temple of Madinat Habu, Western Thebes. New Kingdom.

HATHOR

The goddess Hathor was the goddess of women par excellence. By the beginning of the historical period, she was equated with many different local goddesses and manifested herself in several different forms. Her name means literally, 'the Mansion of Horus,' and she must have originally been a personification of the shrine which protected the falcon-god. As the king was a manifestation on earth of Horus, so the queen was intimately associated with Hathor. In the Old Kingdom, statues of King Menkaure are sometimes accompanied by his wife, Queen Khamerernebty, sometimes by the goddess Hathor. Both females bear exactly the same facial features and would be indistinguishable were it not for the goddess's distinctive headdress. By the New Kingdom, the Hathor headdress had become part of the queen's regalia, confirming the intimate connection with the goddess.

Hathor was the goddess of procreation and maternity in all its aspects: pregnancy and birth as well as beauty, love, and pleasure. She was usually depicted as a cow-goddess, whose protective horns sheltered the sun's disc and whose milk nourished Horus, the king. As a woman, she is shown with cow's ears, wearing the horns and disc as a headdress. In several of the myths, she is portrayed as the daughter of Re, the sun god, who will defend her father when necessary. Her different personalities have different forms. One myth described her as a wild lioness, roaming the deserts and terrorizing people by her blood-thirsty attacks. Her father Re decided that he wanted her near him, to defend him with her fiery nature. He recruited the help of Thoth, god of wisdom, to entice the goddess out of the desert with his magic words while Shu and the dwarf god Bes aided him by distracting and amusing her with their singing and dancing. Together, they transformed her into the peaceful deity of love and beauty and led her to her father. Her ferocious aspect as Sekhmet the lioness was not annihilated but could be recalled to destroy the enemies of the sun-god.

At Dendera, she was worshipped as the consort of Horus of Edfu and the mother of Ihi, the child-god of music. Each year, her statue would leave the temple for a journey up the river to Edfu, called 'the Festival of the Beautiful Reunion,' to celebrate a sacred marriage with Horus. Amid enthusiastic rejoicing, the two deities were symbolically joined in marriage, epitomizing the union of the male and female principles and the resulting fertility. The celebrations were accompanied by singing and dancing, both activities being under Hathor's patronage. One object particularly associated with her was the sistrum, a rattle whose rhythmic sound may have been used to induce a state of ecstasy through which communication with the divine world was possible.

As the goddess of the pleasurable sides to procreation, she was invoked especially by young people in love, and one of her celebrations was 'the Feast of Drunkenness for Hathor.' This feast originated in another myth, in which the goddess in her ferocious lioness aspect was sent down to earth at the request of her father Re to annihilate humanity whose wickedness was disturbing the gods. At the end of the first day, Hathor-Sekhmet returned, her mouth dripping with blood, ready to finish off her task the next day. But Re took pity on the human race, and while the goddess slept, he ordered seven thousand vats of red beer to be brewed. These were tipped out over the land of Egypt and when the goddess arrived the next morning to finish off her task, she mistook the beer for blood. After admiring her reflection, she drank so much that she collapsed in a drunken stupor, forgetting all about the destruction of humanity. Thus mankind was saved by a ruse which was celebrated with enthusiasm each year. Like singing and dancing, drunkenness and love-making were all seen as routes to ecstatic experiences and a greater awareness of the spirit world.

But her role was not just that of wilful seducer or ferocious destroyer, but also that of the mother-goddess who could grant children and protect through the dangers of pregnancy and childbirth. For this, she was worshipped by women throughout Egypt, who visited her shrines to leave dedications asking for children. At her great center at Deir al-Bahari, thousands of votive objects invoked her procre-

ative and nurturing powers. Another form emphasizing her talent for sustaining life was as 'the Lady of the Southern Sycamore,' a goddess who manifested in the sycamore fig tree and offered shade and refreshment, especially to the spirits of the dead.

At Deir al-Bahari and other desert temples of Hathor, the shrine room was a cave cut into the cliff face. This chthonic aspect of the goddess is found again in her titles of 'Mistress of Gold,' and 'Mistress of Turquoise,' precious metals and minerals that were mined out of the rock and were under her aegis.

As goddess of birth in this life, she was the means to rebirth in the Afterlife. At Thebes she was sometimes represented as a cow emerging from the mountain of the West, where the sun sets each day and the dead were supposed to dwell. Another of her forms was as 'Mistress of the West,' a beautiful woman who welcomed the dead. As the living are born from women, so the dead hoped for rebirth in the 'Beautiful West' through the mother-goddess.

MUSICIANS AND SINGERS

Singing, dancing, and music all came under the patronage of Hathor, or her playful, cat-like manifestation, Bastet, and were essential parts of the temple ritual. In the Old Kingdom, the priestesses fulfilled these roles. By the New Kingdom, the title of shemayet, 'singer' or 'chantress,' was the most common temple title for women of the elite classes. At Thebes, almost every woman of status was a 'chantress of Amun,' who was by now the greatest state god.

The administration of temple property, whatever the deity, seems to have been in the hands of men, probably because women were usually not literate, at least, not officially. This question of literacy may also be the reason why, in the New Kingdom, women rarely hold the title of priestess, even in the cult of Hathor. The priesthood had by then become a branch of government bureaucracy and the higher ranks were full-time appointments; women were thus automatically excluded, as they were from all state administrative positions. But from the Third Intermediate Period on, high-ranking women once again bear the titles of priestesses of various cults.

However, in the New Kingdom, women continued to play an important, albeit auxiliary, role in temple ritual as singers and musicians attached to cults of all deities, male or female. These singers were often the wives of priests in the same cult, and it is not known if their post was part of the husband's appointment, or an independant position. Groups of singers are shown accompanying processions and festivals, singing hymns to the gods, and performing vigorous dances. They usually carry as a badge of office the sistrum rattle and the menit—a many-stranded necklace of beads attached to a counterpoise—both of which made a rattling noise when shaken. More sophisticated instruments were also used in the temples at this period, such as harps, flutes, and tambourines.

A band of singers and musicians called a 'musical troupe' was attached to the temple or to a palace. The title of 'overseer of the musical troupe' was usually held by the wife of a high-ranking priest of the temple. These troupes seem to have included men as well as women but their status in the temple hierarchy is not clear. Judging from the inscribed objects which they have left, the female musicians appear to belong to the elite classes while the male musicians are usually not named. They are depicted performing together on reliefs of Hatshepsut, where she is shown as king carrying out rituals before the god Amun. A male harpist sings a hymn while behind him, three women of the musical troupe are shaking sistrum rattles and singing. Below, female dancers do vigorous back bends accompanied by male singers.

PRIVATE RELIGION

Outside the elite state cults, local communities very often had their own small temples where men and women of quite humble background could hold office. For example, on the north side of the workmen's village of Deir al-Madina stood small temples dedicated to Amun and Hathor which served the community. The men and women of the town performed the priestly duties in the local cult. Women who did not hold a position in the temple were still able to go into the outer courts of small and large temples to 'pour water' for the god or to petition the deity through prayer. Some women could afford to set up an inscribed stone tablet or stela within the temple precinct which would guarantee her spiritual presence before the god. These stelae were more commonly set up for men than women, but often women are shown with their husbands, more rarely alone, presenting offerings or lotus blossoms, or just raising their arms in adoration of the deity.

Quite apart from the local cult center, each house seems to have had its own domestic shrine, often housed in a small niche or alcove in the front room. Wealthy country houses even had a small chapel in the garden. Here, the domestic deities were worshipped, particularly those associated with the family and with children, such as Hathor, Taweret, and Bes. In a workman's house at Amarna, in a tiny room below the staircase a stele depicting a woman and a girl before the goddess Taweret, two female figurines, and two model pottery beds were found, all images connected with female fertility and childbirth. No records survive to tell us what form the rituals took at these shrines, or when they were used. In all probability, a simplified version of the offering ceremony took place at certain times

Maat, daughter of the god Re, mistress of heaven holding the ankh sign and with
the feather of Truth on her head. Tomb of Seti I, Valley of the Kings. New Kingdom.

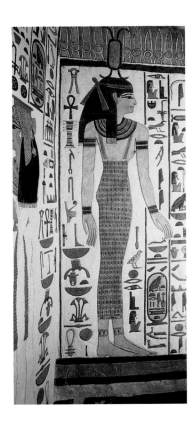

of the month or even each morning when prayers were said and food offerings were presented to the statue or stele in the niche.

Also found sometimes in the houses at Deir al-Madina were stelae venerating the deceased members of the community, addressed as 'excellent spirits of Re.' Sometimes dead relatives are mentioned on offering tables, and portrait busts set up on pillars in some houses are usually interpreted as ancestor figures. These ancestors must have been venerated at home, as well as at the nearby tombs.

'GOD'S WIFE OF AMUN'

In the early New Kingdom, the title 'god's wife of Amun' was bestowed by King Ahmose on his wife, Ahmose-Nefertari. The new importance of this ancient priestly office was guaranteed by a large endowment of goods, land, and personnel under the authority of the incumbent. For the next three generations, this office was bestowed on queens and princesses and seems to have carried considerable wealth and influence. After Ahmose-Nefertari, the title passed to her daughter, Queen Meritamun, to Hatshepsut while she was queen, and then to her daughter, Neferure.

It has been suggested in a recent study that Hatshepsut used this office to establish a powerbase from which she eventually took the titles of king. Little is known about the official priestly duties of the holder of this title. From relief scenes on a dismantled chapel dating from Hatshepsut's reign, it seems that she had an active role in temple ritual. These show a series of rituals performed by an anonymous god's wife of Amun, possibly Princess Neferure. She is shown leading a group of male priests to the sa-

The goddess Neith of Sais conceived all of the deities and humanity in her heart.
Tomb of Nefertari, Valley of the Queens, Western Thebes. New Kingdom.

cred lake of the temple for the ritual purification before entering the temple courts. They then proceeded to the sanctuary of the god where Hatshepsut as king performed the ceremonies in front of Amun with the god's wife of Amun in attendance.

After Neferure whose records cease at about the same time as those of Hatshepsut, the title was only used sporadically by royal women, and appears not to have carried the same privilege and importance. It was not used at all during the reigns of Amenhotep III and Akhenaten. If Hatshepsut's claim to kingship was in part derived from the prestige of this priestly office, it may well be that Thutmose III deliberately reduced its importance and authority to prevent any other ambitious woman from using it as a stepping stone to political power.

At the end of the New Kingdom, the importance of the office of god's wife of Amun was gradually revived, but in a different form. Until the middle of Dynasty 20, the title was held by female members of the royal family and seemed to have carried no particular prestige. By now the royal family resided in the Delta, some nine hundred kilometers from the religious center of Thebes and the temple of Amun, and probably only visited Thebes for the most important festivals.

From the earliest times, the temples were large land and property owners. Some of the income was used directly in the temple cult, some was used as salaries of staff and workers, and the rest was stored to be used as needed, particularly in times of want. Over the prosperous years of the New Kingdom, the temple of Amun at Karnak had become, apart from the king, the greatest landowner in the country, and controlled an enormous amount of wealth. Each king expressed his piety by endowing upon the temple extensive land holdings in addition to booty seized from the many Asiatic and Nubian campaigns. This included not only gold and silver, but livestock and prisoners-of-war. It has been estimat-

Life-size painted statue of the goddess Hathor as a cow emerging from the papyrus. Below her head is a figure of King Amenhotep II who is also shown drinking milk from her udder. Deir al-Bahari. Egyptian Museum, Cairo. New Kingdom.

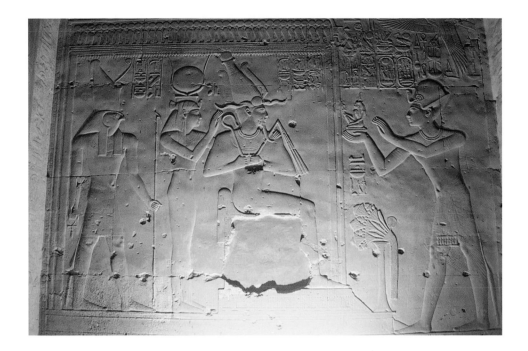

ed that the temple of Karnak owned about a quarter of the cultivated land of the country, as well as extensive storehouses, granaries, and workshops manned by slaves. By consequence, the office of high priest of Amun was one of the most important and influential posts in the country. By the middle of Dynasty 20, it had passed into the hands of one family who consolidated their power and attempted to found a family dynasty.

In the reign of Rameses VI, his daughter Iset was appointed to be god's wife of Amun. For the first time, it seems that the holder of this office was unmarried. Her successors, all daughters of the king or of the high priest of Amun at Karnak, were also apparently not married and thus unable to found their own dynasties. Their loyalty would therefore be undivided. This change in the character of this office came at a time when political and economic difficulties were threatening the stability of the country and the high priests of Amun at Karnak were ruling not just Thebes, but virtually the whole of the South.

In the two centuries following the end of the New Kingdom, the country was in decline and fragmenting into smaller units. While the North was ruled by Dynasty 21, the South was controlled by a dynasty of high priests of Amun. The wives of the high priests bore high-ranking titles, including that of priestess in various different cults, while their daughters were appointed god's wife of Amun. At first relations between the northern capital at Tanis and Thebes were friendly and the families were linked by marriage. But when the kings of the following dynasties tried to control the South by appointing a son to the office of high priest, their attempts were unpopular and unsuccessful.

Eventually, the last rulers of Dynasty 23 used the more traditional appointment of a royal daughter to the position of god's wife of Amun to draw the South under their control. As the post demanded celibacy, the office passed by adoption to the daughter of the next ruler, keeping it firmly under the

King Seti presenting an offering of Maat to Osiris. Behind him
stand Isis and Horus. Temple of Seti I, Abydos. New Kingdom.

control of the northern kings. The system was so successful that it worked through changes in the ruling family, as when the invading Kushite kings from the South established themselves as Dynasty 25. The incumbent god's wife, a daughter of Osorkon IV called Shepenwepet, adopted the new ruler's sister, Amenirdis. This office increased in wealth and prestige once more until it eclipsed that of high priest, and the god's wife became the virtual ruler of Thebes. Her huge estates were managed by stewards who themselves became figures of great importance in Thebes, leaving many monuments and magnificent tombs.

After the final expulsion of the Kushites by the Assyrians sometime between 667 and 657 BC, Psamtek I established Dynasty 26 at Sais in the Delta and his daughter Nitocris was adopted as the successor to the god's wife of Amun. She came to the post with considerable wealth and ruled Thebes for over seventy years. Her adopted daughter, Ankhnesneferibra, held office for at least sixty years. Both held the title of chief priestess of Amun as well that of god's wife, and are well documented through the chapels they erected at Karnak. Here, the god's wife is portrayed wearing the double plumes of the queen's headdress and performing rituals usually associated only with the king. She is shown in front of the god, presenting offerings or an image of Maat, playing the sistrum or conducting foundation ceremonies. In their turn, the gods are shown purifying her, crowning her, and embracing her, as was depicted in representations of a king's accession.

Their tombs which were also built like small chapels, lie across the river in the precinct of Rameses III's mortuary temple at Madinat Habu. These were the last two gods' wives of Amun who wielded power. After the Persian invasion of 525 BC, this religious position declined as Thebes lost its supreme importance as a religious center.

Nefertari with the goddess Hathor, Mistress of the west. Tomb of Nefertari, Valley of the Queens, Western Thebes. New Kingdom.

Nut in the form of the goddess of the sycamore tree offering food and refreshment to the deceased. Tomb of Sennedjem, Deir al-Madina. New Kingdom.

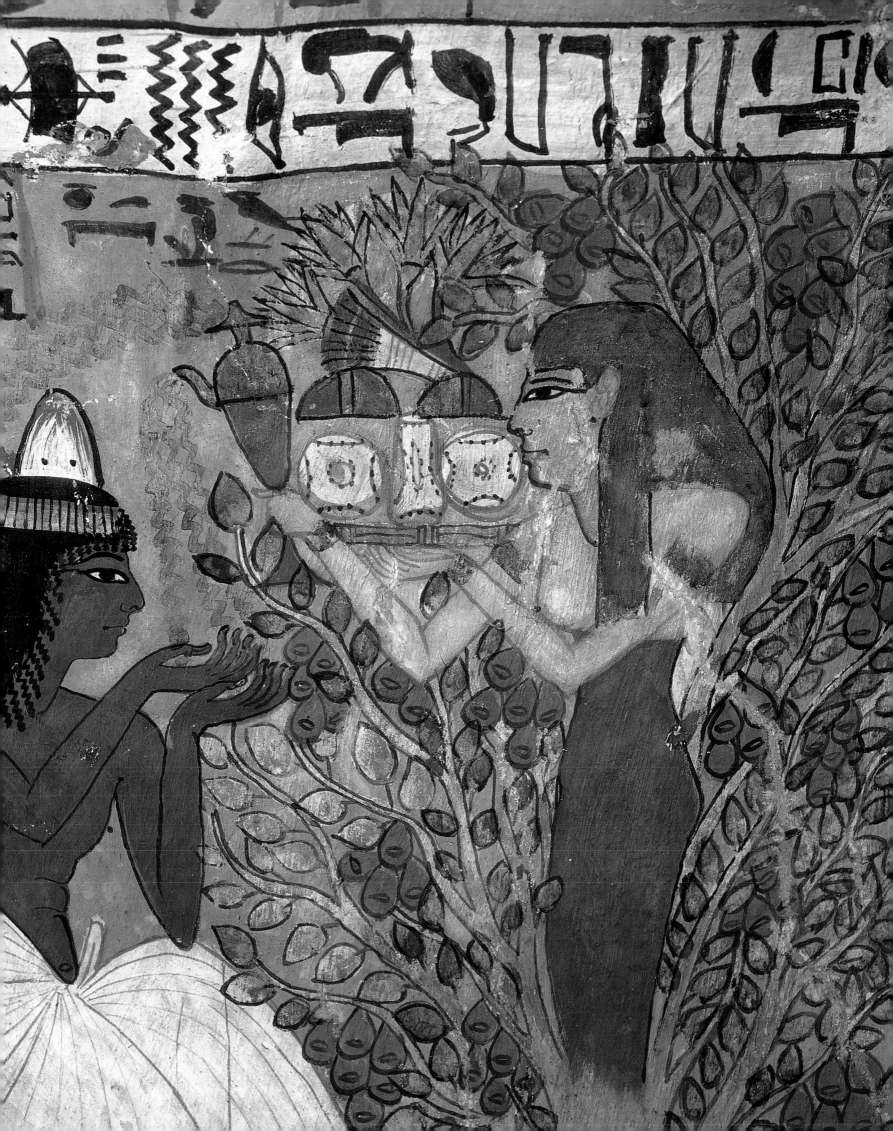

XII
DEATH AND THE AFTERLIFE

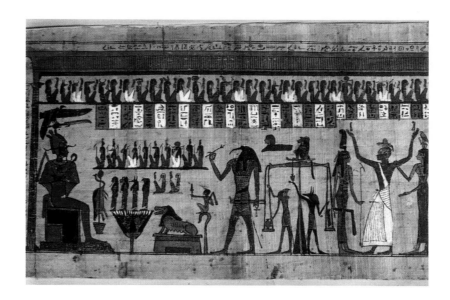

To the early Egyptians the natural rhythms of nature, the daily rising and setting of the sun, the annual fertilizing flood of the Nile, and the growth of crops were seen as cycles of life, death, and rebirth. They gave assurance that mankind was also part of these cycles and could expect life after death. This was reinforced by the mythology of Osiris, the god who died and was brought to life again as the ruler of the Underworld.

Before the invention of writing, religious beliefs can only be guessed through interpretations of archaeological material. The idea that death was a transition to rebirth in another existence seems to be in evidence already in the earliest burials of the predynastic period. Here, in shallow graves in the desert, bodies were wrapped in mats or skins and placed in a foetal position. The face was turned towards the west—the direction of the setting sun, the abode of the dead. Women as well as men were buried with care. At Abu Rawash, excavations by the Department of Antiquities uncovered the grave of a woman whose head was resting on a grinding palette; stone vessels and ornaments had been placed nearby.

In these shallow graves, the desiccating action of the hot sand dried the bodies and preserved them naturally. This phenomenon may have contributed to the belief that the preservation of the body after death was important. It could have been the inspiration for the development of mummification in later periods, for when the body was placed deeper in the ground, and protected from the hot sand by coffins and wood-lined burial chambers, it would have decayed.

By the earliest dynasties, attempts were being made to preserve bodies by wrapping them in linen and sometimes remodelling the features in painted plaster. This produced a lifelike appearance, but the body inside the wrappings was soon reduced to a skeleton. No doubt, experiments were made with dif-

In the Hall of Judgement, the heart of the deceased is weighed before Osiris, god of the dead, and the jury of forty-two gods. Book of the Dead. New Kingdom.

Pyramid texts in the pyramid of Unas, Saqqara. Old Kingdom.

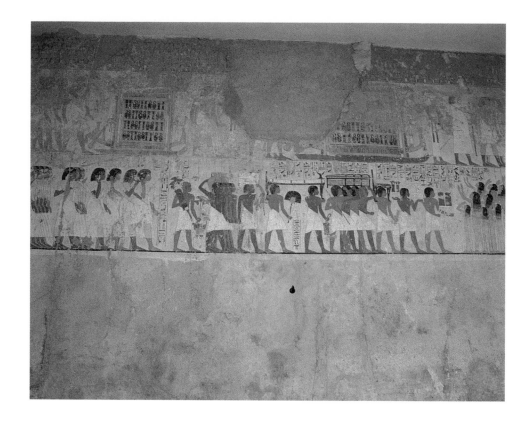

ferent procedures, but none of the early mummies has survived. However, one royal burial of Dynasty 4, that of the mother of King Khufu, Queen Hetepheres, was found at Giza. Although her body was not found within its sarcophagus, it had certainly been mummified. An alabaster box still contained her wrapped viscera (soft organs) resting in a dried solution of natron (a natural salt compound) after four-and-a-half thousand years. This is one of the earliest pieces of evidence for the removal and separate preservation of the fast-decaying viscera.

LIFE AFTER DEATH

At death, the Egyptians believed that a person's being fragmented into several different elements, which included the *ka*, the *ba*, and the *akh*. The *ka* was the individual life force and protective genius; present in life, it had the same needs after death—food, drink and shelter. The tomb was built for the *ka*, as a dwelling place where offerings were presented. The *ba* was a more mobile spirit entity and was usually depicted as a human-headed bird. It could travel between the tomb, the celestial regions, and the Underworld. It was the *ba* that had to find its way to the Judgement Hall of Osiris, where it had to answer to the forty-two assessor gods and convince each one of them in turn that it had not sinned:

O wide-of-stride who comes from On: I have not done evil.

O Flame-grasper who comes from Kheraha: I have not robbed.

O Long-nosed who comes from Khmun: I have not coveted…

Then the heart (the seat of conscience) was weighed against the feather of truth, symbol of the god-

Grave goods carried in a procession to be placed in the tomb.
Tomb of Ramose, Western Thebes. New Kingdom.

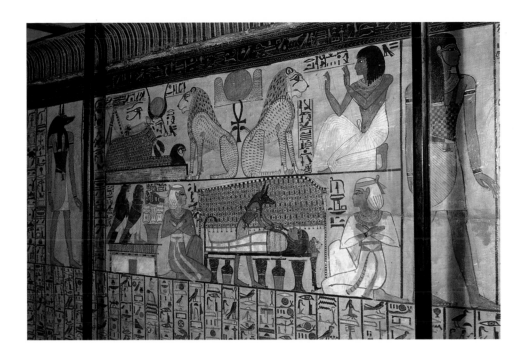

dess Maat. Those who did not pass the judgement were denied entry into the realms of Osiris and died a second and final time.

The focus of many of the funerary practices was the union of the *ka* and the *ba* after death. When this was achieved, the deceased became an *akh*, a transfigured spirit whose place in the Afterlife was assured.

You have gone away to live.

You have not gone away to die.

You have gone away to become *akh* among the *akhs*.

In order to accomplish this reunion, the *ka* needed a 'home base' which was the body. This was undoubtedly the reason why mummification played such an important role in Egyptian funerary practices. To protect the body, elaborate tomb structures were developed. These varied over time, but always included the place of burial which was below ground and closed off. Above or near the burial chamber were usually (but not always) the offering place, which could be a niche or a false door set in a wall, and an offering table. In wealthier tombs, the false door was housed in a decorated multi-roomed chapel that was accessible to visitors.

MUMMIFICATION

The process of mummification developed into a craft which reached its apex in the realistic preservation of the body in Dynasty 21. Traditionally, the period between death and burial was seventy days,

Upper register: The deceased adoring the sun disk in the horizon between the two lions of yesterday and today. New Kingdom. Lower register: A priest wearing the mask of the god Anubis tends a mummy lying on a lion bed. On either side the goddesses Isis and Nephthys protect the deceased. Sarcophagus of Khonsu, son of Sennedjem, Egyptian Museum, Cairo.

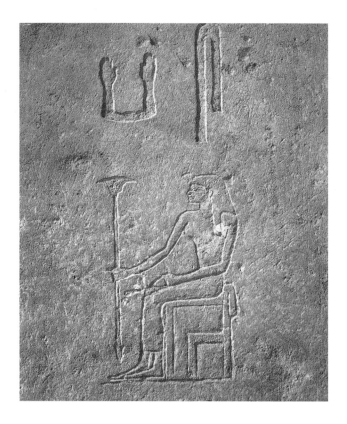

during which time the body was mummified. It was removed to the per nefer, the 'good house' where the process of embalming was carried out. First, four of the internal organs were removed through an incision in the left abdomen; these were the lungs, liver, stomach and intestines which were dried, wrapped, and placed in four 'canopic' jars. The heart, thought to be the seat of intelligence, was left in place. The brain, which also decays and turns to liquid fast, was extracted through a hole pierced through the nasal cavity. This process was sometimes speeded up by injecting a purgative liquid into the skull that dissolved the brain tissue. The resulting fluid then drained out through the same hole. This initial process probably took about four days, after which the disembowelled body was packed in natron and completely dried out, a procedure which took between thirty and forty days.

Then came the art work. The embalmers' job was to turn the emaciated body into something resembling its former self. First the internal cavity was coated with resin and filled with cloth, sawdust, bags of clay, anything in fact that came to hand. The skin was coated with oils and then sometimes padded out with wads of cloth inserted just below the skin. Artificial eyes of stone, glass or wood were inserted in some cases.

At this stage, the body was ready for bandaging, an operation that was done according to a lengthy ritual over a period of fifteen days. The fingers and toes were wrapped separately, then the arms were each bound and folded over the chest or stomach, or placed beside the body. The legs were wrapped separately and then bound together. The body and head were enveloped in meters of linen bandages and the whole covered by a shroud. Protective amulets, often of gold or precious stones, were inserted at specific points in the wrappings, and each layer of bandages was sealed with hot resin. For royalty, gold finger and toe stalls were placed on the body before bandaging and a gold mask was put over

Scene showing Queen Khentkaus wearing the vulture crown of the goddess
Nekhbet while sitting on a throne. Bas relief from her tomb at Giza. Old Kingdom.

the head. Then the finished mummy was taken to the wabet or 'purification place' for the rituals of purification and fumigation with incense, before being placed in the coffin and prepared for the final journey to the tomb.

In the New Kingdom, the whole process took seventy days, a period that may have been connected more with mythological ideas than with practical necessity. This was the period of time that the stars of the night sky disappeared below the horizon, where they were thought to undergo a process of renewal in the primeval waters of Nun, to be reborn just before dawn seventy days later.

FUNERARY RITES

The body, now transformed into something that would last for eternity, was taken on its final journey to the tomb. This is described in glowing terms in the Middle Kingdom story of Sinuhe: 'A funeral procession is made for you on the day of burial; the mummy case is of gold, its head of lapis lazuli. The sky is above you as you lie on the hearse, oxen drawing you, musicians going before you. The dance of the muu-dancers is done at the door of your tomb; the offering list is read to you; sacrifice is made before your offering-stone.' The procession was accompanied by relatives, the women wailing, tearing their clothes and hair, and sometimes collapsing from grief.

In front of the tomb, a special ceremony known as 'the Opening of the Mouth' was conducted by the sem priest, who ideally would be the eldest son of the deceased and the human representative of Horus vindicating his father, Osiris. Two women enacted the roles of Isis and Nephthys mourning for the

Part of the Book of Day and Night. Tomb of Rameses VI,
Valley of the Kings, Western Thebes. New Kingdom.

dead Osiris. In many cases these were close relatives, but professional mourners who would impersonate the two goddesses for a fee, are also known. The mummy was placed upright on a heap of sand and the mouth, eyes and nose were touched with various implements in order to restore the senses and enable the *ba* to return. Then a complicated offering ritual ensured that, through the presentation of food, drink, incense and many other things, the *ka* of the deceased would be strengthened and could eventually reunite with the *ba*.

After the ceremony, the body was lowered down the shaft to the burial chamber and the grave goods which had been brought in the funeral procession were put in place. The shaft was often filled up with stones and rubble to prevent robbery. Meanwhile, a feast was prepared for the relatives and mourners in which the deceased was expected to participate. As food and drink are essential for existence in this world, the life-sustaining energy that they obviously contain was believed to benefit the dead as well, although it was clear that the food itself was not consumed. At various times throughout the year, the family would come back to the tomb chapel, to share a meal with the dead who were considered part of the extended family. In return for regular food offerings, it was hoped that the dead ancestors would use their spirit powers to bring prosperity and ward off misfortune for the living. At Deir al-Madina busts or stelae of dead relatives, often not specifically named, but called 'spirits of Re,' feature in domestic dwellings and were undoubtedly included in the domestic cult. Letters were sometimes written to the ancestors asking for their help, for children, or even telling them to stop bothering the living.

These petitions, like the offerings of food and drink, were presented at the false door of the tomb. This niched recess was the interface between this world and the Duat, where communication was possible with the spirit of the deceased. In order to ensure continued offerings, wealthy people would endow property, especially land, for their cult and for the payment of a funerary priest, the hem *ka* or 'servant of the *ka*.' The person appointed was very often one of the heirs, so the property remained within the family while the dead were supplied with their needs.

In the Old Kingdom, we have plenty of evidence that women could serve as funerary priests, even in the cults of dead kings, and there are also titles of women serving as overseers of funerary priests. But from the Middle Kingdom on, these titles are borne by men only, although there are many representations of women making libations and offering before the dead. Wives are shown offering to husbands, or daughters to parents. Women could still inherit property, including tombs, and administer it on behalf of their families.

EARLY ROYAL TOMBS AND PYRAMIDS

In the period immediately before and after the unification of Egypt, two great cemeteries grew up at Abydos in the south and Saqqara in the north, both centers of ancestor worship. The kings, it seems, were buried at the foot of the cliffs at Abydos. In a central chamber lined with wood or mats, the body was buried in an extended position in a wooden coffin. Grave goods were placed in adjoining chambers. The tombs seem to have been marked by simple tumuli of sand, and around them, graves contained the bodies of court attendants who were almost certainly buried at the same time as their masters. Large mudbrick enclosures on the edge of the cultivation were the funerary palaces for the cult of the dead king.

Certain royal ladies were also given elaborate burials at this early time, but the dearth of historical records makes interpretation of these monuments difficult. Certainly Neith-hotep, probably the wife of King Aha of Dynasty 1, was given a magnificent burial in a huge mastaba tomb at Naqada and must have been a woman of some importance. Another queen's burial, that of Queen Merneith, was found in the royal cemetery at Abydos. On later analogies, the location of her tomb in a kings' cemetery implies that she may have ruled in her own right.

Further north, on the desert cliffs at Saqqara overlooking the new capital of Memphis, flat-topped mastaba tombs were built for officials and perhaps also members of the royal family. Here the two separate elements of the Abydos burials, the grave covered by a low mound and the funerary enclosure, were combined in one unit. The burial pit was covered by a brick superstructure containing many chambers filled with grave goods, all enclosed within a recessed mudbrick wall. The form of these tombs was almost certainly adapted from the houses and palaces of the time, and they were regarded as the dwelling places of the dead.

In one early tomb, the tumulus over the burial shaft was built of stepped mudbrick. As this has no obvious structural function, it is most likely that it was a symbolic recreation of the primeval mound from which all living beings arose. It was this feature which was later developed into the step pyramid in the reign of King Djoser of Dynasty 3. His architect, Imhotep, broke with tradition by constructing at Saqqara the first 'pyramid' of six steps. This dominates a huge enclosure containing courtyards and stone buildings intended for various ceremonies connected with the Afterlife of the king. The step pyramid itself is a representation of the primeval mound, and even when the true pyramid was developed a few generations later, it never lost this original symbolism. The capstone on the top was called the benben, a name for the primeval hill at Heliopolis.

For the next thousand years, kings and often also their queens were buried in pyramids. At Giza, where the greatest pyramids were built, the chief royal ladies of Khufu and Menkaure were interred in small pyramids next to that of the king. Nothing remains of their burials and very little of the small offering chapels on the east side of each pyramid. The size of their monuments, about two-thirds smaller than the kings' pyramids, leaves no doubt about their status. Khafra's queens, however, did not have pyramids, but mastaba tombs in the nearby cemeteries, and the queens of later kings were not always buried in subsidiary pyramids. At the end of Dynasty 4, Queen Khentkaus built a large, mastaba-like monument at Giza, indicating her important status as a link between Dynasty 5 and the kings of the previous dynasty.

In Dynasty 6, each king's pyramid had one or more smaller pyramids for the royal women. Most of these are now very ruined, but inscribed door-jambs, false doors or offering tables record the queens' names. The results of excavations at Saqqara by the Department of Antiquities have demonstrated that the pyramid of Queen Iput I, which lies next to that of her spouse, King Teti, was probably built for her by her son, Pepi I, whose funerary complex is named on her false-door. The burial chamber of her pyramid was robbed, but fragments of alabaster and copper vessels, and bracelets were found. In the shaft was a limestone sarcophagus containing the body of a young boy, Tetiankhkem, perhaps another son; an X-ray examination showed that he was about 15 years old when he died.

The Dynasty 6 kings, Pepi I, Merenre, and Pepi II, all built small pyramids for their queens adjacent to their own funerary monuments. Four small and very ruined pyramids were recently discovered by electro-magnetic survey in the vicinity of Pepi I's pyramid at Saqqara. Three of them belong to his queens. The fourth may be later in date as its construction is different and it lies in an area where burials of Dynasty 8 may be expected. It belongs to a Queen Meritites who is named after a grand-daughter of Khufu. Her titles were 'king's daughter' and 'king's wife' and she may have been a grand-daughter of Pepi I.

PRIVATE TOMBS

Most of the king's family and other high-ranking officials were allowed to construct tombs near the king's own funerary monument. These were modified versions of the early royal mastabas with a solid

superstructure through which a shaft descended to the burial chamber. The recessed outer wall was simplified to contain only one or two niches in the eastern wall. Wives usually shared the same tomb as their husbands and were buried in the northern half of the mastaba. The northern niche served as the focus for their offering cult, the southern one for their spouse's cult.

These niches gradually developed into small chapels built into the superstructure. At first they were decorated simply with the names and titles of the owner and the essential prayer for offerings, but by the end of the Old Kingdom the whole superstructure was filled with chambers decorated with scenes of the deceased and his family. The subject matter of the scenes is often described as 'everyday life' but it is clear that the repertoire was highly selective. As the ancient Egyptians believed that depicting or even naming an object brought it into being, these scenes of agricultural pursuits or craft production served to guarantee, by magic, a constant supply of requirements for the dead. They did not, however, supplant the actual offerings which would be brought to the tomb periodically to be shared between the living family and the dead ancestors.

Tombs were often family affairs, and women were usually buried with their husbands, or at least with a male relative. It is rare outside the royal family to find a separate tomb for a woman. In the larger tombs of the Old Kingdom, a separate part of the chapel was sometimes given to the wife, but more often, she would just have a separate false door. In the smaller tombs, she might be depicted on one side of the false door that she shared with her husband. It seems that the construction of a tomb was a male privilege requiring a considerable outlay. By convention, women would share the tomb of a male relative, often in a minor capacity, rather than build their own.

The decoration of the tomb chapel reflects this bias. Although the wife and sometimes the mother

Mourning women accompanying the deceased on his journey to his tomb. Tomb of Ramose, Western Thebes. New Kingdom.

of the deceased are depicted in the scenes of everyday life, they usually appear with other members of the family. Only in the rare cases when women have their own tombs or a separate section of the funerary chapel is a feminine version of everyday life shown. For example, the wife of the vizier Mereruke is shown in her chapel surrounded by female attendants. Even when she goes out in her sedan chair it is carried by women.

Women expected an Afterlife in their own right, however, not as mere dependants of their menfolk. Mummification and funeral rites for women were the same as for men; so was the journey through the Underworld and the interrogation in the judgement hall of Osiris. After passing the tests and becoming one of the justified dead, women too enjoyed the realms of the 'Field of Offerings' and the 'Field of Reeds,' sometimes alone, sometimes accompanying their husbands. Here they lived eternally without dying again.

PYRAMID TEXTS

Apart from the offering ritual, no religious writings have survived before the end of Dynasty 5, when the burial chambers of King Unas's pyramid at Saqqara were inscribed with religious writings known as the 'Pyramid Texts.' These texts, written in a language already archaic, are selected 'utterances' or 'spells' designed to ensure that the king's spirit is released from his body so that it might leave the tomb and travel. No single coherent picture of the king's Afterlife emerges from them; some express the idea that he joined the other gods, or even absorbed their powers and magic by devouring them thus be-

The four canopic jars of King Tutankhamun. Alabaster.
Egyptian Museum, Cairo. New Kingdom.

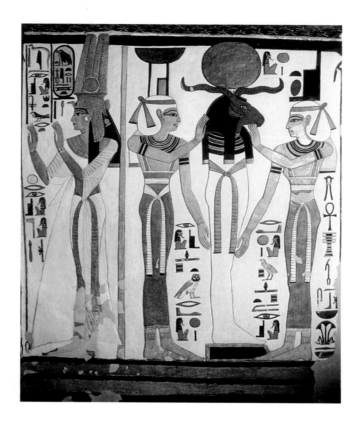

coming greater than them. Other instructions told him to ascend to the sky to join the circumpolar stars that never set, the 'indestructibles,' or the constellation of Orion identified with Osiris. Another option was to travel with the sun-god, Re, who sailed over the sky in a boat by day and, after 'dying' in the west, continued his journey by night through the Underworld to be 'reborn' on the eastern horizon at dawn. All these images empowered the king and guaranteed another existence after his death.

At first, these ideas applied only to the king's Afterlife, and it is not clear what a commoner could expect after death. But throughout Egyptian history, a 'democratizing' process can be traced whereby the magico-religious texts which defined and ensured the future life of the king ceased to be exclusive to royalty and eventually applied to all people. By the end of the Old Kingdom selections of Pyramid Texts are found in the pyramid chambers of Pepi II's queens, implying that they could achieve the same Afterlife.

COFFIN TEXTS

By the Middle Kingdom these Pyramid Texts had evolved into the 'Coffin Texts' and were often inscribed on the large wooden coffins of anyone wealthy enough to afford a good burial. Although many of the 'spells' remained unchanged or slightly modified, the later versions reveal a different emphasis. There is less stress on a sky-orientated Afterlife and instead, Osiris features much more prominently. Commoners, both men and women, could now expect to join him in the Underworld.

One popular selection of 'spells' was known as 'The Book of the Two Ways.' This was a guide to the

Osiris united with Re in the form of a ram-headed mummy between the two goddesses Isis and Nephthys. Tomb of Nefertari, Valley of the Queens, Western Thebes. New Kingdom.

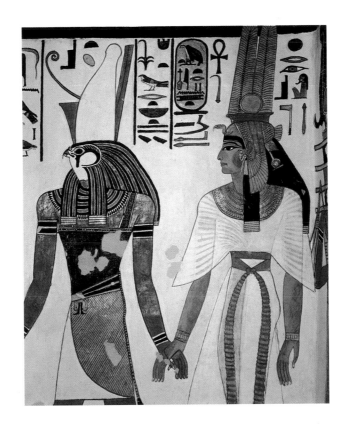

Underworld, describing the various routes to get there, the obstacles encountered and the appropriate words to recite to avoid danger. The text is often illustrated by a map of the Underworld. The pyramids of this period reflect this change in emphasis. The northern entrance, pointing to the polar stars, ubiquitous until the early Middle Kingdom, was abandoned and a complex of subterranean passages formed a sort of labyrinth beneath the pyramid, accessible through a concealed entrance on one side. The twists and turns in the passages undoubtedly deterred robbers, at least for a while, but they also reflected the crooked paths leading to the Realm of Osiris.

Royal ladies, queens and princesses, continued to be buried near the king, but, probably for security, their graves within the pyramid enclosure were now unmarked. Some of the later pyramids, those of Senwosret III and Amenemhat III, include chambers for the burials of the royal ladies. Even so, all of these burials, including the pyramids, were plundered in antiquity. But excavations have brought to light some marvellous jewelry, hidden away in secret niches and overlooked by the robbers.

BOOKS OF THE DEAD

In the reign of Thutmose I, the pyramid form was abandoned for royal monuments, and, like the religious texts, was 'democratized' and used by non-royalty in a very diminished size. Small pyramids are found at the west end of private funeral enclosures at Saqqara, or built above the funerary chapels in the artisans' village at Deir al-Madina. The kings were now buried in rock-cut tombs in a secluded

Queen Nefertari. Valley of the Queens, Western Thebes.
New Kingdom.

desert valley in Thebes, dominated by a pyramid-shaped mountain. Their funerary cults were maintained in separate temples built along the fringes of the cultivation.

The traditional religious writings were now expressed in several different 'books,' descendants of the Pyramid Texts and Coffin Texts. Several of these were used exclusively to decorate the kings' tombs and had a common theme of the nightly journey of the sun-god, Re, who was depicted as a ram-headed human carrying the sun's disc on his head. The dead king was thought to travel on the boat of Re as he passed through the twelve regions of the Underworld, bringing light to the inhabitants there. This was the first royal book known in Dynasty 18 and which the ancient Egyptians called Imy duat, the book of The Underworld. In the morning, the sun was reborn on the eastern horizon, an assurance that the dead king would also be reborn into another existence. In Dynasties 19 and 20, new variants of this theme were added. The 'Book of the Gates,' written late in Dynasty 18, depicts the twelve gates of the Underworld guarded by giant fire-breathing snakes. The 'Book of Night and Day' describes the birth of the sun-god from the body of the sky-goddess, Nut. The 'Book of Caverns' deals with different regions of the Underworld, characterized by caverns and pits. All these books are now collectively known by scolars as the books of 'The Underworld'.

NEW KINGDOM TOMBS

One reason for the change in the location of the rulers' tombs was undoubtedly the need for security, for most if not all the pyramids had been entered and robbed in earlier periods. The burials in the Valley of the Kings were concealed and the area could be easily guarded, a system that worked well in prosperous times, but proved to be quite inadequate in the political and economic unrest at the end of the New Kingdom. Most of the tombs in the Valley were plundered then, as were other rich burials at Western Thebes. The priests of Amun of Dynasty 21 attempted to put right some of the depredations, but the damage was so great, that in the end they emptied all the pillaged royal tombs of their contents and rewrapped the damaged mummies. These were then placed in two secure deposits, one in the tomb of Amenhotep II, the other in the cliffs in Deir al-Bahari.

When these caches came to light in the last century, they included the mummies of several of the most powerful queens of the early New Kingdom—Tetisheri, Ahhotep, and Ahmose-Nefertari. Their original undecorated tombs have been found in the cliffs at Dra Abu Naga, south-east of the Valley of the Kings where the kings of Dynasty 17 were buried. However, only a few of the tombs of royal ladies of Dynasty 18 have been located. Queen Meryetamun, the wife of Amenhotep I, was buried at Deir al-Bahari. Another tomb, hidden in a cleft in one of the cliffs, produced objects buried with three of the minor queens of Thutmose III.

The Valley of the Kings was reserved for rulers and very few women had tombs there. Hatshepsut was one exception; after she had taken kingly titles, she abandoned an earlier tomb at Deir al-Bahari and built another in the Valley. She also allowed two favored court officials to place their tombs here. One of these exceptionally privileged people was her nurse, a lady called In. The canopic jars of another royal nurse, Senetnay, were also found in the Valley, implying that she was buried there. Thuya, the mother of Queen Tiye, also shared a tomb in the royal valley with her husband.

From the Rameside Period comes the only decorated queen's tomb found in the Valley of the Kings, that of Queen Tausret. Although much damaged and usurped by her successor, Setnakht, her tomb is exceptionally interesting in her choice of images and texts. The first part of the tomb is decorated with non-royal illustrations from the Book of the Dead such as would normally be used for a queen. But in the pillared hall are excerpts from the royal guides to the Underworld, and stellar constellations on the ceiling. The accompanying texts have sometimes been adapted for the female occupant of the tomb; for example, masculine deities have been given female epithets, such as 'lady' instead of 'lord.' This may in-

dicate that the nature of the gods of the Underworld encompasses both masculine and feminine aspects. Thus the ruling queen can merge with them, in the same way that the dead king can enter into the being of a god, without losing her female identity.

As in earlier periods, women, even of the elite classes, did not have tombs of their own but shared the family tomb with husbands, sons or even fathers. It has been postulated that the necessary wealth to build a tomb, and perhaps also the permission, could come only with an official government position from which women were excluded. Whatever the reason, women, however independently wealthy, had to be content to share their everlasting home, its contents, and decoration with their menfolk. They were probably happy to be surrounded by their family. Nevertheless, their burials were by no means inferior as they often have elaborately decorated coffins, sometimes overlaid with gold.

Frequently a well-illustrated copy of the infallible 'Book of the Dead' was placed inside the coffin beside the mummy to aid it on its journey. This 'Book of the Dead' was the successor to the Pyramid Texts and Coffin Texts, and was used by non-royalty in their tombs or copied onto papyrus rolls. It consisted of a repertoire of some 200 spells, over half of which have earlier variants. Called by the Egyptians, the 'Book of Coming Forth by Day,' it contained instructions for the deceased on how to proceed through the Underworld and overcome the dangers there. The focal point was the judgement scene, where the deceased was briefed on the correct replies needed for the forty-two assessor gods. A favorable judgement meant entry into the realms of Osiris; anyone found lacking suffered a second and final death. All who could afford a copy would be sure to have one in their tomb. The price was not prohibitive, about the same as a good cow! Many have survived which were 'personalized' with the name and titles of women.

THE VALLEY OF THE QUEENS

None of the known tombs of royal women of the early New Kingdom was decorated, and there was no special burial ground for them before Dynasty 19. Then in the Rameside Period, a valley in southern Thebes known today as the Valley of the Queens was used systematically for members of the royal family. Many of the 80 tombs discovered here were unfinished or too damaged to be identified. Other tombs, notably those dating to the reigns of strong pharaohs such as Rameses II and Rameses III, were decorated with great care by the best craftsmen of the day.

The tombs here are smaller than those of the kings and are decorated with scenes from the Book of the Dead, not from the exclusive kings' texts. One exception, however, is the tomb of Queen Nefertari, Rameses II's favorite wife. She was granted a tomb which, in size and in much of the decoration, was a deliberate echo of a king's tomb. Without using the royal mortuary texts, spells and vignettes from the 'Book of the Dead' were selected which were similar to those found in kings' tombs.

Here in a series of corridors and pillared halls, the queen, unaccompanied by her husband, is led before various divinities of the Underworld: Osiris, Hathor, and Anubis, and different aspects of the sun god: Re-Horakhty and Khepri. Although the actual journey of the sun god is not depicted, it is suggested through the image of a ram-headed mummy who wears the sun's disc. 'It is Re who has come to rest in Osiris' the text says, and on the other side, 'Osiris rests in Re.' In other words, when the sun 'dies' at night, its soul merges with Osiris in the Underworld, to be rejuvenated and reborn the next morning.

Other images are very close to the royal texts. The stars painted on the ceiling are suggestive of the Book of Night, and the depiction of Hathor as a cow emerging from the western mountain corresponds to the Book of the Celestial Cow, both exclusive to the tombs of kings. Weird figures holding knives guard the doors of the Underworld, as they do in the Book of Gates.

Apart from the choice of scenes, the quality of the decoration in Nefertari's tomb sets it apart from

the others. Faced with the poor, crumbling limestone of this valley, the craftsmen prepared a smooth surface by coating it with plaster on which the figures were modelled and painted. The artists who decorated the tomb were among the finest and, not content with the usual simple color schemes, they attempted to blend colors and to use shading to suggest the moulding of a face or the transparency of fine linen in a way that is almost unparalleled elsewhere.

Unfortunately the combination of poor limestone and delicate plaster has led, over the last three thousand years, to a sad deterioration of the decoration. Natural salt deposits in the limestone have gradually crystallized behind the plaster, pushing it off the wall, and with it, the priceless decoration. A joint project by the Egyptian Antiquities Organization and the Getty Conservation Institute has recently completed conservation work. This has consolidated the plasterwork and cleaned the paint, revealing the original vivid colors and exquisite craftsmanship. The deterioration has been arrested, but the delicate paintings remain vulnerable and will only survive with protection.

Elsewhere in the Valley of the Queens, several of the young princes of Rameses III were buried in large, well-decorated tombs. Here, the king is shown accompanying his sons, who were perhaps thought to be too young to face the unknown without their father. It has been suggested that they all died at the same time in an epidemic. The recent discovery of a multiple-chambered tomb in the Valley of the Kings belonging to the sons of Rameses II has opened up again the question of what happened to all the royal princes. Perhaps the young ones who had not reached puberty were buried with their mothers, while the older ones who had not yet established their own households were interred near their father.

Like its kingly counterpart, the Valley of the Queens ceased to be used after the end of the New Kingdom. The kings and their queens of the subsequent periods were buried in the northern capitals. In the Late Period, the god's wives of Amun, the virtual rulers of Thebes, were buried within the temple enclosure of Madinat Habu. Their simple chapels marking the burial chambers may reflect the style of the royal tombs in the north. Their stewards built themselves massive tombs at Deir al-Bahari, lavishly decorated with religious texts, including excerpts from those books formerly reserved for the kings. Once more, the process of democratization had brought exclusive royal writings within the reach of the nobility and commoners.

A mummy placed upright for purification and fumigation with incense. The deceased's wife mourns him. Egyptian Museum, Cairo. New Kingdom.

Sennedjem and his wife working in the fields of Earu. Tomb of Sennedjem, Deir al-Madina, Western Thebes. New Kingdom.

XIII
ART AND BEAUTY

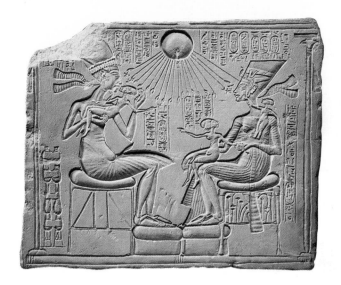

The Egyptians were greatly appreciative of beauty. Even in the predynastic period, simple artefacts such as flint tools and pottery were fashioned with such care that the best are works of art. This ability to turn even apparently mundane, everyday things into objects of beauty endured throughout the dynastic period. The custom of placing fine objects and works of art in tombs and temples means that a huge legacy has survived.

Art was essentially a function of religion. In fact, the ancient Egyptians had no word for 'art.' Making an object, whether a statue or a pot, was an act of creation, and came under the aegis of the god Ptah, patron of craftsmen. Each object had its own identity and if it were decorated with human or divine images, their spirits could be invoked. Figures of kings and deities were ceremonially purified and rendered effective through the 'Opening of the Mouth' ritual which allowed the image to become an abode of the invoked spirit. They were thus truly capable of possessing life and became the object of veneration. Private statues likewise, once animated by this ritual, offered the possibility of housing the spirit which could then exist forever. The beauty that the Egyptian craftsman strove for was part of this function; it provided a handsome dwelling place for the spirit, and an attractive focus for veneration and offerings.

Wherever possible, the Egyptian artist avoided unpleasant and violent scenes, or depicted such scenes in a way that the images became symbols of the eternal conflict of order against chaos. For example, the large battle scenes that decorate the outside of temples show the king followed by neat lines of troops (order), confronting a melée of enemies (chaos).

The beauty of Egyptian art was achieved through a combination of pleasing proportions and superb craftsmanship. Above all, the human body was celebrated as an image of the spirit within. All formal

Akhenaten and his wife Queen Nefertiti with their daughter
in an unusual family scene. Berlin Museum. New Kingdom.

Colossal statue of Meryt-Amun, daughter of
Rameses II. Akhmim. New Kingdom.

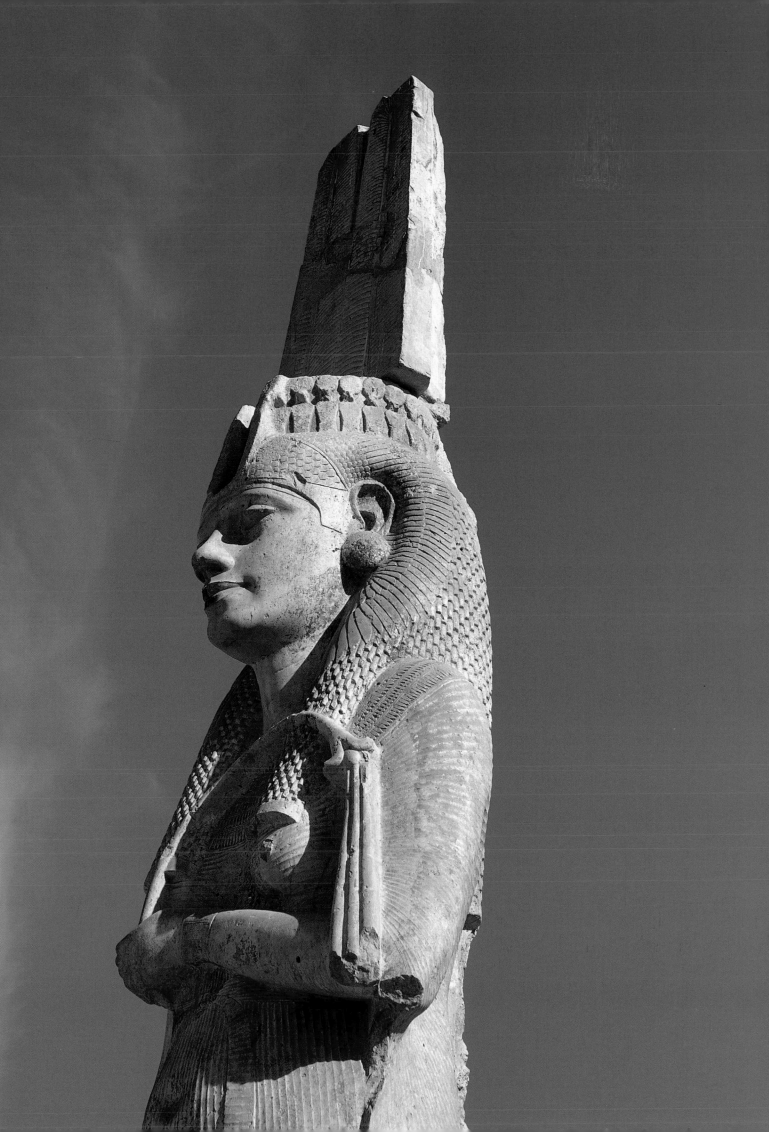

representations were drawn to a strict canon so that for human figures, the ratio between different parts of the body was always the same, no matter what the size. In paintings and reliefs, the most important figures are always shown much larger, be it the tomb owner, the king or a deity. An object was depicted in its most characteristic form; for a human, this meant drawing the head and chest in profile, the shoulders frontally, the eye fully frontal, and the legs in profile. Such a figure, although anatomically impossible, is remarkably lifelike. The same canon also applied to the hieroglyphic script, and the figures, sculpted in the round, or in relief, are enhanced and extended by the hieroglyphic text that usually accompanied them.

Paintings and reliefs were usually organized in strict horizontal registers, limiting spatial relationships. The exceptions are the large battle motifs mentioned above and the scenes in the Amarna temples and tombs. In these, the whole wall was used for panoramic depictions of palaces, temples, and ritual events which become almost narrative.

A pervading need for symmetry and balance occasionally produces results that are static and repetitious such as mirrored texts or images on either side of a doorway or lintel. But it can also achieve harmonious compositions out of difficult subjects. A good example is the statue of the dwarf Seneb and his wife. Seneb is seated cross-legged on a bench, his wife beside him with her arm around him in a protective gesture. In the space in front of him normally filled by the statue's legs, stand his two children, a tactful and clever way of drawing attention away from the dwarf's abnormalities, while fulfilling the requirements of this family group.

The craftsmen who made the statues and wall decorations worked in teams, under the direction of a master. Young apprentices were trained in the workshops, and as their skills increased, were given more

Fragment of a seated statue of Djedefre and his wife, who
is kneeling beside his feet. Louvre Museum, Paris. Old Kingdom.

complex assignments. When working on a statue, the outline was painted onto the initial stone block. Assistants removed excess stone using copper or bronze chisels and stone mauls. Then the outline was painted again and the whole operation repeated until the statue was roughed out. At this stage, trained sculptors finished the body while the master completed the head. Finally the statue was polished with sand, and then painted.

Relief sculpture was made in a similar fashion. The outline was painted on the wall in red ink and corrected in black ink. Then the masons would remove the background, and more skilled craftsmen would carve the inner detail of the figures. Finally, the reliefs were painted.

The results would vary, of course, with the skills of the craftsmen. Art mirrored society, and in periods of prosperity, standards were high. At one end lay the perfectly mastered techniques of the royal ateliers. They set the style, usually based on an idealized portrait of the ruling king and his consort. At the other end, mediocre and clumsy products of provincial workshops can be distinguished by their lack of sophistication.

Although the conventions of Egyptian art were formed during the Archaic Period and endured for the next three thousand years, there are recognizable modifications over such a long time. Certain traditions persisted, however, throughout most of the historic period. The standard posture for men and women differs. Standing male figures are shown striding forward with the left leg in contrast to females who have one foot very slightly advanced or both feet placed sedately together. This distinction between the active, outward life of men and the quieter, house-orientated existence of women is maintained by the conventions of depicting women's skin a pale yellow. Male figures are usually shown a deep red-brown.

Clay statue of a female dancer. Brooklyn Museum, New York. Naqada I Period.

THE ARCHAIC PERIOD AND THE OLD KINGDOM

Painting and three-dimensional art of the predynastic period have survived, but show few traits in common with the later historic style. A painted tomb at Hieraconpolis exhibits haphazardly juxtaposed motifs that are found singly on the decorated pottery: boats, shrines, various animals, and women with their arms raised above their heads. Terracotta figures also exist of women in a similar stance; they may be dancing or, more likely, in an attitude of mourning. These buxom, stylised figures are so unlike the slender ladies of later depictions, that there appears to be no continuity of style or purpose.

The changes that appeared early at the beginning of the dynastic period may have been prompted by foreign models, but they immediately evolved into a distinctive and idiosyncratic Egyptian style that endured for three thousand years. Few early examples of sculpture and painting have survived, but they show that by the end of the Archaic Period, the classic conventions and proportions had been worked out, if not yet perfected. Royal statues, which have rarely survived, undoubtedly served as models for the few private statues that exist from this early period. These early works are clumsy to look at; the head is disproportionately large, and the body and limbs, especially the legs, are heavy and static.

All this changed within a few generations. Royal and private patronage flourished during the obvious prosperity of the Old Kingdom. Sculpture in the round and in relief reached a perfection which was never really equalled again. The stability and unquestioned power of the king were expressed in simple, elegant art, summed up in the diorite statue of Khafre seated on a throne with the hawk-god Horus behind his head, as if guiding him. The strength of Khafra's muscular body and his serene countenance express the ideals of kingship.

The statue of Nefret, dating to the early 4th Dynasty, is one of the first female masterpieces. She is shown beside her husband, her pristine white dress and pale complexion contrasting dramatically with his dark skin and half-bare torso. Hints of archaism in the thrust of the head and the heavy feet are still apparent, but the body is dynamic and the facial expression lifelike.

Nefret's name means 'Beautiful' and no doubt her plump round features embodied the ideal of that time. The eyes of inlaid rock crystal give life to the statue. A thick short wig is held in place by a diadem inlaid with colored floral designs. It is painted white to represent silver, a rarer metal than gold. Her dress is the classic Old Kingdom sheath, a simple tube of linen reaching from below the breasts to the ankles and held up by two shoulder straps. Although a shawl covers her arms and chest, her breasts are clearly delineated below. A 'broad collar' of multicolored beads contrasts with the whiteness of the linen garment.

Individual statues of women are rare in the Old Kingdom. This may be due to the chances of survival, or because few were made. Those that we have were probably originally placed next to the husband's statue, like that of Nefret beside Rahotep. Pair- statues are more common, with husband and wife side by side. Often she places her arm around her husband's waist, her other arm reaching across to touch him, as in the royal group of Menkaure and Khamerernebty. This conventional posture of affection and support is repeated in private pair-statues. It has the effect of thrusting the man forward, as the chief recipient of offerings in his tomb. This mirrors the real-life situation where the bread-winner supports his wife and children. Likewise in the tomb, offerings presented to the deceased man will support his family in the Afterlife.

Occasionally, a variation appears, as the Dynasty 6 statue of Memi-sabu and his wife, where he places his arm over her shoulders. The effect is instantly different. The wife, despite her small height, appears as more of an equal.

Normally, even in a pair-statue, the wife is shorter and slighter than the husband, a distinction that reflects a real difference in male and female bone structures. But another common arrangement of figures shows the wife at a much smaller scale, kneeling at her husband's knees which she embraces.

At this diminutive scale, she is often not much bigger than the small children who appear at their parents' sides.

Why some women were depicted on the same scale as their husbands and others very much smaller is not clear. There are royal prototypes for both; Menkaure stands beside his wife, while a seated statue of Djedefre shows his wife kneeling at his feet. It may be simply that the statues had different functions. Where the husband's statue was the sole focus of attention, the wife may have had her own memorial. Where they shared a monument, the overall impression is that the wife plays a supportive and sometimes secondary role; it is the husband who is depicted as active and outgoing. It was he who commissioned the statue, and presumably decided how his wife should be depicted. The choice of posture may possibly reflect an aspect of their relationship.

A woman's clothing, as depicted on statues, emphasizes her inactive role. The figure-hugging sheath dress shown on the monuments is a mere convention, allowing the artist to delineate the contours of the body below. This he did, in great detail, showing a youthful, slender and taut body. The muscles are less emphasized than on male figures, but nevertheless, the Old Kingdom females look fit and healthy, almost athletic. This is the cultural ideal for few women could actually have retained such youthful figures after several years of childbearing. Facial features are also idealistic rather than portraits. Here, the royal family set the standard for beauty, and private sculpture tended to imitate them.

In the tomb paintings, the role of the owner's wife is similarly restricted. She is shown accompanying her husband and family, but never in the out-door scenes. This, like her paler complexion and tight dress, is a device to emphasize her indoor life, in the home and with the family. Her role is to complement the man's outdoor existence as the bread-winner. The tomb scenes depict an ideal state of affairs, however, and we cannot be sure that a woman's life was really so circumscribed.

This standardized ideal was applied to almost all female representations. Even the servant figures which were placed in the tombs to serve the owners in the Afterlife are usually shown as youthful women, clad only in a kilt, toiling over the grinding stone or pushing beer mash through a sieve. Their short, full hair is held in place by a fillet, or sometimes covered by a cloth to keep out the dust. Sometimes, a band of finer hair is shown below the fillet, as if this is the real hair below a wig. But it seems so impractical and unlikely that a servant would wear a wig, surely a sign of status, while performing a menial task, that this must be another convention and not a realistic depiction. The object here is to produce a pleasing and idealised figure to accompany the tomb owner, not an accurate portrait. The skeletal material that has been examined from the workmen's cemetery at Giza gives a different picture of the physical reality of the workers' lives.

Interestingly, the depiction of men was not so bound by this idealism. Older bureaucrats were shown with paunchy stomachs and all the other accoutrements of middle-age spread. Working men were also shown plump and balding. Women are rarely shown other than slim and youthful. Occasionally, a discrete bulge of the stomach indicates pregnancy. But the spreading waistline and sagging stomach of middle-aged motherhood are never depicted. If mothers are depicted with their grown-up daughters, or daughters-in-law, both figures are alike in their youthfulness. The impossibly tight sheath dress which they wear is part of this convention and is simply a means of conveying the details of the body beneath without actually showing it naked.

THE ART OF THE POOR

The workmen and the artisans buried in the upper and lower cemetery of the pyramid builders made their tombs from the material left over from the construction of the pyramids. The statues in these tombs are in the Old Kingdom style, but they are different from all other statues fom this period, since

the artisans were farmers and were representing the common people. Consequently, men of all ages are depicted, and the faces do not display the features of nobility.

One example is the statue of a man and his wife Nefermenkhes, found inside the serdab, a small niche cut into the rock wall of their tomb. The statue, which looked outward, facing the eastern horizon, was sculpted from white limestone and painted, and represents the tomb owner and his wife seated on a chair with a high back. The male figure wears a short wig, and his face is round; his wife wears a very tight dress. She embraces her husband with her right hand and rests her left on her knee. Her body is painted light yellow, and she wears a thick, braided black wig, typical of Dynasty 5, which, although not long, covers her ears and reaches her shoulders. The artist also used black to draw a small line under the wig to represent the woman's real hair. From the front, the face of the woman is similar to that of her husband, but they actually have very different profiles.

Inscriptions carved beside the couple's feet reveal the husband's profession: Nefernsuref, the overseer of the craftsmen.

The canon used for this double statue followed specific rules. Artists always showed the woman standing or sitting on the left side of her husband. Most statues of this type represent the woman sitting with her left hand resting on her left knee and her right hand embracing her husband who sits next to her. Some rare examples represent the wife embracing her husband with her right hand, the palm of her hand on his right shoulder. However, standing statues portray the husband embracing his wife's shoulder while she embraces his waist. Statues of this period also represent female figures seated alone, the woman resting her left hand on her left knee while her right hand, which is clasped, rests on her right knee.

Hieroglyphic determinative for a female of old age.
Tomb of Ti, Saqqara. Old Kingdom.

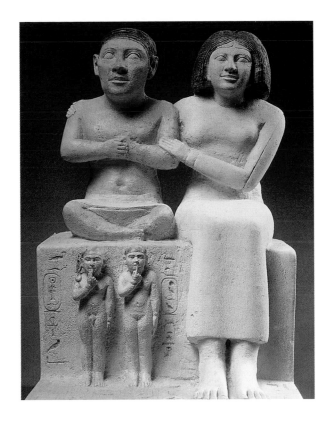

The female figures of double statues dating from Dynasty 5 display some remarkable features: they are full-bodied, their faces glow with youthful features and calm smiles, their eyes are well defined, and their lips are full and embossed. In a very few cases the face is also broad and flattened, as in the case of the statue of a man and Nefermenkhes.

These features raise several questions. The statues date from the Old Kingdom, yet the faces are completely different from the style of other statues in this period. The difference in features can be explained by the fact that these women belonged to a section of society who were farmers and workers, rather than officials and nobles. Their faces therefore show their rural background, and differentiate them from urban sections of society.

The statues of the men from this group of people possess round faces with idealistic features, but they are less full than those of their female counterparts.

THE FIRST INTERMEDIATE PERIOD AND THE MIDDLE KINGDOM

During the troubled First Intermediate Period, the royal workshops ceased; the few statues and tomb decorations that survive from this period are provincial and somewhat clumsy in style. The traditions of the Old Kingdom began to be revived at the end of Dynasty 11 as shown in the limestone sarcophagi of Queens Asheit and Kawit. These are decorated with clear, well-proportioned figures, which, however attractive, are still very flat and lack subtlety.

By Dynasty 12, the quality of surviving sculpture is as good as that of the earlier periods. Par-

Statue of the dwarf Seneb and his family.
Painted limestone. Egyptian Museum, Cairo. Old Kingdom.

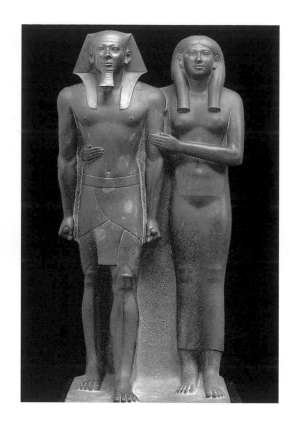

ticularly remarkable are the portraits of the later kings, shown not with the calm confidence of absolute majesty, but with careworn expressions of responsibility. The authority of the kings had been challenged in the First Intermediate Period, and the rulers never recovered their absolute power again.

Pair-statues from this period are rare, and seem to have gone out of fashion for a while. Instead, individual statues of husband and wife were placed side by side. Several of these statues of women have survived. The seated figure of Sennuwy, wife of an important provincial governor from Asiut, reveals a different ideal of femininity. She appears quieter, more graceful than her Old Kingdom counterparts. Other statues also show a different style of feminine elegance with more delicate features, heavier wigs, and slender, softer bodies. Even in the rather formal statue of Queen Nefret, wife of Senwosret II, her facial features and body are softly contoured in the hard stone.

Nearly all the women's statues reflect a new individuality in the facial features. Queen Nefret's face is round and plump; Sennuwy's is more slender and classic. The waif-like features of a wooden statue are accentuated by unusually long, heavy eye-brows and a straight, serious little mouth. Her nose has unfortunately been smashed in an attempt to 'kill' her by making her unable to breathe.

THE NEW KINGDOM

The Second Intermediate Period marks less of a break than the First, but the lack of a unified government limited artistic output. In the New Kingdom, older forms were once again revived and

Statue of Menkaure and his wife Khamerernebty II.
Giza. Museum of Fine Arts, Boston. Old Kingdom.

developed, at first in a simple and elegant style. Statues of royal women of the early New Kingdom are characterized by their small piquant faces and delicate features, typified in the statues of Queen Hatshepsut. Even when represented as a king, Hatshepsut's slender limbs, unmistakable breasts, and fine features set off by delicately arched brows belie the male garb that she wears.

This slim, fine-featured youthful image sets the style for the early part of Dynasty 18, but with the increasing prosperity of the period art forms become richer and more elaborate. Costumes and wigs, in particular, become more luxurious and the slender forms of both men and women become almost effete in their mannered elegance. Long, full outer garments are depicted as transparent, revealing all the details of the body underneath. Cloaks, shawls and sashes appear, adding richness and detail. From the time of Amenhotep III on, the tomb paintings include new scenes of the king and queen at various state occasions. The old, formal postures are relaxed and the artists experiment with freer ways of depicting the body, especially in the figures of servants or of dancers.

Statues of this period and later are characterized by their complicated and elaborate clothing. A pair-statue of Khaemwaset and Menena show him clad in the newly fashionable long kilt, carefully sashed and pleated, worn over a tunic. She wears a longer version of the classic sheath, with rosettes embroidered on the breasts. A shawl covers one arm, and her huge, braided wig is a new style, popular with royal and private women. But the body under the clothing is stylized and her beautiful oval face is so lacking in naturalistic modelling that it appears to be masklike.

One statue that appears at least in part to be an exception in that it is a depiction of old age is that of a nurse carrying four royal children on her knees, which was found in the village of Kafr al-Wahhal near Bubastis (Zaqaziq). The gilded limestone statue is seated on a chair that is executed in relief, imi-

Fragment of the head of Queen Tiye. Yellow Jasper.
Metropolitan Museum of Art, New York. New Kingdom.

tating straw meshwork. A monkey holding a mirror appears in relief on the left side of the statue, and another carrying a double kohl tube and a kohl stick is situated on the right side.

The woman's face displays all the signs of old age, and she wears a heavy black wig. The hair ends in well-arranged braids. Both the left and right arms are broken, but the nurse's long fingers can still be seen supporting the body of the princess sitting on her knees.

The nurse's facial features, her hairstyle, her attitude, and her dress, all clearly demonstrate that the sculpture belongs to the first half of Dynasty 18. It is believed that the statue dates from the reign of Thutmose III or his son Amenhotep II.

THE AMARNA PERIOD

The reign of Akhenaten and the Amarna period produced a radical new style of art which tried to throw off many of the classical traditions. At the beginning of his reign Akhenaten had himself depicted in an extraordinarily exaggerated style, emphasizing to the point of distortion his long chin, slanting eyes, heavy hips and thin legs. The unmistakable female look of his body may have been intentional; his wife, Nefertiti, played an unprecedented role in the new cult of the Aten. She is frequently shown beside Akhenaten, and sometimes hardly distinguishable from him. Her small waist, huge buttocks and thighs, and prominent pubic mound are clearly revealed beneath the many pleats of her semi-transparent garments, offering a lush voluptuousness. Her epithets, 'Fair of Face, Mistress of Joy, Great of Favors,' affirm the deliberately sensuous nature of these statues. This emphasis on femininity is probably why Nefertiti's six daughters, all depicted in the same exaggerated form, feature frequently with their parents.

The banishment of the old gods left a hiatus into which the divine royal family stepped. Tombs, temples, and domestic shrines now included new scenes of the royal family in domestic situations, at meals, or playing with their children. These include unusual scenes of affection between the king and queen who are shown kissing while riding in their chariot or approaching the bedchamber hand in hand. These subjects were never depicted before or after in public places and emphasize the erotic overtones of Amarna art. They are graphic reminders of the mythological role played by the royal couple in ensuring the fertility of the land and the people. This role was not restricted to this life, but extended beyond death; fertility also meant rebirth in the Afterlife. The substitution of the king and queen in the tomb scenes at Amarna in place of the divinities of the Underworld was probably meant to ensure the means for rebirth.

Despite the physical exaggerations of the new royal mode, the craftsmen of Akhenaten were free to explore a more realistic style, experimenting with depicting the human body from different angles and in unusual postures. Naturalistic scenes of papyrus thickets with birds and fish are painted with astonishing and sensitive realism.

Towards the end of Akhenaten's reign, the extreme distortions of the early style were modified. More than anything else, the wonderful painted head of the queen, as well as some highly sensitive portraits of the king, are proof that the early depictions of the royal family were far from being based on supposed physical deformities of the king, as has sometimes been argued. The exaggerations must have been nothing more than a strange form of propaganda for the new cult of the Aten. It is sobering to note that, had not the two later portraits of Nefertiti survived, we would know her only as a grotesquely bottom-heavy matron.

The fame of the head of Nefertiti in Berlin has meant that her name has become synonymous with beauty. The poise of the head on its long neck, balanced by the backwards sweep of her blue head-dress, the fine, classic features and high cheekbones, have a cool, timeless perfection which is witness to the return of a more traditional style.

Another head in Cairo shows the same classic features, softer because they are unfinished. The careful modelling of the cheeks, the perfect nose, and, above all, the slight disdain in the thrust of the chin make it almost certain that this is Nefertiti. The counterbalance of the tall crown is lacking, but the angle of the long neck is the same. For some, the softer features of this unfinished masterpiece are more appealing than the sharp perfection of the painted head.

In the aftermath of the Amarna period, details of the earlier style lingered on for another generation. Some of the extraordinary range of objects found in Tutankhamun's tomb are decorated in the style of Akhenaten's reign, although by then the traditional religion had been restored. The slight stoop and the forward thrust of the head, the fleshy stomach and thin legs of the king and his queen are a hang-over from the previous reign. The classic proportions of the magnificent gold mask with its peaceful expression and the gold coffins with their protective goddesses, Isis and Nephthys, hark back to the old traditions.

The damaged statue of the wife of General Nakhtmin is one of these post-Amarna pieces. Despite the damage to the nose and mouth, her face with its long, almond eyes, prominent cheek bones, and full lips conveys a sensuality reminiscent of the Amarna style. The treatment of her body under the pleats of her elaborate, see-through gown reinforces this impression. Her high waist, plump round breasts, and heavy thighs and buttocks are redolent of ripe womanhood and are a far cry from the taut, athletic ladies of the Old Kingdom.

THE LATE NEW KINGDOM

The Rameside Period showed a return to older, more conservative values. Although the size and number of monuments increase, the overall quality declines. The reigns of Seti I and Rameses II are known for their beautiful and numerous monuments, the style characterized by slender, elegant figures clad in long pleated garments. The female body is now more concealed beneath its costume, and indeed, as the period progressed, the elaboration of pleats, folds, and fringes begins to distract from the form below. Tuy, mother of Rameses II, is depicted as a quiet and sedate matron wearing a full wig and a complicated pleated dress. Her limbs and body are only summarily indicated under her dress in a return to older, more chaste conventions.

Another piece from this period depicts a consort of Rameses II, possibly his daughter, Meryt-Amun. Her charming, rounded face is reminiscent of that of the colossal statue found a few years ago at Akhmim. Her features, especially the mouth, are soft and delicate, a very different image of femininity from the preceding dynasty. She wears a heavy wig and the base of a crown which would originally have carried two tall plumes. Her unpleated dress, which goes over one arm, clings tightly to her body.

This return to a more conventional style can be seen also in the beautiful paintings in the tomb of Nefertari in the Valley of the Queens. The figures are stiff and formal, and the transparent garments, so beautifully rendered, reveal none of the lasciviousness of the Amarna age. Nevertheless, the craftsmanship is of the finest, the skilfully modelled details and careful painting making this tomb one of the masterpieces of ancient Egypt.

Rameses II was particularly fond of large statues of himself and often of his queens as well. During his long reign, he graced nearly every major shrine in Egypt with them. But towards the end, the quality of the work declined; with increasing economic and political troubles at the end of the New Kingdom, monumental buildings as well as works of art become scarcer.

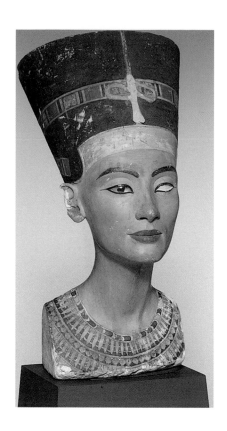

POST NEW KINGDOM

The Third Intermediate Period likewise has left us relatively few monuments. Thebes became a backwater when the political and economic center of the country shifted to the north. Here, in the populous Delta, ancient monuments have fared badly and sites like Tanis and Bubastis, once magnificent capitals, have been ravaged and reduced to heaps of stones. Few of the statues which must have graced the temples have survived, and the royal tombs were modest affairs without complementary funerary temples. In the south, rather than build and decorate new individual tomb chapels, existing shafts were reused, frequently becoming family vaults. Where tomb or temple decoration has survived, it shows a continuation of style of the Late New Kingdom, emphasizing slender limbs, narrow waists, and elongated proportions.

The advent of a strong line of rulers from Nubia in Dynasty 25, brought about a revival in building and arts, harking back to older models from the Old and Middle Kingdoms. Thebes and the other ancient temple sites were once again embellished with new reliefs and statues. A remarkable find of disused statues that were later buried in a courtyard at Karnak, the 'Karnak cachette,' has brought to light some fine examples of this late revival. Amongst these were several standing statues of the god's wives of Amun, the royal daughters who were appointed to this high office at Thebes. Statues of Amenirdis I and Shepenwepet II display once more the strict conventions of the idealized image. The formal posture and the clear-cut facial features are stylized, but the plump body contours are discreetly rendered beneath the archaic dress. The heavy wigs are reminiscent of the styles of the Middle Kingdom.

Painted limestone head of Queen Nefertiti, wife of Akhenaten,
from Amarna. Berlin Museum. New Kingdom.

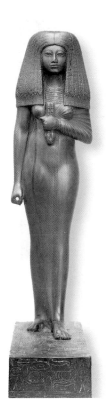

This revival reached a peak in Dynasty 26, known as the Saite Period, when older works were copied, sometimes line for line, or inspired similar postures and styles. Some of these Saite pieces are magnificent; the proportions and finish are perfect. During this period, a new realism developed alongside the traditional idealism, reflected in a range of portrait heads showing remarkably lifelike details. This realism may well have been due to the growing influence of Greek culture in Egypt during the centuries before the conquest of Alexander.

Few portraits of women have come to light from this period. In the reliefs, a new style emerged. Plump, full faces, often with a double chin, mirror royal iconography. Bodies too are fleshy, with round prominent breasts and deeply incised navels. The best of these are skilfully carved with limbs and muscles carefully modelled beneath the tight dresses, but the result is mannered and stilted, leading to the empty stylization of the Ptolemaic period.

Wooden statue of Touy.
Louvre Museum, Paris. New Kingdom.

PREHISTORIC PERIOD: to 3100 BC

Before 10000		Palaeolithic period; nomadic food gatherers.
c.5500–3100		Neolithic period; farming and domestication of animals and first settlements. Simple pottery; copper and gold working. Local rulers.

EARLY DYNASTIC PERIOD: c.3100–2686 BC

c.3100–2890 Dynasties 1 and 2	Narmer/Aha	Unification under one ruler; capital at Memphis and royal tombs at Abydos and Saqqara.

OLD KINGDOM: c.2686–2181 BC

c.2686–2613 Dynasty 3	Djoser Huni	Step pyramid at Saqqara.
c.2613–2494 Dynasty 4	Sneferu Khufu Khafre Menkaure Shepseskaf Queen Khentkaus	Strong centralized government; pyramids at Dahshur and Giza.
c.2494–2345 Dynasty 5	Userkaf Sahure Neferirkare Unas	Pyramids and sun-temples at Abu Sir and Saqqara; Pyramid Texts.
c.2345–2181 Dynasty 6	Teti Pepi I Pepi II Queen Nitokerty	Strong beginning but decline during long reign of Pepi II; pyramids at Saqqara; last ruler probably Queen Nitokerty.

FIRST INTERMEDIATE PERIOD: c.2181–2055 BC

c.2181–2055 Dynasties 7–10		Collapse of central government; country divided among local rulers; famine and poverty.

MIDDLE KINGDOM: c.2055–1650 BC

c.2055–1985 Dynasty 11	Mentuhotep II	Reunification of Egypt by Theban rulers.
c.1985–1795 Dynasty 12	Amenemhat I Senwosret I Amenemhat II Senwosret II Senwosret III Amenemhat III Amenemhat IV Queen Sobekneferu	Powerful central government; expansion into Nubia (Sudan). Capital at Lisht, near Memphis.
c.1795–1650 Dynasties 13 and 14		Rapid succession of rulers; country in decline.

SECOND INTERMEDIATE PERIOD: c.1650–1550 BC

c.1650–1550 Dynasties 15 and 16 (Hyksos)		Country divided with Asiatics ruling in the Delta.
c.1650–1550 Dynasty 17	Seqenenre Taio I Seqenenre Taio II Kamose	Theban dynasty begins reunification process.

NEW KINGDOM: c.1550–1069 BC

c.1550–1295 Dynasty 18	Ahmose Amenhotep I Thutmose I Thutmose II Thutmose III Queen Hatshepsut Amenhotep II Thutmose IV Amenhotep III Amenhotep IV Akhenaten	Reunification and expulsion of Asiatics in North; annexation of Nubia in South. Period of greatest expansion and prosperity. Thebes (Luxor) became main residence.

	Tutankhamun	
	Ay	
	Horemheb	
c.1295–1186 Dynasty 19	Rameses I	After glorious reign of Rameses II, prosperity threatened by incursions of 'Sea Peoples' in North. Residence in Delta.
	Seti I	
	Rameses II	
	Merenptah	
	Siptah	
	Queen Tausret	
c.1186–1069 Dynasty 20	Setnakht	Economic decline and weak kings ruling from the Delta. Civil disturbances and workers' strikes. Royal tombs robbed.
	Rameses III–XI	

THIRD INTERMEDIATE PERIOD: c.1069–747 BC

c.1069–945 Dynasty 21	Smendes	Egypt in decline. Siamun may have been the Pharaoh who gave his daughter in marriage to Solomon.
	Siamun	
c. 945–715 Dynasty 22	Sheshonq I	'Shishak' of the Bible. Egypt fragmented and politically divided.
	Osorkon I	
	Sheshonq II	
	Osorkon IV	
c. 818–715 Dynasties 23–24		Egypt divided between local rulers.

LATE PERIOD: c.747–332 BC

c.747–656 Dynasty 25	Kashta	Rulers from Kush (Sudan) united Egypt and started cultural revival. Threatened by Assyrians who invaded in 671, 667, and 663 BC. Last king fled south.
	Piankhy (Py)	
	Shabaqo	
	Shabitqo	
	Taharqa	
	Tanutamani	
664–525 Dynasty 26	Psamtek I	Dynasty from Sais in Delta. Defeated Kushite kings and continued rebuilding program after Assyrians left.
	Nekau II	
	Psamtek II	
525–404 Dynasty 27	Cambyses	Egypt annexed to Persian Empire.
404–343 Dynasties 28–30	Amyrtaios	Last native rulers of Egypt. Cultural renaissance and nationalism but political decline.
	Nectanebo I	
	Nectanebo II	
343–332 Dynasty 31	Artaxerxes III	Persian reconquest.

GRAECO-ROMAN PERIOD: 332 BC–AD 642

332–304 Macedonian Dynasty	Alexander the Great	Macedonian rulers after death of Alexander in Babylon (323).
304–30 Ptolemaic Dynasty	Ptolemy I–XV	Last ruler, Cleopatra VII, allied with Mark Anthony against Rome. Defeated at the Battle of Actium by Octavian.
30 BC–AD 642 Roman Province		Egypt becomes a Roman province. Heavy taxation drains wealth from country. Christianity spreads and eliminates ancient religion.

FAMOUS WOMEN OF ANCIENT EGYPT

Ahhotep: Principle wife of Seqenenre Taio II and mother of Ahmose, first ruler of Dynasty 18.

Ahmose-Nefertari: Principle wife of Ahmose and mother of Amenhotep I with whom she was later deified and worshipped by the villagers of Deir al-Madina.

Amenirdis I: God's Wife of Amun at Thebes; sister of the Nubian king Piankhy, the first ruler of Dynasty 25, and adopted daughter of Shepenwepet I.

Amenirdis II: God's Wife of Amun at Thebes; daughter of Taharqa of Dynasty 25 and adopted daughter of Shepenwepet II.

Ankhesenpaaten/Ankhesenamun: Daughter of Akhenaten and Nefertiti and wife of Tutankhamun under whom she changed her name to its second form. She later married Ay.

Ankhnesneferibra: God's Wife of Amun at Thebes; daughter of Psamtek II of Dynasty 26 and adopted daughter of Nitocris.

Ashait and **Kawit**: Two queens of Dynasty 11, wives of Montuhotep II, buried in tombs at Deir al-Bahari.

Hatshepsut: Daughter of Thutmose I and wife of Thutmose II. On her husband's death she became coregent with her step-son Thutmose III, and assumed the role of ruling queen for about 20 years.

Henutsen: Queen of Khufu, builder of the Great Pyramid at Giza. She is probably the owner of the southernmost subsidiary pyramid on the east of her husband's pyramid.

Hetepheres: Principle wife of Sneferu, founder of Dynasty 4, and mother of Khufu. Her intact tomb was found to the east of her son's pyramid at Giza.

Khentkaus: Probably the mother of the second and third kings of Dynasty 5, Sahure and Neferirkare. She may have been a queen of a late Dynasty 4 ruler as her tomb is located at Giza between the pyramid cemeteries of Menkaure and Khafre.

Maat-hor-neferu-Re: Daughter of the Hittite king Hattusilis III; wife, and for a time principle queen of Rameses II.

Meresankh: Granddaughter of Khufu and wife of Khafre, builder of the Second Pyramid at Giza.

Merit: Daughter of Senwosret III of Dynasty 12 and buried in his funerary complex at Dahshur.

Meritaten: Daughter of Akhenaten and Nefertiti, later a wife of Akhenaten, and of his coregent and possible successor Smenkhkare.

Merneith: A queen of Dynasty 1 whose tomb in the royal necropolis at Abydos may indicate that she ruled on her own. Her position in the dynasty is uncertain.

Meryt-Amun: Fourth daughter of Rameses II and Nefertari, and briefly Rameses II's principle wife after the death of her mother.

Mutnodjmet: Principle wife of Horemheb, possibly related to the family of Tiye and a sister of Nefertiti.

Nefertari: First principle wife of Rameses II, commemorated on many of his monuments, most strikingly in the smaller temple at Abu Simbel. She is famous for her beautifully decorated tomb in the Valley of the Queens.

Nefertiti: Principle wife of Akhenaten and mother of six princesses. She is depicted both with and without her husband participating in formal ceremonies and in scenes of family intimacy unique to this period.

Neferuptah: Daughter of Amenemhat III of Dynasty 12; her intended sarcophagus in the burial chamber of her father's pyramid at Hawara was never used; instead, she was buried in a separate monument nearby.

Neferure: The only known child of Queen Hatshepsut.

Neithhotep: An important queen of the early part of Dynasty 1 whose grand tomb has been identified at Naqada. She may have been the wife of either Narmer or Aha.

Nitocris: God's Wife of Amun at Thebes; daughter of Psamtek I of Dynasty 26.

Nitokerty: Probably the last ruler of Dynasty 6, she is known only from later records.

Sat-Hathor: Daughter of Senwosret III of Dynasty 12; buried in her father's pyramid complex at Dahshur with exquisite jewelry.

Shepenwepet I: God's Wife of Amun at Thebes; daughter of Osorkon IV of Dynasty 24; adoptive mother of Amenirdis; sister of Piankhy.

Shepenwepet II: God's Wife of Amun at Thebes; daughter of Piankhy and sister of Taharqa of Dynasty 25; adoptive mother of Amenirdis II.

Sobekneferu: Daughter of Amenemhat III. The last ruler of Dynasty 12, she may have assumed kingship when there was no male heir, or as the victor in a family feud.

Tetisheri: Wife of Seqenenre Taio I, grandmother of Kamose and Ahmose, later regarded as the royal ancestress of Dynasty 18.

Tiye: Principle wife of Amenhotep III and mother of Akhenaten. Apparently of non-royal birth, she played a prominent role in the reigns of both her husband and her son.

Thuya: Wife of Yuya and mother of Queen Tiye. This non-royal couple were granted the honor of a tomb in the Valley of the Kings.

Tausret: Wife of Seti II and stepmother of his successor, Siptah, for whom she acted as regent during his minority. At his death, she assumed the kingship as the last ruler of Dynasty 19.

BIBLIOGRAPHY

Aldred, C., *Egyptian Art*, London, 1980.

Aldred, C., *Jewels of the Pharaohs*, London and New York, 1971.

Allam, S., *Everyday Life in Ancient Egypt*, Cairo, 1990.

Allam, S., "Quelques aspects du marriage dans l'Egypte ancienne," in *Journal of Egyptian Archaeology*, 64, 1981 pp. 116–35.

Baines, J., and J. Màlek, *Atlas of Ancient Egypt*, Oxford and New York, 1980.

Bierbrier, M., *The Tomb-Builders of the Pharaohs*, London, 1982.

Bleeker, C., *Hathor and Thoth*, Leiden, 1973.

Bourghouts, J. F., *The Magical Texts of Papyrus Leiden I 348*, Leiden, 1971.

Caminos, R., "The Nitocris Adoption Stela," in *Journal of Egyptian Archaeology*, 50 1964 pp. 71-101.

Černy, J., "The will of Naunakhte and the related documents," in *Journal of Egyptian Archaeology*, 31, 1945 pp. 29–53.

Černy, J., *A Community of Workmen at Thebes in the Rameside Period*, Cairo, 1973.

D'Auria, S., P. Lacovara, C. H. Roehrig (eds.) *Mummies and Magic: The Funerary Arts of Ancient Egypt*, Boston, 1988.

Davis, T. M., G. Maspero, E. Aryton, G. Daressy, *The Tomb of Queen Tiyi*, London, 1910.

Desroches-Noblecourt, C., *La femme au temps des pharaohs*, Paris, 1986.

Desroches-Noblecourt, C., *Tutankhamen: Life and Death of a Pharaoh*, London, 1963.

Dunham, D., and W. K. Simpson, *The Mastaba of Queen Mersyankh III*, Boston, 1974.

Edwards, I. E. S., et al. (eds.) *Cambridge Ancient History*, 3rd. ed., Cambridge, 1970–75.

Edwards, I. E. S., *The Pyramids of Egypt*, revised ed. London, 1993.

Edwards, I. E. S., *Treasures of Tutankhamun*, New York, 1976.

Fischer, H. G., *Egyptian Women of the Old Kingdom and of the Heracleopolitan Period*, Atlanta, 1989.

Gaballa, G. A., *The Memphite Tomb-chapel of Mose*, Warminster, 1977.

Gardiner, A. H., "A Lawsuit Arising from the Purchase of Two Slaves" in *Journal of Egyptian Archaeology*, 21, 1935, pp. 140–46.

Ghalioungui, P., and Z. el-Dawakhly, *Health and Healing in Ancient Egypt*, Cairo, 1965.

Gitton, M., *L'Épouse du dieu Ahmès Nèfertary*, 2nd ed. Paris, 1981.

Gitton, M., "Le role des femmes dans le clergé d'Amon à la 18e dynastie," in *Bulletin de la Société Française d'Egyptologie*, 75, 1976, pp. 31–46.

Hall, R., *Egyptian Textiles*, Aylesbury, 1986.

Handoussa, T., "Marriage and divorce and the rights of wives and children in Ancient Egypt." Unpublished doctoral dissertation, in Arabic. Cairo, 1973.

Hart, G., *A Dictionary of Egyptian Gods and Goddesses*, London, 1986.

Hawass, Z., "The Funerary Establishments of Khufu, Khafre and Menkaure during the Old Kingdom." Unpublished doctoral dissertation, Philadelphia, 1987. Microfilm, Ann Arbor, 1987.

Hawass, Z., *The Pyramids of Ancient Egypt*, Carnegie, 1990.

Hoffmann, M., *Egypt before the Pharaohs*, New York, 1979.

Hornumg, E., *The Valley of the Kings*, New York, 1990.

Hornung, E., *Conceptions of God in Ancient Egypt*, London, 1983.

Ikram, S., "Domestic Shrines and the Cult of the Royal Family at el-Amarna," in *Journal of Egyptian Archaeology*, 75, 1989, pp. 89–101.

Janssen, J. J., "Marriage Problems and Public Reactions (P. BM 10416)," in J. Baines et al. (eds) *Pyramid Studies and other Essays presented to I. E. S. Edwards*, London, 1988, pp. 134–37.

Janssen, R. M. and Janssen, J. J., *Growing up in Ancient Egypt*, London, 1990.

Kanawati, N., "Polygamy in the Old Kingdom," in *Studien zur Altagyptischen Kultur 4*, 1976, pp. 149–60.

Kemp, B., *Ancient Egypt: Anatomy of a Civilization*, London and New York, 1989.

Killen, G., *Ancient Egyptian Furniture I*, Warminster, 1980.

Kitchen, K. A., *Pharaoh Triumphant: The Life and Times of Rameses II*, Warminster, 1982.

Kitchen, K. A., *The Third Intermediate Period in Egypt*, Warminster, 1973.

Lesko, B., (ed.) *Women's Earliest Records from Ancient Egypt and Western Asia*, Atlanta, 1989.

Lichtheim, M., *Ancient Egyptian Literature, I :The Old and Middle Kingdoms; II: The New Kingdom; III: The Late Period*, Berkeley, 1975, 1976, 1980.

Lilyquist, C., *Ancient Egyptian Mirrors from the Earliest Times through the Middle Kingdom*, Munich and Berlin, 1979.

Manniche, L., *Sexual Life in Ancient Egypt*, London, 1987.

McDowell, A.G., *Jurisdiction in the Workmen's Community of Deir el Medineh*, Leiden, 1990.

Newberry, P., "Queen Nitocris of the Sixth Dynasty," in *Journal of Egyptian Archaeology*, 29, 1943, pp. 51–54.

Pestman, P. W., *Marriage and Matrimonial Property in Ancient Egypt*, Leiden, 1961.

Pinch, G., "Childbirth and Female Figurines at Deir el-Medina and el-Amarna," in *Orientalia*, 52, 1983, pp. 405–14.

Pinch, G., *Votive Offerings to Hathor*, Oxford, 1993.

Quibell, J., *The Tomb of Yuaa and Thuiu*, Cairo, 1908.

Redford, D. B., *Akhenaten, the Heretic King*, Princeton, 1984.

Reeves, N., *The Complete Tutankhamun*, London and Cairo, 1990.

Robins, G., "The God's Wife of Amun in the 18th Dynasty in Egypt," in A. Cameron and A. Kuhrt (eds.) *Images of Women in Antiquity*, London and Canberra, 1983, pp. 65–78.

Robins, G., *Women in Ancient Egypt*, London, 1993.

Russmann, E. R., *Egyptian Sculpture*, Austin and Cairo, 1989.

Saleh, A. A., *The Egyptian Family in Ancient Times*, Cairo, 1988. In Arabic.

Schafer, H., *Principles of Egyptian Art*, trans. J. Baines, Oxford 1974.

Schulman, A., "Diplomatic Marriage in the Egyptian New Kingdom," in *Journal of Near Eastern Studies*, 38, 1979, pp. 177–93.

Simpson, W. K., "Polygamy in Egypt in the Middle Kingdom," in *Journal of Egyptian Archaeology*, 60, 1974, pp. 100–105.

Simpson, W. K., *The Literature of Ancient Egypt*, New Haven and London, 1973.

Smith, W. S., *The Art and Architecture of Ancient Egypt*, 2nd ed. revised by W. K. Simpson, Harmondsworth, 1981.

Spencer, A. J., *Death in Ancient Egypt*, Harmondsworth and New York, 1982.

Strouhal, E., *Life of the Ancient Egyptians*, London and Cairo, 1992.

Trigger, B., B. J. Kemp, D. O'Connor, and A. B. Lloyd, *Ancient Egypt: A Social History*, Cambridge, 1986.

Troy, L., *Patterns of Queenship in Ancient Egyptian Myth and History*, Uppsala, 1986.

Wilson, H., *Egyptian Food and Drink*, Aylesbury, 1988.

Winlock, H., *The Treasure of the Three Egyptian Princesses*, New York, 1948.

INDEX

Gods and Goddesses

Kings

Royal Ladies

Sites

PAGE 1 Colossal statue of Meryt-Amun, daughter of Rameses II. Akhmim. New Kingdom.
PAGE 2 The Sphinx of Giza.
PAGE 4 A 'King's daughter of his body' kneeling at the feet of her husband. Detail from a husband and wife group in the tomb of Mereruke, Saqqara. Old Kingdom.
PAGE 6 Queen Nefertari wearing the vulture crown with two feathers enclosing the sun disk. Tomb of Nefertari, Valley of the Queens, Thebes. New Kingdom.
PAGE 8 Painted limestone head of Queen Nefertiti, wife of Akhenaten, from Amarna. Berlin Museum. New Kingdom.
PAGE 12 Female musicians and dancers at a banquet. Tomb of Nakht, Western Thebes. New Kingdom.
PAGE 24 The River Nile at sunset.

Quotations of ancient texts are taken from the following:
Allen J. P., in S. D'Auria, P. Lacovara, C. H. Roehrig (eds.) *Mummies and Magic: The Funerary Arts of Ancient Egypt* (Boston, 1988).
Bourghouts, J. F., *The Magical Texts of the Papyrus 1348* (Leiden, 1971).
Kitchen, K. A., *The Third Intermediate Period in Egypt* (Warminster, 1973).
Lichtheim, M. *Ancient Egyptian Literature 1: The Old and Middle Kingdoms;*
2: The Late Period; 3: The New Kingdom (Berkeley, 1976–80).
Redford, D. B. *Akhenaten: The Heretic King* (Princeton, 1984).

Photographic credits:

Zahi Hawass
1, 2–3, 4, 6–7, 8, 12–13, 30 (B), 31, 36–37, 42, 50, 51, 53, 56, 57, 58, 59, 62, 63, 65, 69, 73, 74, 75, 76, 81, 82, 86, 87, 91, 92, 97, 100, 102, 103, 106, 107, 108 (A, B, C), 109, 111, 112, 113, 114, 115, 120, 121, 122, 124, 127, 132, 140, 141, 144, 148, 150, 152, 154, 158, 160, 161, 167, 169, 170, 172, 175, 182, 183, 186, 188, 189, 190, 191, 195, 196, 197, 200, 201

Zahi Hawass/Milan Zemina
10, 24–25, 29, 38, 39, 43, 45, 54–55, 64, 70–71, 85, 95, 125, 126, 130, 137, 138, 139, 151, 153, 155, 157, 159, 162, 163, 166, 168, 171, 173, 176, 177, 180, 188 (A), 187

Zahi Hawass/Patric Chapous
30 (A), 44 (A and B), 84, 90, 101, 118, 119, 123, 181

Zahi Hawass/Osamu Komasagaua
26, 27, 28, 80, 98, 99, 149, 174

Zahi Hawass/Paolo Scremin
4–5, 72, 93, 94, 131, 133, 145, 194

Zahi Hawass/Cary Wolinsky
77, 83

Graphic design by Giorgio Gardel

General Coordination: Gabriella Piomboni, Marta L'Erede

Library of Congress Catalog Card Number: 99-69858
ISBN 0-8109-4478-2 (cloth)
ISBN 0-8109-2732-2 (bookclub pbk.)
Copyright © 1995, 2000 Zahi Hawass

First published in 2000 by Leonardo Periodici, Milan

Published in 2000 by Harry N. Abrams, Incorporated, New York

Printed and bound in Italy

HARRY N. ABRAMS, INC.
100 Fifth Avenue, New York, N.Y. 10011
www.abramsbooks.com